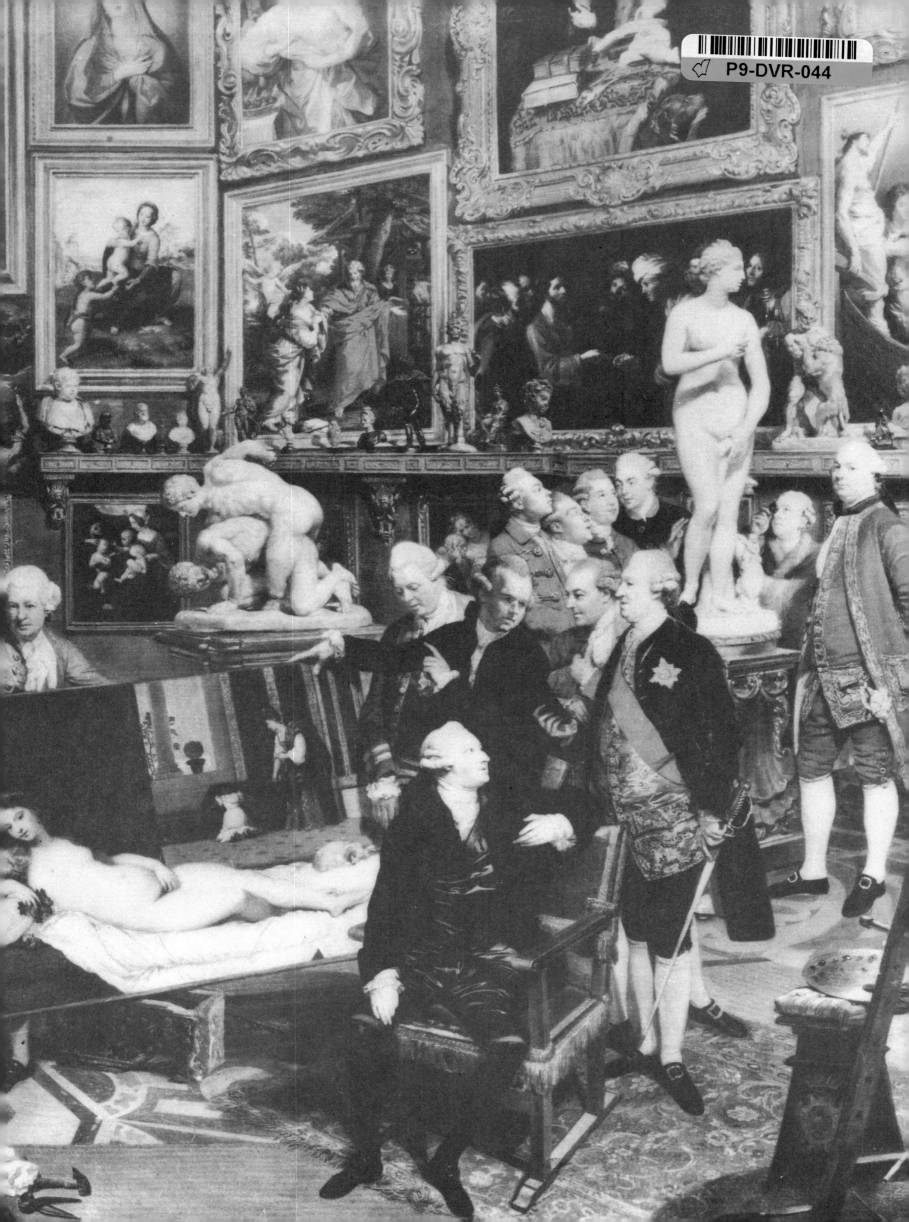

A Gallery of
Great Paintings

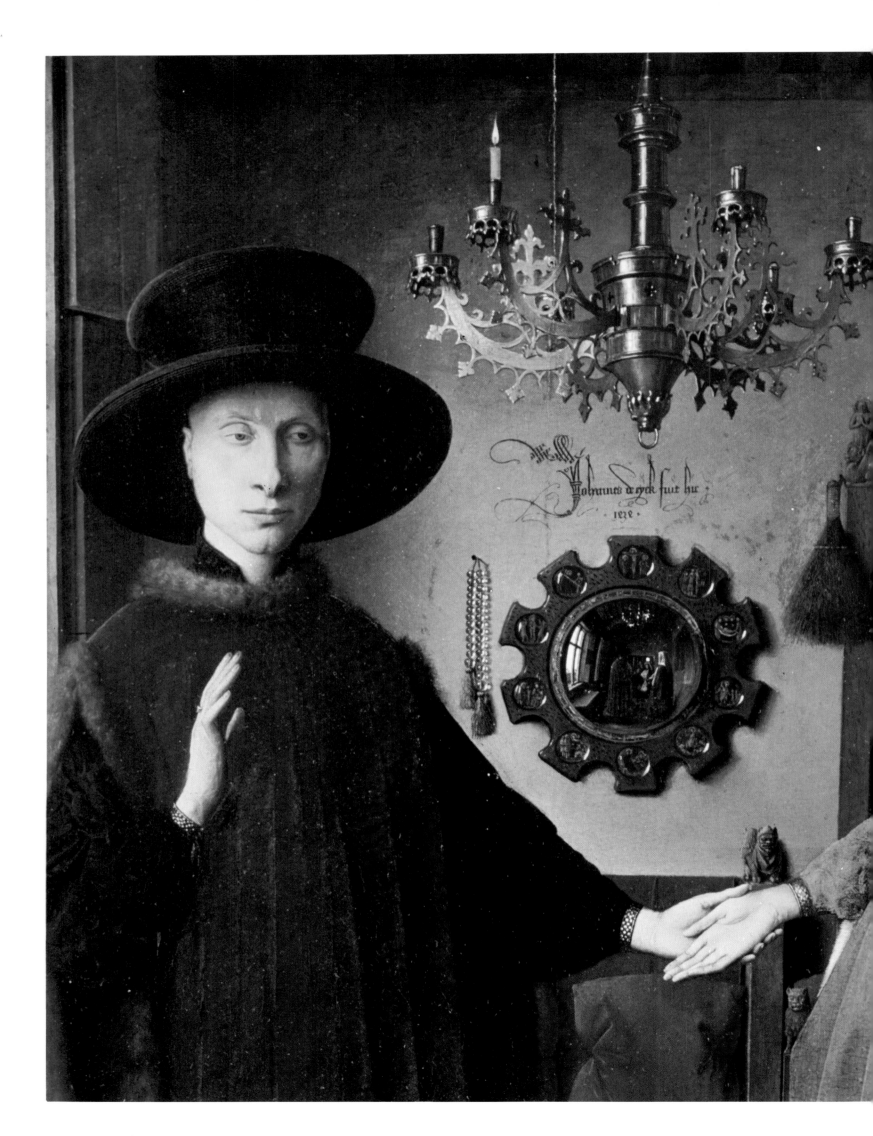

A Gallery of Great Paintings

Daphne Lucas

Hamlyn

London New York Sydney Toronto

Endpapers
The Tribuna of the Uffizi
1772—76
Johann Zoffany (1725—1810)
Royal Collection

Frontispiece
**The Marriage of Giovanni Arnolfini
and Giovanna Cenami** (detail)
1434
Jan van Eyck, active 1422, died 1441
National Gallery, London
(see page 33)

Published by
The Hamlyn Publishing Group Limited
London · New York · Sydney · Toronto
Astronaut House, Feltham, Middlesex, England
© Copyright The Hamlyn Publishing Group 1975

ISBN 0 600 36162 4

Phototypeset in England by Filmtype Services, Scarborough
Printed in Spain by
Mateu Cromo Artes Gráficas S.A., Madrid

Contents

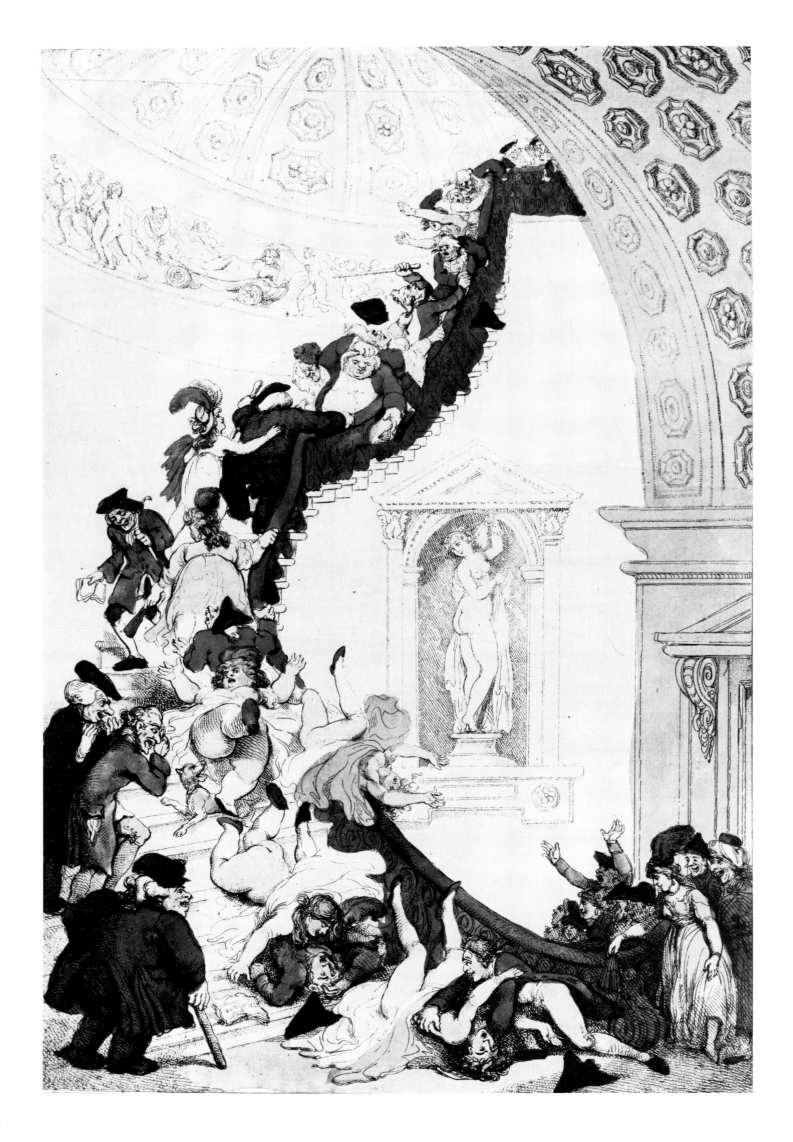

Introduction

While our personal response towards the final achievement is ultimately the most important aspect of a picture, consideration of its place in the history of painting, the possible intentions of the artist and the changing attitudes to particular themes can bring a closer understanding of the work and therefore heighten our enjoyment.

Each room in our imaginary gallery of paintings is devoted to a different subject; a subject which, for various reasons, seems to have captured the imagination of artists throughout the ages.

It is hoped that the pictures themselves will sharpen wits, stimulate intellects and soothe senses and that the words that accompany them will make a new phrase: 'I know what I like *and I know why.*'

Exhibition Stare Case
late 18th century
Thomas Rowlandson (1756–1827)
British Museum, London

Religious Painting

Over the centuries the Christian Church has revised its interpretation of the Bible, its attitude to the achievements of pagan antiquity and its relationship with the State. In turn, politicians, the nobility, merchants and ordinary people have revised their opinions of religion and of the Church. Artists have reflected these changes in their paintings, and a few really remarkable artists have even anticipated them.

The attitude of the Church to art in the Middle Ages was laid down by Pope Gregory the Great when he stated that: 'Paintings figure in churches in order that the illiterate, looking at the walls, may read what they are unable to read in books.' In this way painting became a potent and efficient agent in the religious education of the laity, and the artist was a craftsman who performed a practical function under the direction of the Church and through the organisation of the guilds. In southern Europe, the walls of churches were decorated with scenes from the Old and New Testaments, and from the lives of the saints, executed either in mosaic or in fresco. They were, broadly speaking, Byzantine in style, that is deliberately two-dimensional, highly formal and not particularly concerned with man's physical reality. In addition the Biblical figures were clearly seen to be superhuman, and Christ was portrayed as a stern Judge rather than a loving Saviour. Typical is the towering *Christ in Majesty* from the church of San Clemente at Tahull in Spain. With authoritative stance and divine gesture he must have seemed convincingly omnipotent to the ordinary man.

In the floods that overwhelmed Florence in 1966 a work of great beauty and crucial importance in the history of painting was nearly destroyed. From what remains and the photographs we possess, Cimabue's *Crucifixion* can be appreciated as a landmark in the history of painting and religious art. The body of Christ is still two-dimensional in the Byzantine manner, the drapery flimsy and insubstantial, and the attempts at anatomical detail, such as the ribcage and shoulder muscles, are sketchy and highly stylised. The figure is unnaturally elongated and forms an S-bend which emphasises the agony of death. But the change made by Cimabue was more in spirit than technique, for he attempted to substitute for the conventional idealised image, the rep-

resentation of Christ as a suffering man of real humanity, and in this painting, Cimabue gave the people of his day not only an image to look at but one to love.

This humanising of Biblical characters continued in the work of Giotto, who is considered to be the father of the Italian Renaissance. The new naturalism can be seen in his painting of *The Kiss of Judas*. The figures have weight and solidity, are set firmly one in front of the other apparently moving in three-dimensional space, and the various characters are identified by different emotions and individual movements and gestures. The scene is full of agitation: men raise flares and lances, one blows a horn, and St Peter cuts off a soldier's ear. It suggests all the alarm, scuffling and noise of an arrest at dawn. However nothing detracts from the two chief characters in the drama, who are locked together face to face, in the centre of the scene. The enveloping gesture of Judas, which takes Christ into the power of the priests, is both poignant and dramatically convincing. To us now, Giotto's painting looks wooden as he never really mastered the rules of linear perspective, anatomy or the art of relief modelling in light and shade, but his work and that of Cimabue represent a very important change of emphasis, away from the stereotyped forms of the Middle Ages and towards the ease of expression which is characteristic of the Renaissance.

It was with Masaccio that the next great step forward was taken. In his short life he achieved tremendous advances in colouring, modelling, foreshortening and emotional expressiveness. His figures have the monumental grandeur and solidity of Giotto's, with an even greater mastery in dealing with anatomical and spatial problems. Above all, Masaccio aimed at two things: to represent the human figure as naturally as possible and to apply the recently formulated rules of linear perspective to produce an illusion of depth. Masaccio's talent is demonstrated most compellingly in *The Tribute Money*. A Roman tax gatherer in a short tunic thrusts out his hand, demanding tribute for Caesar. The disciples turn in their dilemma to Christ who directs Peter to go to the river's edge, and at the extreme left Peter is seen finding the money in the mouth of a fish. The complex action is narrated

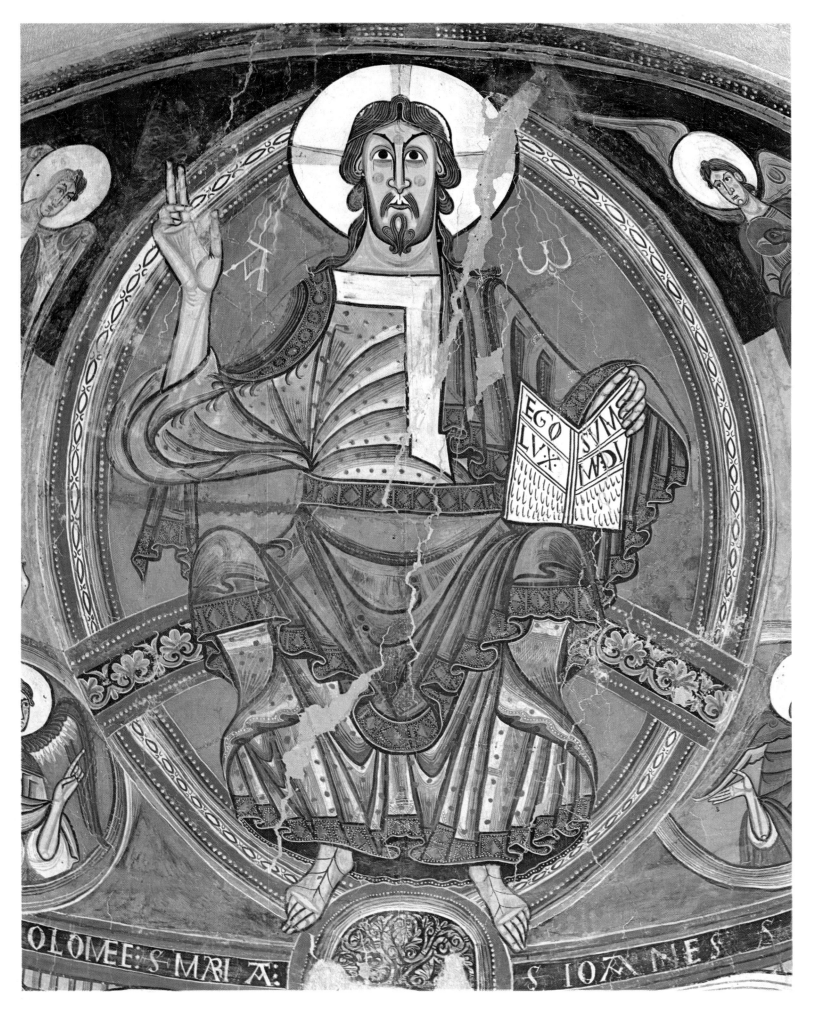

1
Christ in majesty
1123, fresco
Museo de Arte de Catalunã, Barcelona

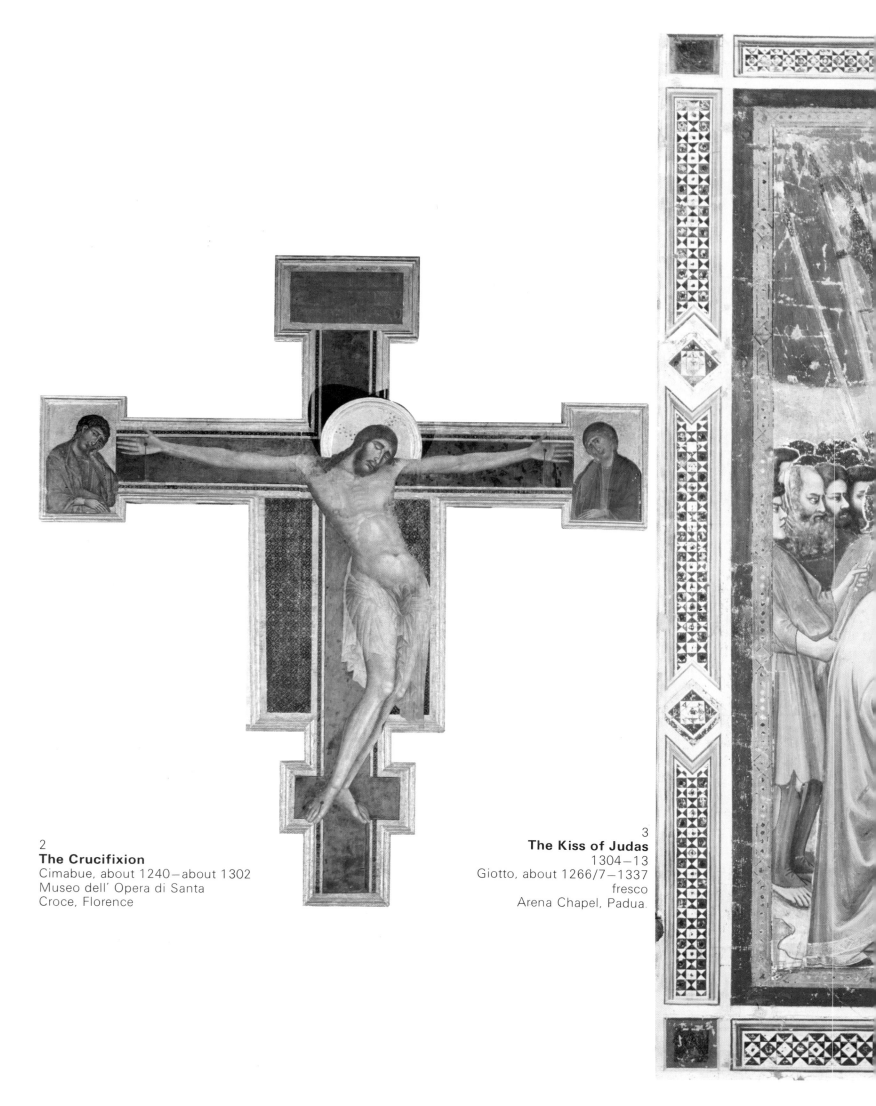

2
The Crucifixion
Cimabue, about 1240–about 1302
Museo dell' Opera di Santa
Croce, Florence

3
The Kiss of Judas
1304—13
Giotto, about 1266/7—1337
fresco
Arena Chapel, Padua.

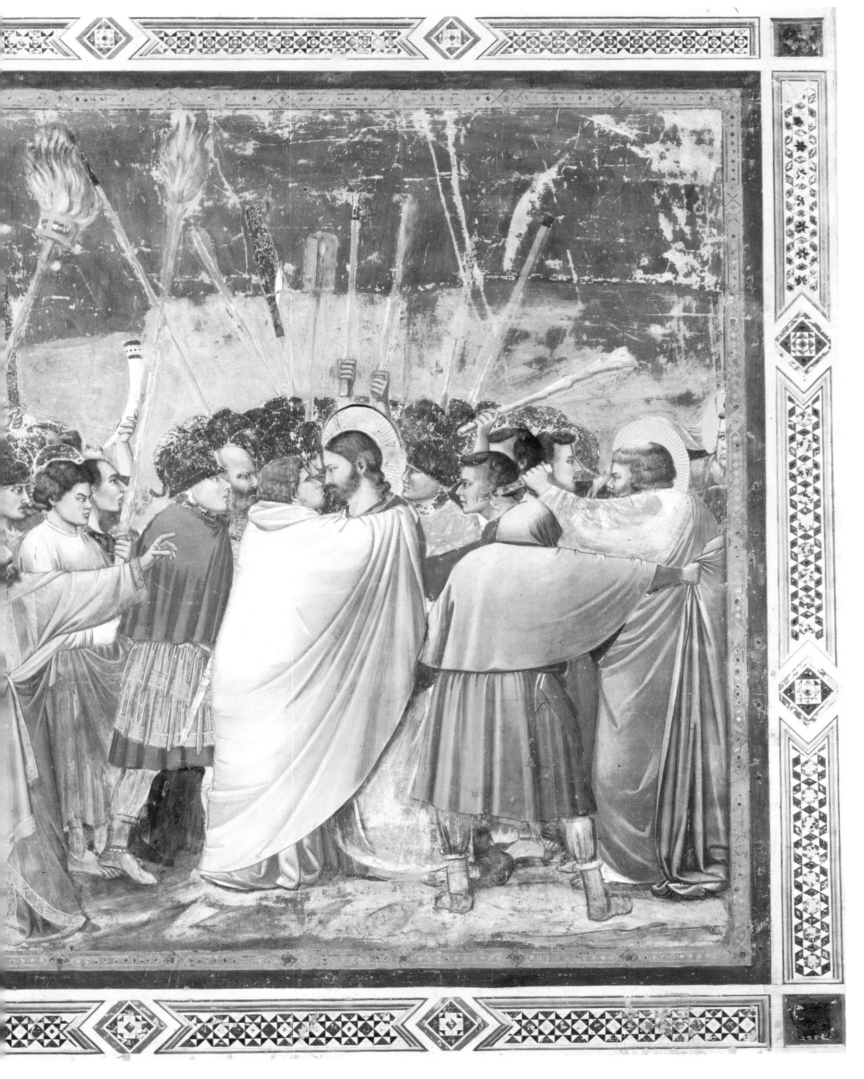

The Tribute Money
1425—28
Masaccio 1401—28
fresco
Brancacci Chapel, Santa Maria del Carmine,
Florence

The Baptism of Christ
about 1440—50
Piero della Francesca 1410/20—92
National Gallery, London

with simple ease. The figures stand firmly, move freely and although they form a compact, visually pleasing composition, they appear to be grouped naturally. The eye is drawn into the picture by the converging lines of the foreshortened architecture on the right and the contours of the deep landscape behind. No extraneous detail is allowed to detract from the subject, as it does in Pisanello's work (see plate 6), and as a result the overall impression of the picture is one of majestic solemnity.

The dilemma for Renaissance artists was that they had to express the spiritual in terms of naturalism. It was in the Renaissance that an objectively analytical point of view towards nature appeared for the first time and, as the most important element in nature, man once more became the focal point of human interest instead of a cog in the theological machine.

Piero della Francesca was a powerful painter who shows a close observation of nature in landscape but in his paintings man predominates in importance. Piero's interest in mathematics and linear perspective make his compositions some-

times seem more like abstract patterns than scenes of actual events. This formal quality can be seen in Piero's *Baptism*. Tall, statuesque figures stand in the foreground, their forms echoing the column-like trunk of the tree. The profile of John the Baptist is balanced by the profile of the angel on the extreme left. The three-quarters view of the faces of the other two angels match each other perfectly, while we the spectators confront Christ full-face. Behind this action in the foreground a winding path leads the eye into the distant Umbrian hills. The whole painting is pervaded by a cool, clear light which, combined with the graceful calm of the hovering dove, gives a sense of absolute peace and stillness. Here is a world in which all action seems to be suspended in contemplation.

The serious art of Cimabue, Giotto, Masaccio and Piero was not appreciated by all Italian patrons, many of whom admired the less austere International Gothic style. In this essentially decorative court art colours are richer, clothing and accoutrements more elegant and every corner is crammed with a multitude of figures, animal and human,

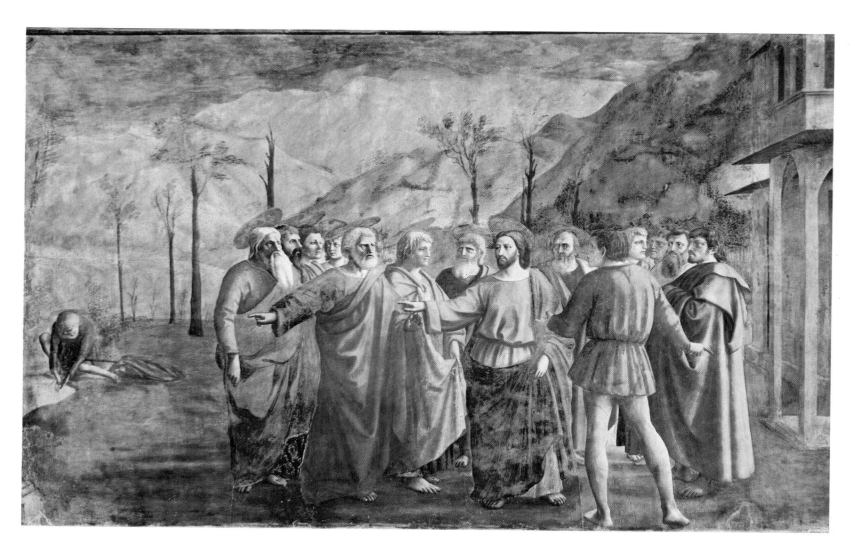

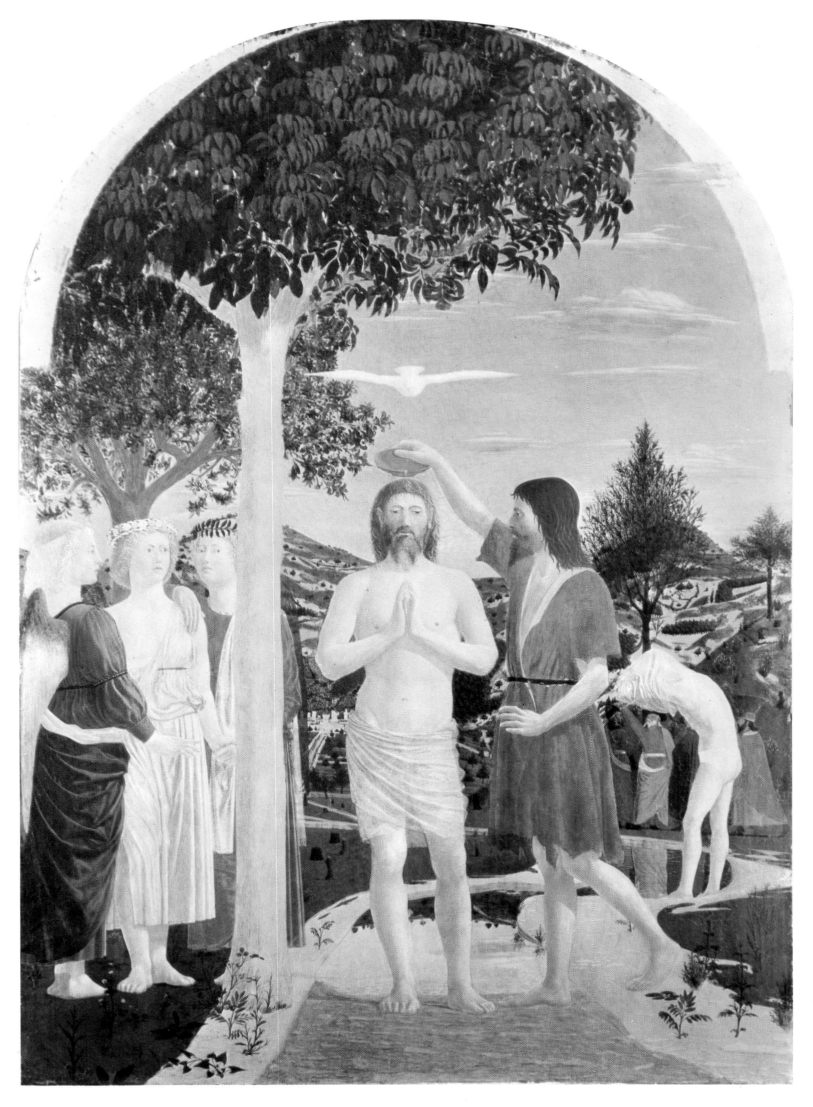

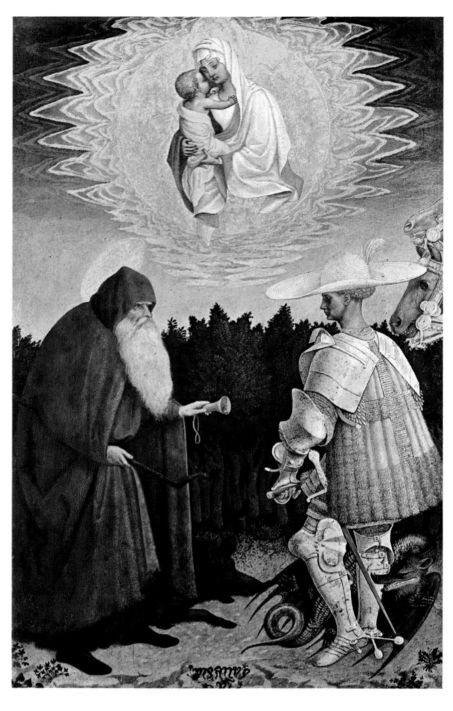

6
**The Virgin and Child
with St George
and St Anthony Abbott**
Pisanello, active 1395—
about 1455,
National Gallery, London

7
The Virgin of the Rocks
about 1507
Leonardo da Vinci 1452—1519
National Gallery, London

which are depicted in great and often fanciful detail. Here we see naive pleasure in the decorative accessories of life: flowers, birds, animals, rich clothes and jewels. Pisanello's *Virgin and Child with Saints George and Anthony Abbot* is an example of a painting where the artist was obviously more concerned with each exquisite detail than with the religious significance of the subject-matter.

In Renaissance Italy commerce flourished. As a result the new middle class, the merchants, amassed great wealth and as an act of piety and to commemorate their own greatness, many religious and private works were commissioned. Greek-speaking scholars were welcome visitors, and the revived interest in Greek and particularly Roman antiquity showed itself in art and literature. The free and democratic atmosphere of Florence encouraged originality of thought and

intellectual curiosity, and created a receptive attitude towards the resulting changes and innovations. One artist working in these enlightened times was Leonardo da Vinci. He encouraged the shift from the medieval notion of the anonymous artist working in the service of God to that of an individual with a particular gift to offer to his patron. Leonardo believed that the painter is an inventor of a rather special kind in that he can make of nature what he will. He was concerned to establish truth by question and experiment rather than by tradition and accepted beliefs.

A glance at the *Virgin of the Rocks* shows Leonardo's skill in depicting natural forms. Probably no artist has studied with such intensity the structure and stratification of rocks, the natural growth of plants, the way in which hair curls and waves, the natural fall of a garment over a human body. He

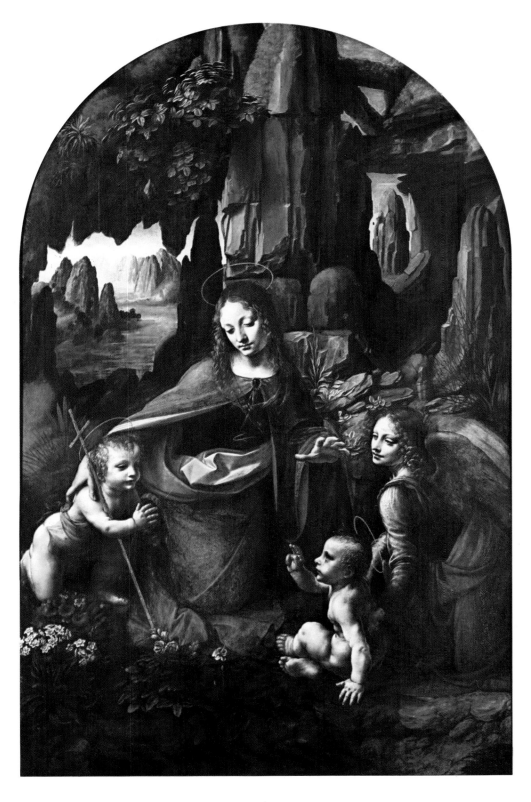

was the first to depict the soft modelling of such delicate features as lips and eyelids, the blurred edges of an object when it falls into shadow or curves round so that it disappears from view. But something else is apparent too. The figures fit easily into the framework of the canvas without being crowded or lost within it. They form a stable triangular composition which is both natural and harmonious. Yet, even with all the emphasis on naturalism, this remains a strange painting. What after all are the Virgin, Child and St John the Baptist doing in this cave with an unearthly landscape just visible in the background? What is this mysterious light which gives such an unreal air to the whole painting, so unlike the clearly lit, rational pictures of Giotto and Piero? There can be no absolute answers. All that can be said is that Leonardo was the first to reject the idea of the artist as crafts-

man, and to introduce the idea of the artist as a man with a unique vision.

The age of the Renaissance and the Reformation was a time of change in almost every field of human activity. As a result of the Reformation and the defensive reaction of Catholic reform, a new spirit of religious earnestness began to be apparent at all levels of society. A conviction of human sinfulness and a stress on the ravages left by original sin in human nature began to outweigh the confident optimism of the Renaissance. This change can be seen in Michelangelo's paintings in the Sistine Chapel. On the ceiling, the earlier fresco cycle, completed in 1512, celebrates the theme of Salvation. In contrast, on the altar wall, is his sombre painting of *The Last Judgement*, a work of desperate pessimism which he began in 1536. It is known that as he grew older

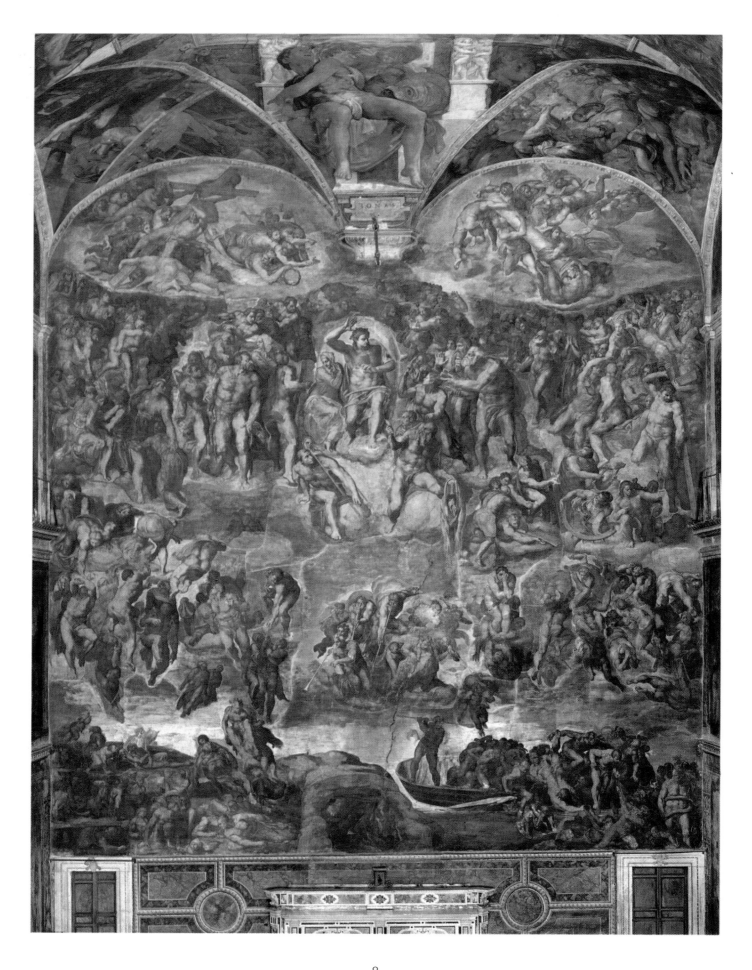

8
The Last Judgement
1536—41
Michelangelo Buonarroti 1475—1564
fresco
Sistine Chapel, Vatican Palace, Rome

Michelangelo became increasingly conscious of the significance of Christianity and at the same time was deeply disturbed by the role played by the Church and by the immorality of everyday society. (By the time he began this fresco Rome, symbol of Italian Renaissance culture, had been sacked, and the formation of the Protestant Church in northern Europe was clearly apparent.) In *The Last Judgement* he stripped the angels of their wings, the saints of their haloes and the crown from God. Christ has become a terrible, wrathful judge, condemning the wicked to eternal damnation. On the left the blessed struggle towards Heaven, while the mouth of Hell gapes over the altar. Michelangelo considered the human body to be the most expressive thing in the world, and the figures of the Sistine ceiling show his ideal of physical beauty. But in *The Last Judgement* the figures are neither idealised nor graceful, as they tumble hopelessly down to Hell, screaming and writhing so that every muscle strains against tightened flesh in an inextricable tangle of limbs. The harmony and ease of composition seen thirty years earlier in the work of Leonardo has vanished, and the lack of structure echoes Michelangelo's loss of confidence and hope.

The conflict between the dogmatic ecclesiastics of the Counter-Reformation and an artist brought up in the liberal Renaissance tradition surrounds Veronese's painting of the Last Supper, and indeed landed him in trouble. Less interested in historical truth than sensuous beauty, Veronese could not resist the opportunity to produce a magnificent pageant painting. To the feast Veronese brought grand luxury and dignified ostentation, a love of decoration and of finely wrought things, and a gift for richly coloured, civilised display. In 1573 he appeared before the Inquisition to defend his interpretation of the holy event. He had set the scene under a superb colonnade, where servants bustle around the table, and in the foreground a major-domo conducts affairs with the assurance of a successful restaurateur. These figures were thought inappropriate and the Inquisitors released Veronese on condition that he promised to correct the picture. This he did, not by tampering with any of his beautifully painted figures but by changing its title to *The Feast in the House of Levi*. This title is inscribed on the picture, which nevertheless remains the most splendidly set Last Supper in the history of painting. For us today, the subject is immaterial. It is pleasure enough to enjoy its overall cheerfulness and frank and joyous worldliness of Venetian splendour.

During the southern European Renaissance, artists had celebrated life and the most important religious symbol had become the hopeful Resurrection; by contrast, in northern Europe life was considered a vale of tears and the crucifixion and death of Christ were the most prominent religious themes.

One of the first northern European artists to break away from the International Gothic style was the Flemish artist Jan van Eyck. The subject of his masterpiece, the Ghent Altarpiece, is taken from the Apocalypse and represents the redemption of mankind through the suffering of Jesus. In a deep landscape, the Lamb, symbol of Christ's sacrifice for human salvation, stands on an altar that is part of the Fountain of Life. The altar is surrounded by angels carrying the instruments of the Passion. To the left of the Fountain of Life are the prophets and patriarchs, to the right the apostles and martyrs, and in the distance two processions of saints, all of whom witness this proof of God's love. In the background can be seen the towers and spires of the heavenly city.

What is immediately apparent is the richness of the painting and the great detail in the garments, individual faces and even flowers in the grass, all of which are recognisable botanical specimens. To the medieval mind every object in the world had a peculiar significance by virtue of being a divine creation, so that paintings such as this one included layers and layers of symbolic detail. Van Eyck was chiefly interested in portraying each individual object in the minutest detail, sometimes at the expense of the unity of the whole composition, but here the enveloping landscape brings all the separate groups together and the eye floats over the flowery lawns into a distance of golden light. Van Eyck's improved technique of oil painting produced effects never surpassed in luminous richness, and *The Adoration of the Lamb* is memorable for its incredibly transparent greens, lustrous reds and satin whites.

But northern religious painting was rarely so calm and peaceful as Jan van Eyck's vision, and many altarpieces are devoted to the agony of Christ on the Cross and the martyrdoms of saints which are often depicted in all their gruesome detail. The northern concept of Christ was close to that of Michelangelo's wrathful judge, and man was considered to be weak and sinful, and undeserving of the rewards of Heaven.

The difference between the religious conceptions of the northern medieval world and those of the Renaissance south is most clearly seen in the Isenheim Altarpiece by Matthias Grünewald. Hardly anything is known of Grünewald's life but, as we can see from his *Temptations of St Anthony* which is a side panel of the altarpiece, he was profoundly affected by the mystical writings of his time and the forms of revivalism which preceded and accompanied the Reformation. His is a stern and unrelenting view of religion and he expresses the most severe religious doctrines. Everything in this picture is intended to have the most violent and immediate effect on the emotions. The agony of St Anthony is reflected in the desolation of the wilderness, the demons which fly about ecstatically in the background, and the violence of the grotesque animals and diseased and festering sub-human creatures. The picture shows Grünewald's sense of design, composition and dramatic colour, but a mood of extreme and brutal suffering predominates.

Undaunted by the great achievements of the Italian painters who immediately preceded him, Caravaggio sought an independent style of his own which proved to be an innovation at the time and a most powerful influence in the future. He became the pioneer of social realism and chose not only to see but portray dirty feet, weathered faces and old clothes, and had the audacity to paint these into religious subjects. It was an art of the people, for the people, and as such was often rejected by his Church patrons. But Caravaggio maintained that he was only interpreting the Gospel stories literally, for Christ was a carpenter and many of the disciples fishermen. In the *Death of the Virgin* he represents the

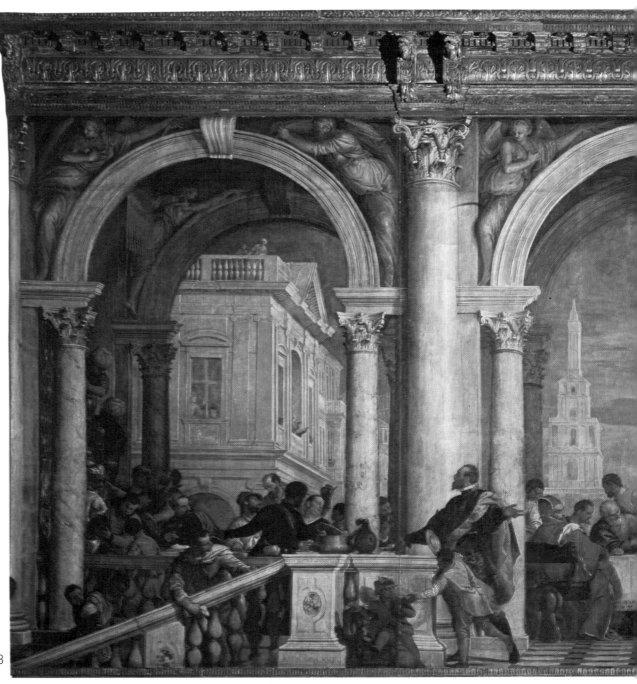

9
**The Feast in the House
of Levi** 1573
Paolo Veronese about 1528–88
Accademia, Venice

Mother of God with a swollen body and bare feet, and wearing a plain dress. The figures of the mourners around her are of old peasants with hands, worn from hard work, covering their faces in grief. The chair supporting the weeping form of the girl is a rustic one and the pot beside her well-used. Ordinariness is the theme but the striking rhythm of the huge red curtain which sweeps across the painting, the sudden foreshortening of the Virgin's feet, the gusto with which Caravaggio uses paint, and the light which isolates parts of the forms in livid brilliance and creates shadows which are thick, impenetrable and airless, give a highly dramatic effect and force attention on the sadness of the subject.

For Spain the time of the Counter-Reformation was a heroic age. The discovery of the New World opened vast horizons and the Church shared the national spirit of crusading zeal and adventurous expansion. In painting El Greco expressed the turbulent frenzy and spiritual rapture with which the Spaniards plunged into American forests to win

souls for their Church, land for themselves and wealth for their king. El Greco's roots were in the Byzantine world as he was born in Crete and there is more than a hint of those stylised superhuman figures in his work. Italian Renaissance painters like Veronese allowed their figures a huge field of action, whereas El Greco preferred a narrow stage, pulling his twisted, elongated forms out of it. With El Greco all is movement, impassioned exaltation and a flux of living forms in constant evolution. The Catholic Church, seeking to maintain its authority, found in El Greco a useful ally because he so vividly declared the truth of the miracles that were being discredited by humanists and scientists. The representation of the miracle which was said to have occurred during the burial of Count Orgaz, when St Augustine and St Stephen intervened to lay the body to rest, is a subject which allows full play of El Greco's art. He has painted the miracle in an unearthly dramatic light, not as a supernatural, but rather as a supremely natural event. The fusion of the transcendent and terrestrial worlds can be felt on

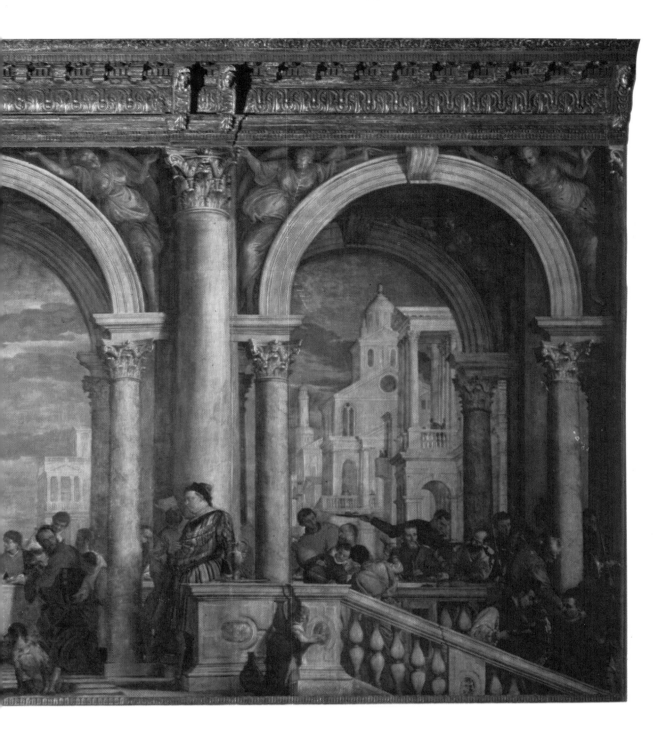

every level of the composition, with the ethereal figures of the saints mingling naturally with living men.

Quite different in mood is the stillness of the 17th-century French master Georges de la Tour. In his choice and treatment of religious subjects, de la Tour followed contemporary trends in Catholic thought: devotion to the saints, emphasis on the virtue of humility, and meditation on the fact and meaning of death. During the 17th century the doctrines of the Counter-Reformation, whose tendency was to instil a simple piety, bit particularly deep in provincial areas and were strongly preached in Catholic territories bordering on Protestant states. There seems to have been a positive fever of Catholic spiritual activity in Lorraine where de la Tour was born and lived. A calm meditative mood is the chief characteristic of de la Tour's work. In *The Nativity* the infant Christ lies tightly bandaged in swaddling clothes, and the adults draw close together around the Child and seem to be fathoms deep in thought. There is the minimum of overt religious symbolism but an unambiguously religious atmos-

phere, conveyed mainly by the protective gesture of the hand shielding the flame, and the beauty of the light.

In the 18th and 19th centuries religious art was no longer the powerful propaganda force that it had been. Artists looked elsewhere than the Church for patronage, and few of the great painters tackled conventional religious themes. But in the mid 19th century with the Pre-Raphaelites, who thought the grandeur of Italian 16th- and 17th-century religious painting insincere, there was a return to previous methods and subjects. In his painting *The Light of the World*, Holman Hunt portrays Christ in an orchard at night, holding a lantern which symbolises the light of redemption. He is about to knock on an old door, representing the soul, which is cluttered up with the ivy and brambles of sin and spiritual neglect. This is how the painting would have easily been understood by the Victorian Bible-reading public. While perhaps missing much of its religious symbolism, we might still consider this picture an accomplished piece of painting, noting the careful representation of detail, the brilliance of

10
The Adoration of the Lamb
completed 1432
Jan van Eyck, active 1422, died 1441
St Bavon, Ghent

11
The Temptations of St Anthony
1512—15
Matthias Grünewald 1470/80—1528
Musée d'Unterlinden, Colmar

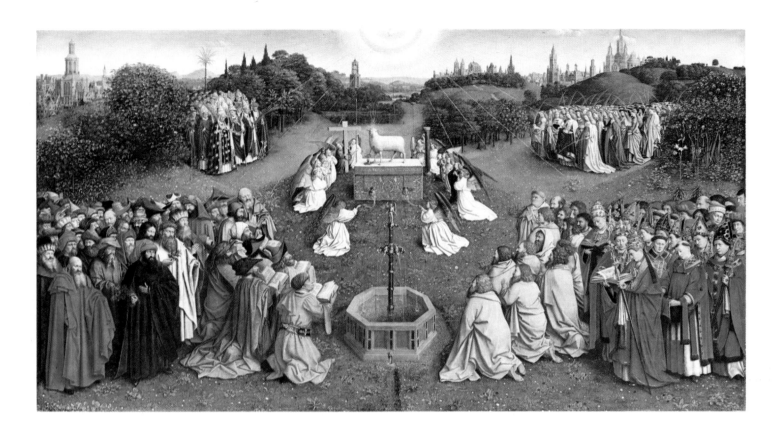

the colour, and the curious way the light from the lantern is cast on the ground.

From the early part of the 19th century artists had been finding their way to Brittany. They were captivated by its savage nature, its rugged coastline, and its glorious sandy beaches with the great curving Atlantic rollers. The individual character of the local life was also strong and compelling. Inevitably Brittany appealed to Gauguin, a restless and determined artist who was anxious to live in a more spiritually vital environment, and his stays at Pont-Aven may be interpreted as a stage in that retreat from European civilisation which finally led him to Tahiti. The motives which induced him to go to Pont-Aven were mixed. In later years he told a friend that he went there out of *tristesse* (melancholy), while another painter friend believed that he had responded to the lure of an atmosphere different from that of worldly Paris. There was also a practical consideration. Gauguin was extremely hard up and while in Paris had discovered that one of the hotels in Pont-Aven was prepared to extend long credit. Most of his pictures during this period were either straightforward landscapes or still-lifes, but he was often exercised by religious and philosophical questions and painted a number of religious pictures. The figure of Christ in *The Yellow Christ* is based on a wooden crucifix in the chapel of Tremalo, near Pont-Aven, and the village of Pont-Aven and the surrounding countryside can also be seen in the background. With this step towards the simple life came a new simplicity in style. Bold, firm outlines and large flat areas of colour with a minimum of modelling help to define

form and space. The sketchy modelling of the torso of Christ's body recalls the Christ by Cimabue discussed earlier in this chapter. The colour is frequently unnaturalistic: the body of Christ is yellow, the foliage of the trees red and orange, and the landscape in the distance changes abruptly from yellow to blue. This subjective colouring and simplification of form were to be two of the most important elements in the development of modern art, elements which used to be present in the paintings of the Middle Ages and can still be seen in primitive art. In contrast to Holman Hunt's detailed work Gauguin recommended: 'Work freely and madly and you will make progress. Above all don't labour over your picture. A great emotion can be translated immediately: dream over it and look for the simplest form.'

Another artist who has continued the theme of the Crucifixion into modern times is Graham Sutherland. During the time he was working on a commission for a Crucifixion for an English parish church, he went for a country walk and began to notice thorn bushes and the structure of thorns. Their connection with the thorns in the Gospel story struck him, and in a series of paintings which followed he came to regard the Crown of Thorns as the quintessential symbol of the cruelty involved in the act of the Crucifixion. Sutherland's view is that, for all its visible horror and underlying threat of extinction, the Crucifixion carries a message of hope, that the flesh can suffer and perish matters little because the spirit within, fortified by suffering, can rise, phoenix-like, to far greater heights of achievement. In 1945, when *Thorn Trees* was painted, this theme was particularly apt.

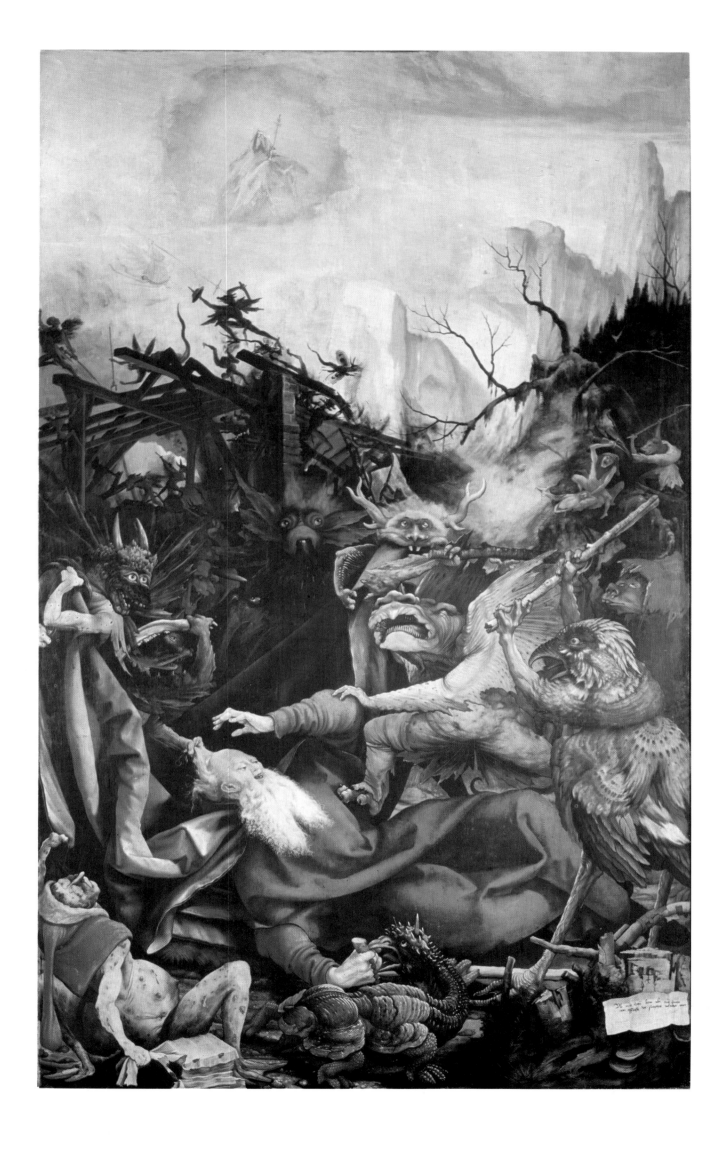

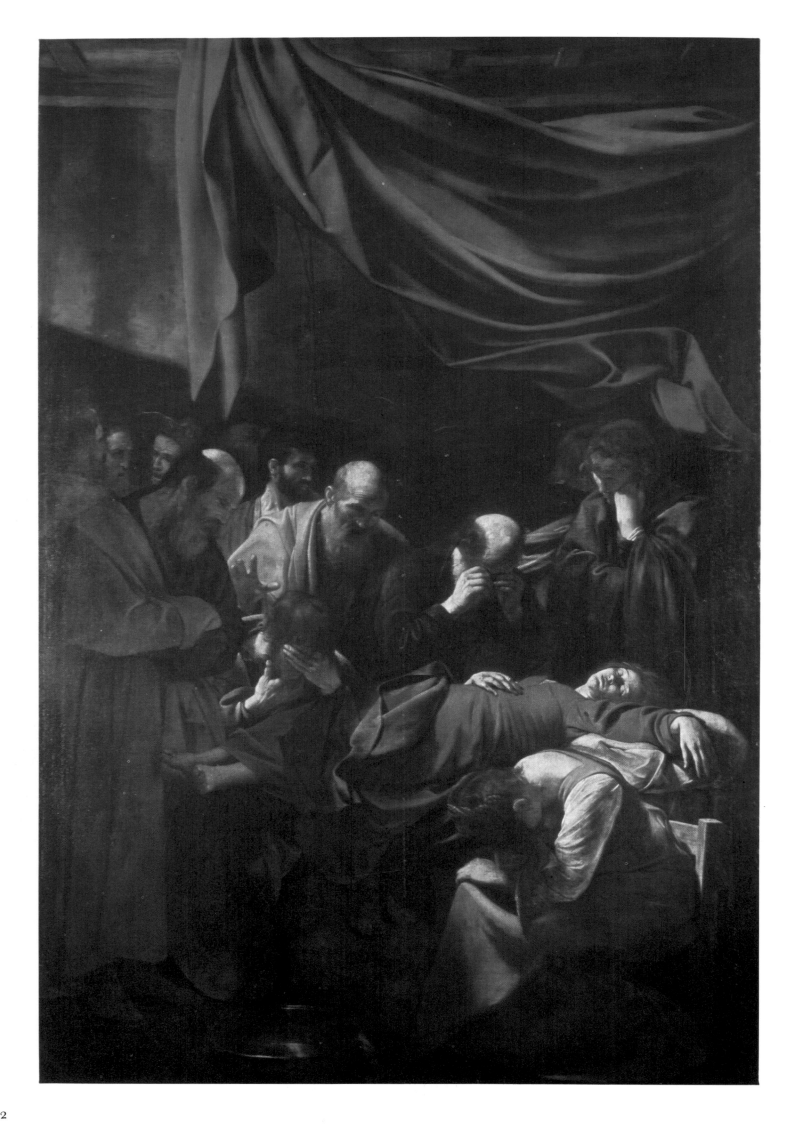

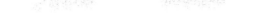

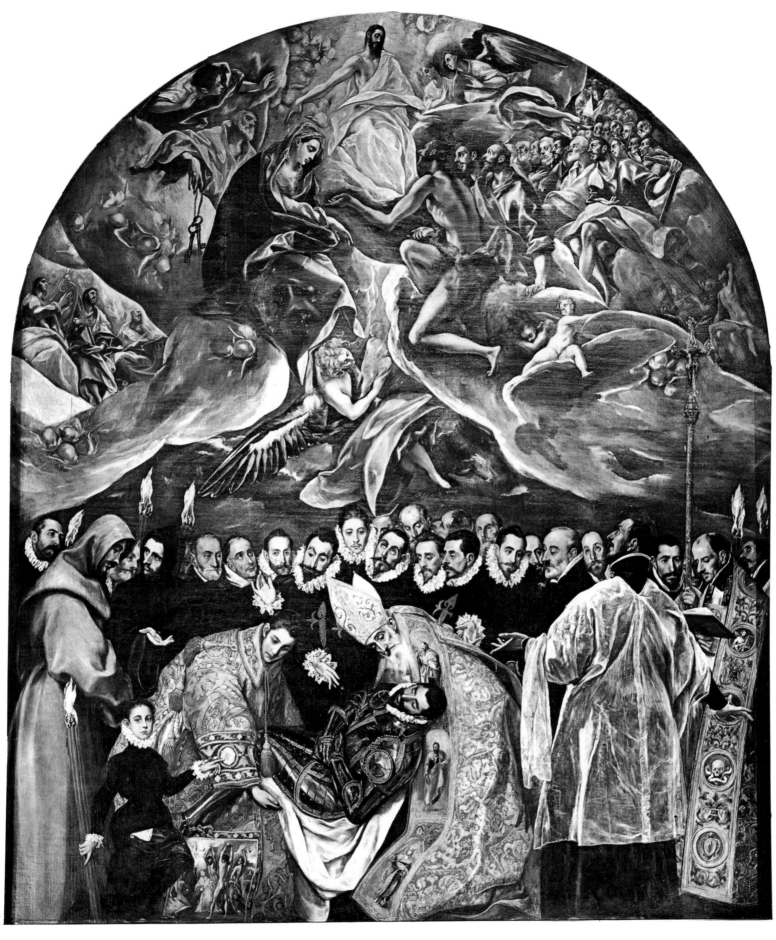

12
The Death of the Virgin
1605—06
Caravaggio 1573—1610
Louvre, Paris

13
The Burial of Count Orgaz
1586
El Greco 1541—1614
Church of San Tomé, Toledo

14
The Nativity
about 1650
Georges de la Tour 1593—1652
Musée des Beaux Arts, Rennes

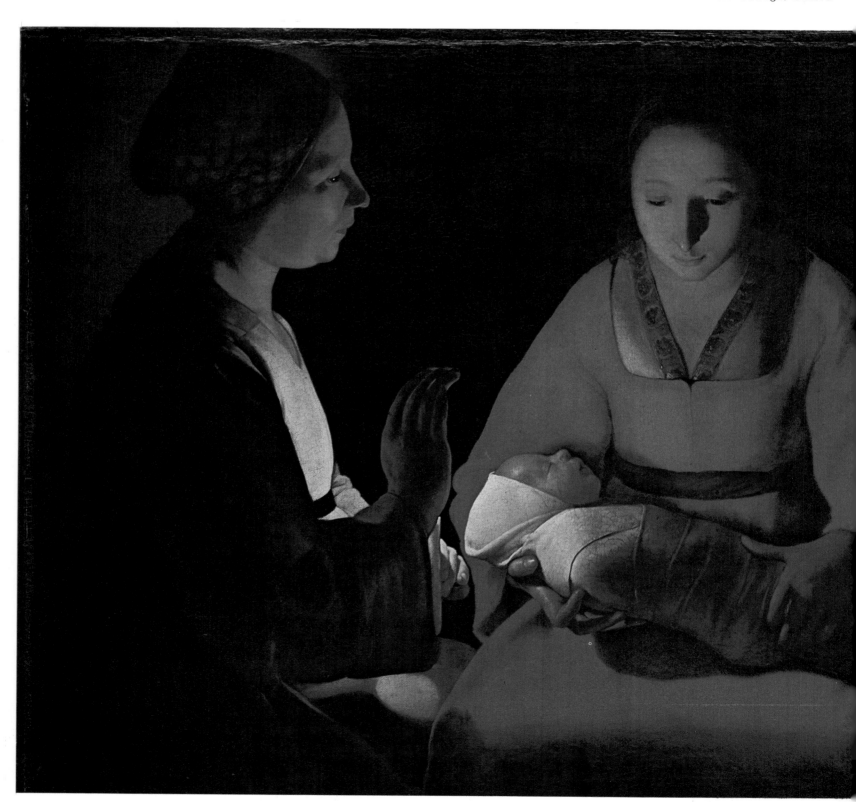

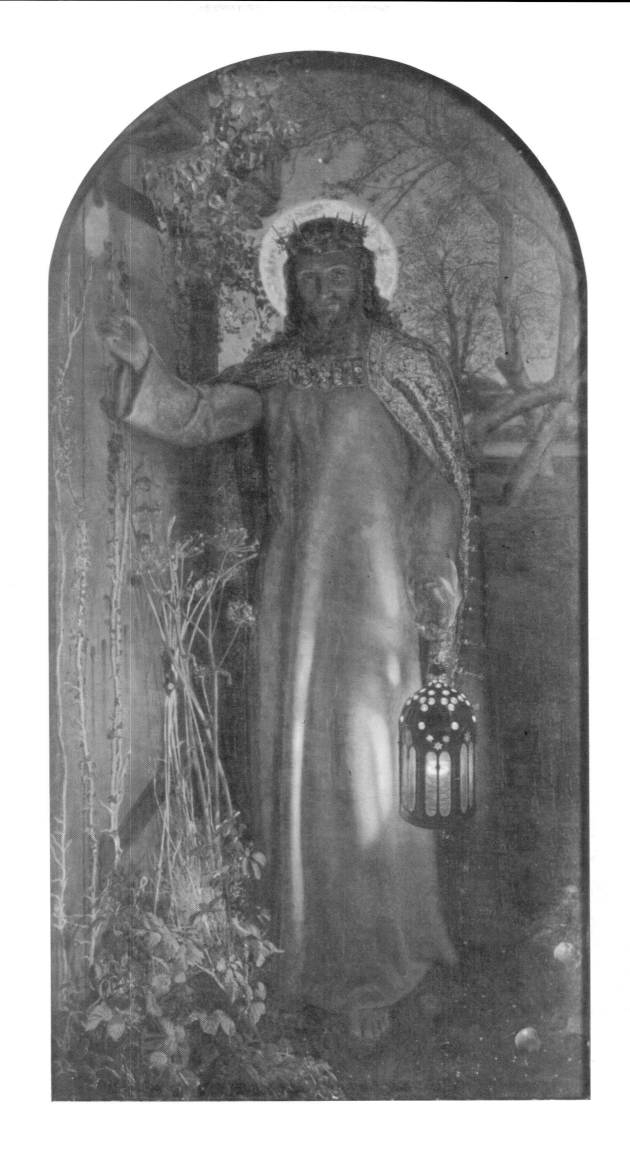

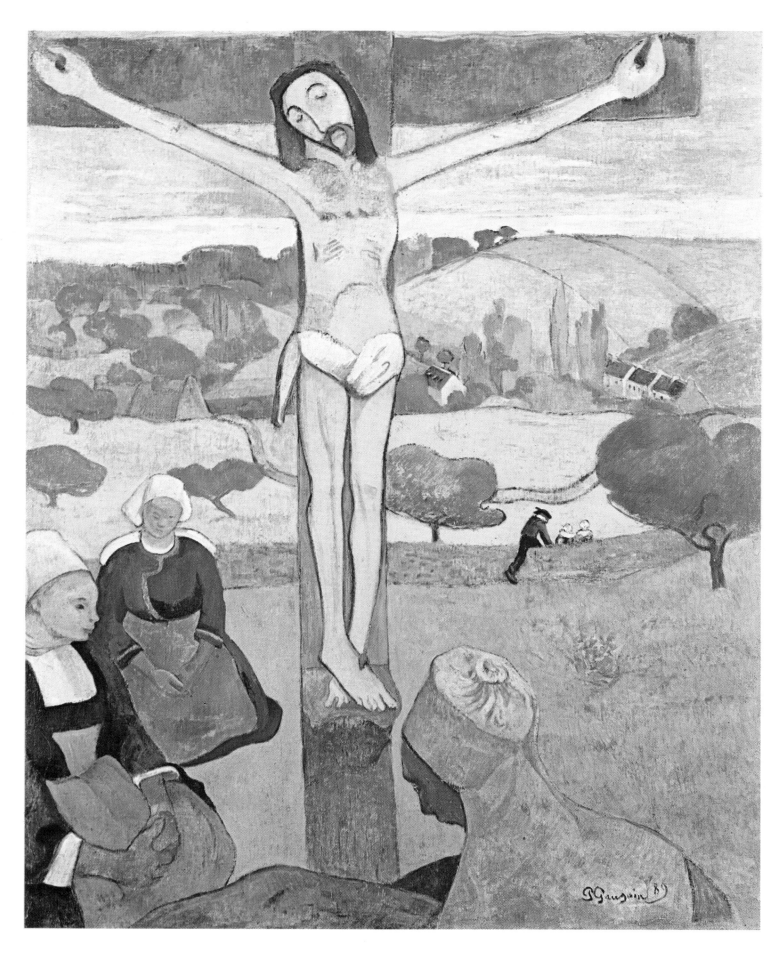

16
The Yellow Christ
1889
Paul Gauguin 1848—1903
Albright-Knox Art Gallery,
Buffalo, New York

26

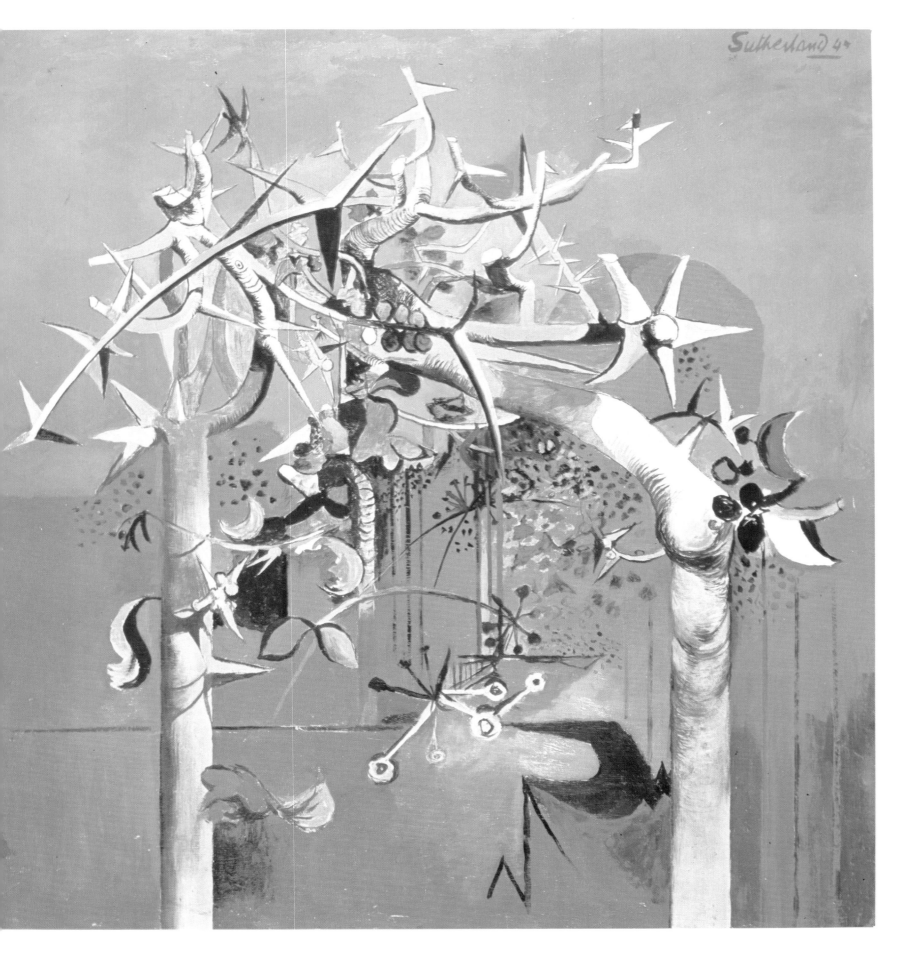

17
Thorn Trees
1945
Graham Sutherland 1903—
Albright-Knox Art Gallery,
Buffalo, New York

Portraits

The rise in power of the merchant class during the 14th and 15th centuries marked the end of the Church-dominated Middle Ages and the birth of modern secular society. Entrepreneurs, financiers and soldiers of fortune joined the Court and the Church as patrons of the arts, and demanded a whole new range of subject-matter from the artist. Although portraits of the donors had frequently been included in altarpieces, showing them, for example, kneeling at the feet of the Virgin or grieving over the death of Christ, these new patrons did not necessarily want a portrait to portray their godliness or humility but rather to commemorate their importance, and to display their power and wealth.

Such is the background to Piero della Francesca's portrait of Federigo da Montefeltro, soldier, scholar and Duke of Urbino, called in his day 'the light of Italy'. We surely feel looking at that profile of rugged authority it was true to his character.

Piero's Florentine contemporary, Ghirlandaio, painted that most moving of portraits, *Old Man and his Grandson*, in which we join with the boy in seeing the old man as the personification of love and tenderness and not as a man with a repellently deformed nose. Here, the reality of what the mind knows transcends what the eye sees.

For Raphael, also, this inner life of the sitter was most important. He conceived his portraits as a psychologically truthful image based on conscious analysis of character. The problems posed by multiple portraits in the early 16th century were by no means simple, but in his only papal portrait group of *Pope Leo X with his Nephews Cardinals Giulio de' Medici and Luigi de' Rossi* he applied himself to the problem of the integrated group most successfully. Early Italian portraits had shown simply the head and shoulders of the sitter, either full-face or in profile, as in Piero's *Federigo da Montefeltro*. Gradually the portrait developed showing more and more of the figure, and in progressively more natural poses. Here Raphael shows three men grouped quite naturally, as they might be in real life.

The portrait is extremely large, and no expedient is spared to make the figure of the Pope seem even bigger than it is. The converging moulding and cornice in the background, the steep angle of the chair and table, and the flanking figures of his sycophantic nephews all contribute to this effect. The painting is full of fascinating and voluptuous detail: the chair knob reflecting the source of light, the tassels at the back of the chair, and the soft white quilting of the robe. But the most memorable feature is the Pope's masterful, self-indulgent head.

Venetian portraits were expected to be more than a likeness or a type but also a pleasure to the eye, with the result that the sitter was always shown at his best. In Titian's *Portrait of a Man*, the quiet pose, the serene expression, the simple lines of the face and head, the plain background and limited colour scheme, all emphasise the ideals of order, dignity and reserve which tempered the luxury of the age. However, Titian painted the quilted silken, shimmering balloon of the grey-blue sleeve, touched with deeper blue in the slashes and shadows, with typically Venetian bravura and obvious pleasure.

The importance of the new class of patron showed itself in northern Europe as well as Italy. The burst of creative energy which culminated in the emancipation of the Netherlands from Spanish rule, and their success in trade and commerce, was reflected in painting. A sense of confidence was the keynote of the golden age of northern portraiture, tempered with a typically northern respect for bourgeois virtues. Man liked to be set in his surroundings with all the trappings of his new found, and greatly enjoyed, affluence, but with due awareness of the spiritual life.

Van Eyck's painting of the merchant Giovanni Arnolfini and Giovanna Cenami portrays a solemn moment in their life: the moment of their betrothal. The inscription states that *Johannes de eyck fuit hic* (Jan van Eyck was present) and thus the painting bears witness to the event. But the painting is more than just a marriage portrait. Much of the detail has symbolic significance, some of which is now forgotten, although we can still imagine that the dog represents fidelity. The mirror reflects the objects in the room, a door and two additional figures. In its frame are ten minute pictures of episodes from the Passion of Christ. The brasswork of the chandelier, the elaboration of the painter's signature above the mirror, the dog, the shoes and the burning candle are all painted with extreme precision.

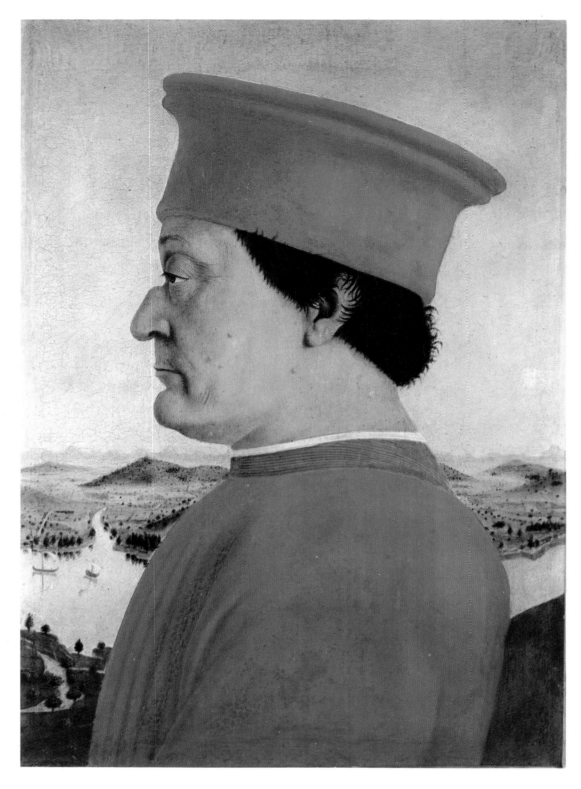

18 **Federigo da Montefeltro,** about 1465
Piero della Francesca 1410/20—92, Uffizi Gallery, Florence

The northern European technique of oil painting which enabled the artist to achieve such exquisite detail was much admired in Italy (the Arnolfinis themselves both came from Lucca). But Italy in turn held a great fascination for northern painters. The talented and ambitious Dürer left his native town of Nuremberg to make his first visit to Venice at the age of twenty-three. There he was profoundly influenced by the work of contemporary Italian painters–Leonardo, Mantegna and Giovanni Bellini, among others–and by the artistic theories of the Italian Renaissance. On his return to Nüremberg most of his commissions for the next few years were for portraits of leading local figures.

In this portrait of Oswolt Krel he shows that his Venetian experience was not forgotten. The device of the curtain as a foil for the figure had already been used by Bellini and was to be used by Titian, as was this type of landscape background, which was a reference, perhaps, to Renaissance man's appreciation of nature. In his careful details of outward appearance (the fur-trimmed coat falling casually open, the anxious but sensitive expression) Dürer tried to express the intellectual and emotional character of his sitter.

Although not British by birth, Holbein is closely identified with England. While working in England Holbein painted scores of portraits and, as a result, Henry VIII's court circle is probably one of the most thoroughly documented of any in history. When the search was on to find a candidate for

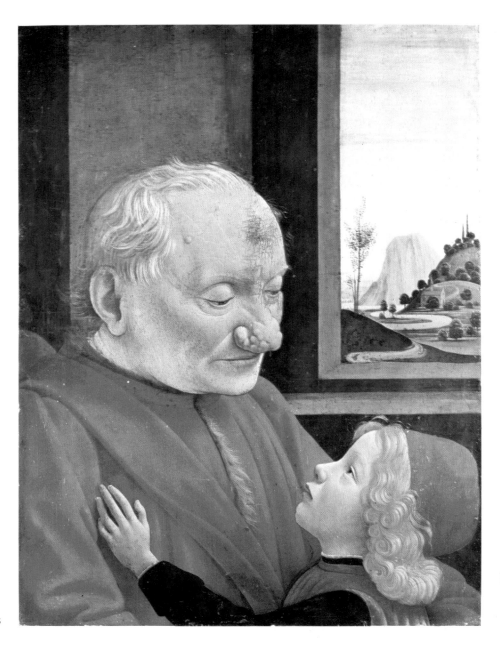

19
**Old Man
and his Grandson**
about 1490
Domenico Ghirlandaio
1449—94 Louvre, Paris

20
Leo X and Two Cardinals
about 1517—18
Raphael 1483—1520
Pitti Palace, Florence

the dangerous privilege of succeeding Jane Seymour, Henry VIII's third wife, Holbein was commissioned to paint a full-length portrait of the recently widowed 16-year-old Duchess of Milan, who uttered the apocryphal remark, 'I should be delighted [to marry] if I had two heads'. Her portrait illustrates Holbein's carefully calculated restraint in the skilful painting of the black silk and dark purplish velvet gown against the plain blue background, which form a setting for the gentle face and beautiful hands. In the magnificent series of portraits of Henry's courtiers and contemporaries we find an impartial and profound search for truth, united with a consummate mastery of technique.

The demand for the commemorative portrait became widespread in Europe from the 15th century. First in Renaissance Italy, then in England, the leaders of society had been brilliantly served. 17th-century Holland was a source of less grandiose sitters, not only the middle class burgher and his wife but also the groups who formed clubs, local committees and city councils. It was in painting such groups that Frans Hals excelled. A group of particular importance in Dutch life was the civic guard which was formed for the defence of towns, and there was a long tradition of making their annual banquet the setting for a group portrait.

This was a great challenge to the painter's ingenuity as it presented him with many problems, not the least of which was getting everyone in. At first this was solved by a single device which consisted of a long line of individual portraits in which an element of variety was introduced in the different gestures of the hands. Hals, however, in the 1627 composition of the *Banquet of the Officers of the St Hadrian Militia Company* completely freed himself from these conventional ideas and brought the banquet alive by a dexterous arrangement of figures and colour.

The party consists of two groups, each occupying half the picture space. Each is reinforced by a figure who sits with his back to the other. The connecting link between the two groups is formed by the innkeeper at the back, holding out a glass and a pewter jug, and by the two figures who lean in from either side for the food in the centre. A third link is made by the standard bearer who passes his empty tankard to be refilled. The view of the tree through the leaded window emphasises the spaciousness of the room.

Hals' arrangement of colour is a striking feature of his vivid painting. The dark costumes are contrasted with the tablecloth and a blaze of white, red, green, yellow, gold and orange accessories. The whole scene reflects Hals' own

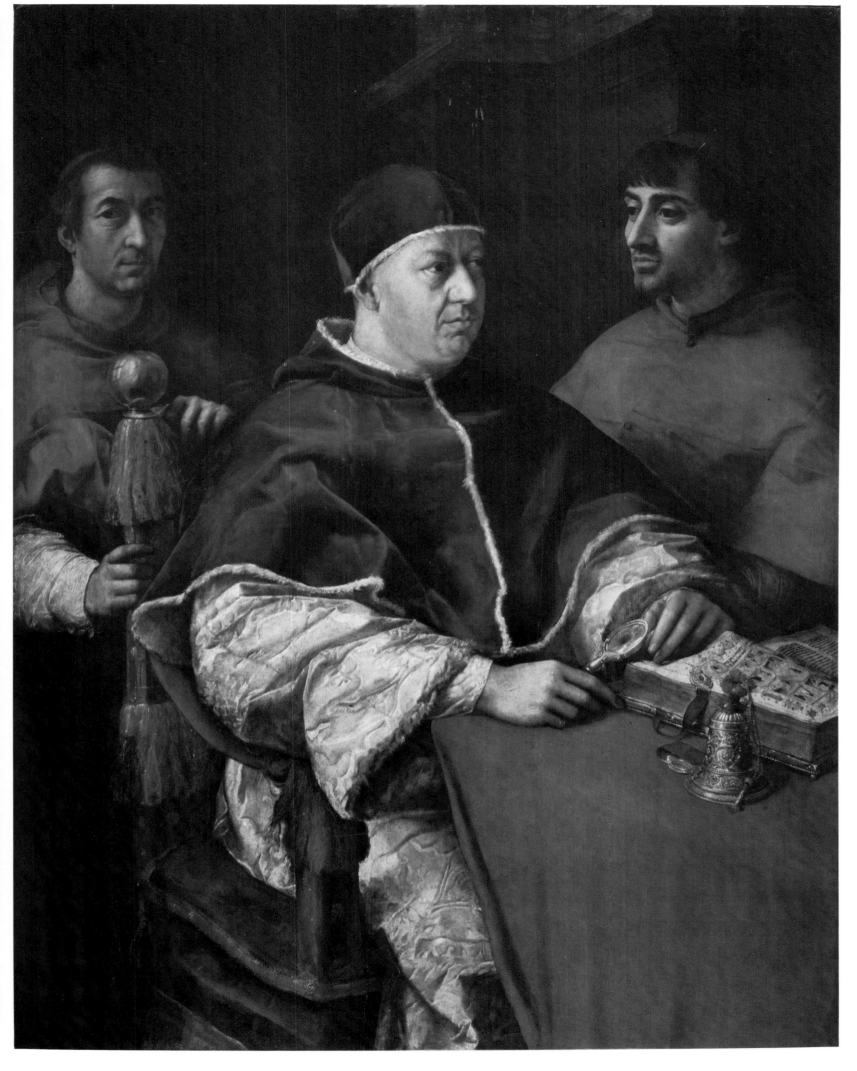

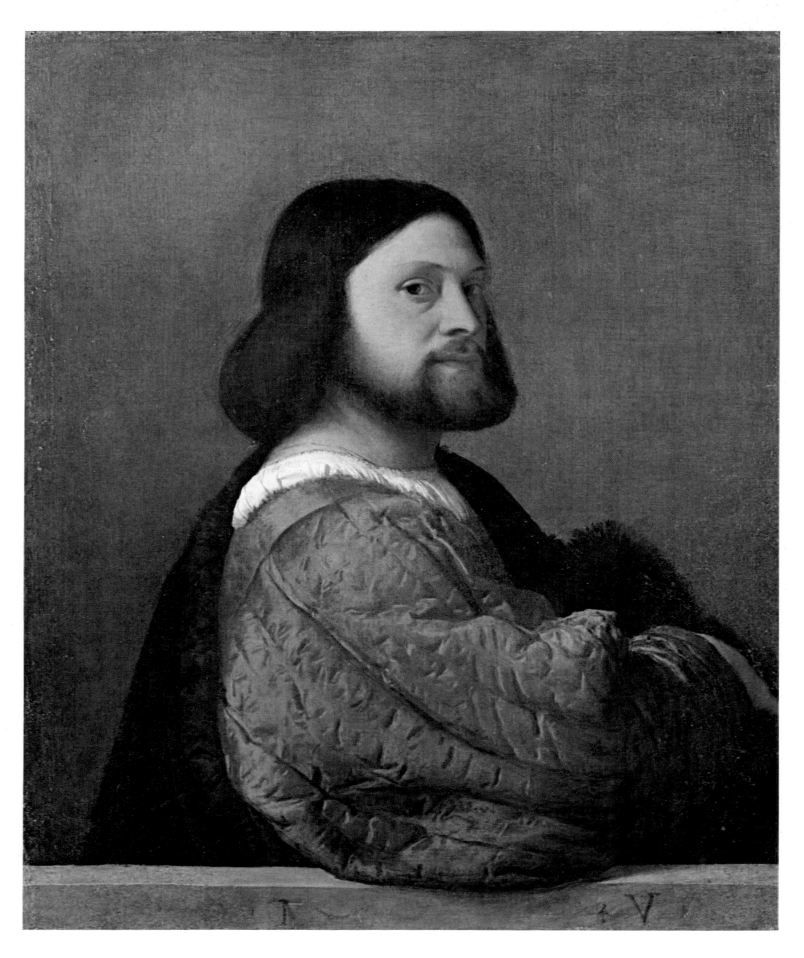

21
Portrait of a Man
about 1511—12
Titian 1487/90—1576
National Gallery, London

22
**The Marriage of Giovanni Arnolfini
and Giovanna Cenami**
1434
Jan van Eyck, active 1422, died 1441
National Gallery, London

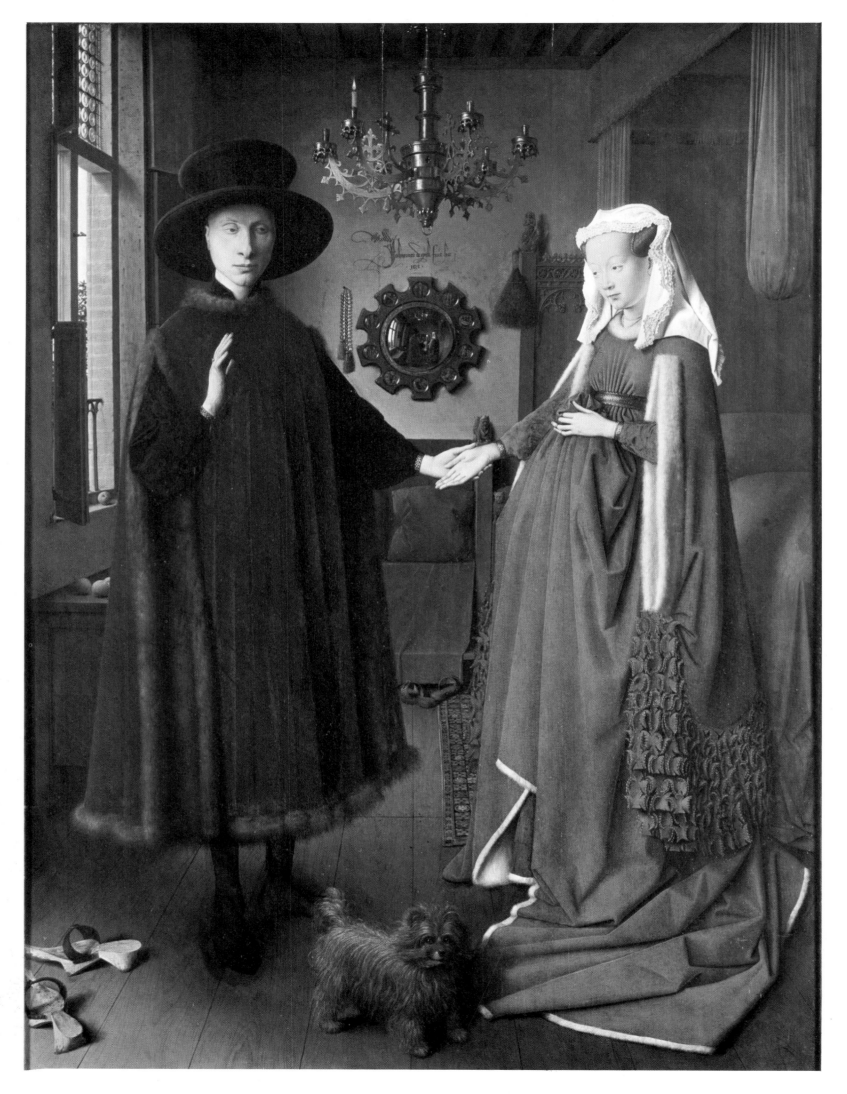

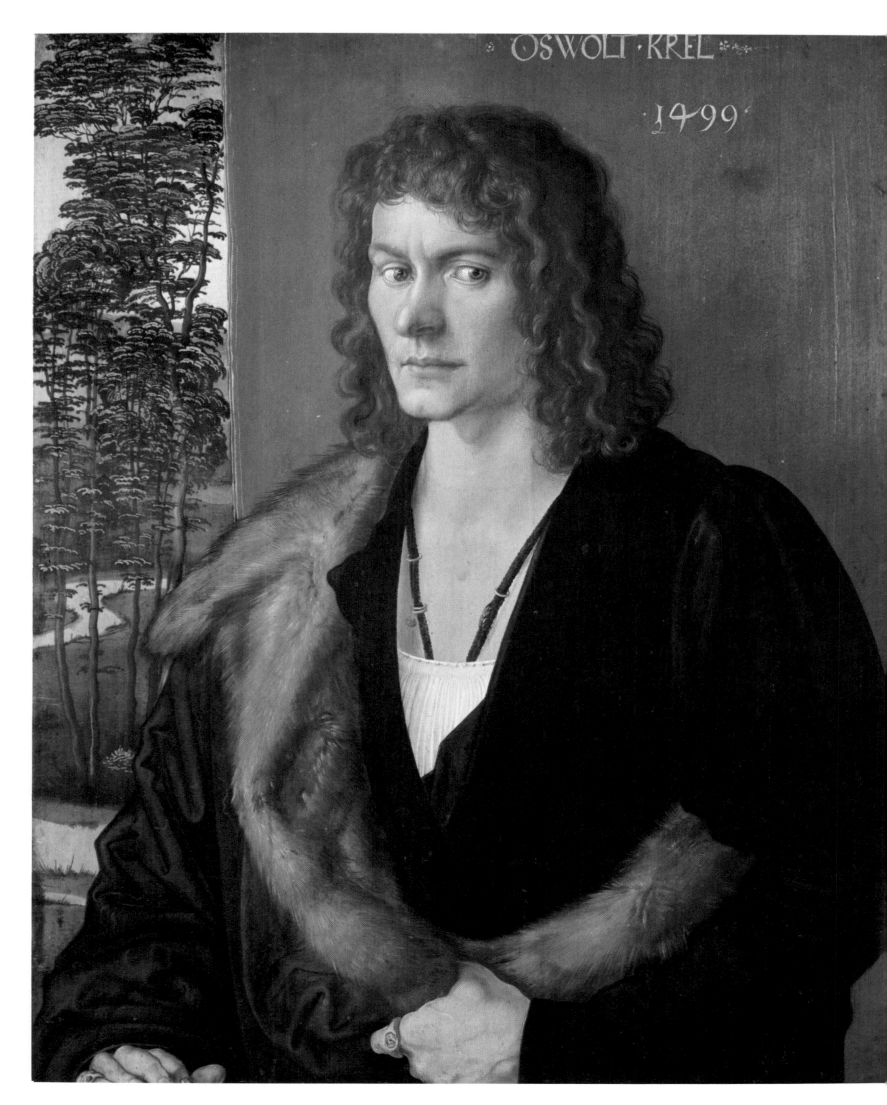

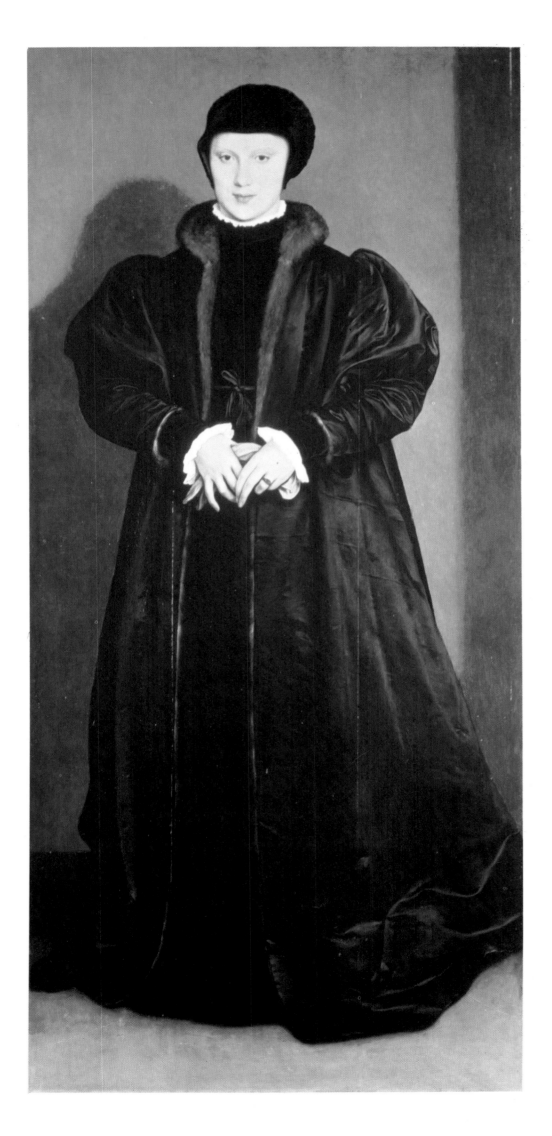

vigorous enjoyment of everyday life and rumbustious people.

During the 17th century in Holland, the art of portrait painting continued to flourish in profuse response to the needs of a rich and energetic middle class Protestant society. With Rembrandt this art was crowned by a towering genius. Hals had lived in and depicted an age of action, when men must be up and doing. Most of Rembrandt's life was spent in an age of comparative peace and quiet, when Holland had the leisure to think and to meditate, not only on the greatness of her political achievements but on the problems of life. With the concern for reality that was a feature of the analytical and scientific spirit of his age, Rembrandt systematically set about to make himself master of that reality. Characteristically, he took for analysis what was closest to him and produced a remarkable range of self-portraits. These show him passing from confident youth to sad old age, and we see not only the gradual development of his technical powers but also the steady advance made by the artist in expressing, with poignant intensity, the thoughts and emotions of humanity.

The Dutch introspection was in complete contrast with Spanish vanity. Few kings have left so many enduring monuments of themselves as Philip IV, and no king has had such a great painter at his command. For thirty-seven years Velasquez painted his monarch, and in the long succession of portraits we can trace year by year the changes that came over Philip, his progress from a slender, shy, idealistic youth to a thickset, heavy-jowled man who suffered deeply and was crushed under the load of his responsibilities. Overall, Philip's features preserved a marvellous and startling uniformity. Whether young or middle-aged, in black silk court dress, hunting suit, military uniform, festive religious attire, sitting, kneeling, standing, or mounted, the same head is there with its everlasting steadfast gaze. Yet Velasquez created no idealised monarch, no stereotyped image. The spectator is always aware of the vulnerability of this ordinary man trapped inside his luxurious clothes.

Equestrian portraits have a long lineage, starting with stern Roman generals on stone horses, and Velasquez's painting of Philip on his rearing horse is a worthy follower in the tradition. But in spite of the brave posture, he makes an unconvincing military hero. Velasquez's frankness was unusual for a court painter, and its acceptance by his royal patrons no less remarkable. Velasquez's painting technique was as unconventional as his portraits, for he used paint with an impressionistic freedom, unconcerned by the brushstrokes being visible, anticipating by two hundred years the pioneers of modern art.

Painting in 18th-century England reflected the social life of the time. There was parliamentary rule, and the court no longer dictated in matters of taste. The Whigs admitted merchants and bankers as equals of the aristocracy, and as a result portraits began to give a much wider view of society. However, it was still customary for the portrait to emphasise the status of the sitter and to give a flattering account of his appearance rather than present the more intimate and personal aspects of his identity. With Hogarth, Reynolds, Gainsborough and Lawrence portraiture in England was to reach new levels of achievement.

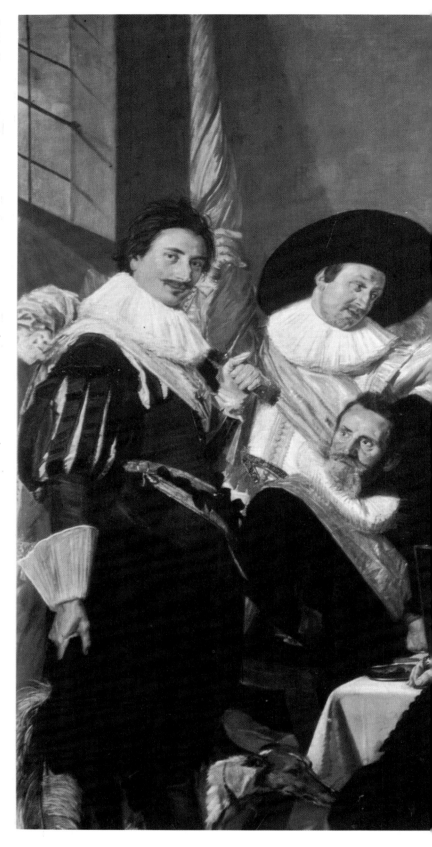

In the second quarter of the 18th century the French portrait painter J. B. Van Loo was monopolising the fashionable business in London. Hogarth, then the creator of *The Rake's Progress*, to quote his own words, 'exhorted the [English] painters . . . to oppose him with spirit but was answered "You talk. Why don't you do it yourself?" Provoked by this I set about this mighty portrait . . .' The portrait to which Hogarth referred was of Captain Coram, the founder of the Foundling Hospital in London. It was designed as a set piece for a boardroom. It contains the pillar and drapery which were almost inevitable accompaniments

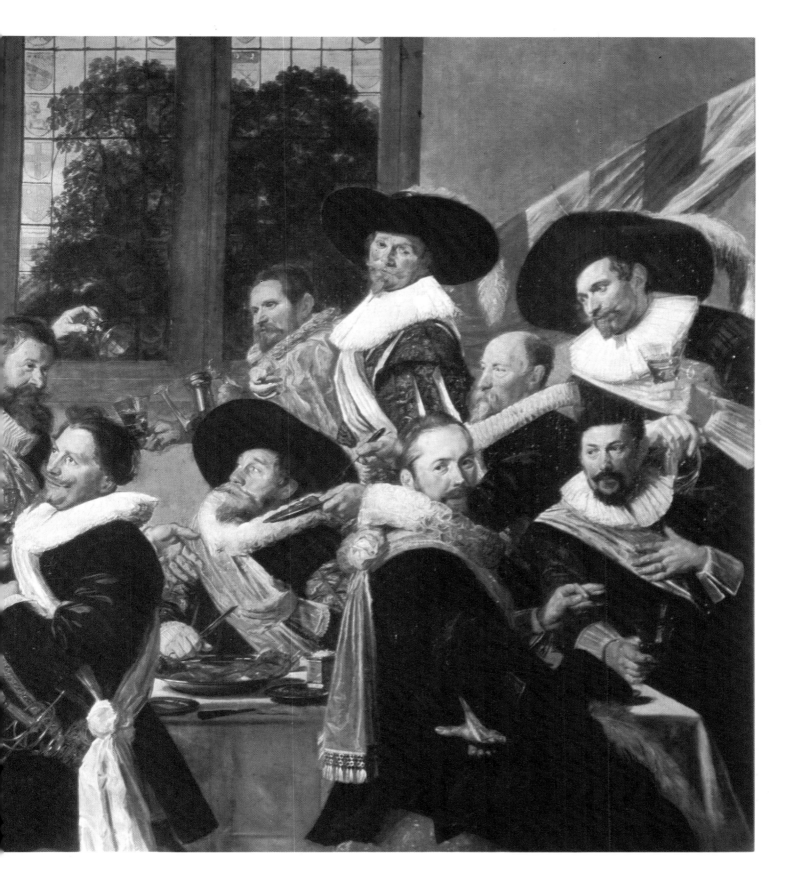

to the grand portraits of the day, and a deliberately self-conscious pose, but certain elements convey the informality and forthright honesty of the sea-captain. His legs are hardly long enough to touch the ground, his hands are strong and his face is kind. It is a bold painting in rich contrasting colours of reds and yellows, dull browns and greens, of a man happy in his philanthropic duty.

It was Reynolds's ambition to raise the status of the painter in England to the same level as that of the man of letters. His work was devoted almost entirely to portraiture, and he applied himself to the promotion of his clients' self-esteem

25
**Banquet of Officers of the
St Hadrian Militia Company**
1627
Frans Hals 1581/5—1666
Frans Halsmuseum, Haarlem

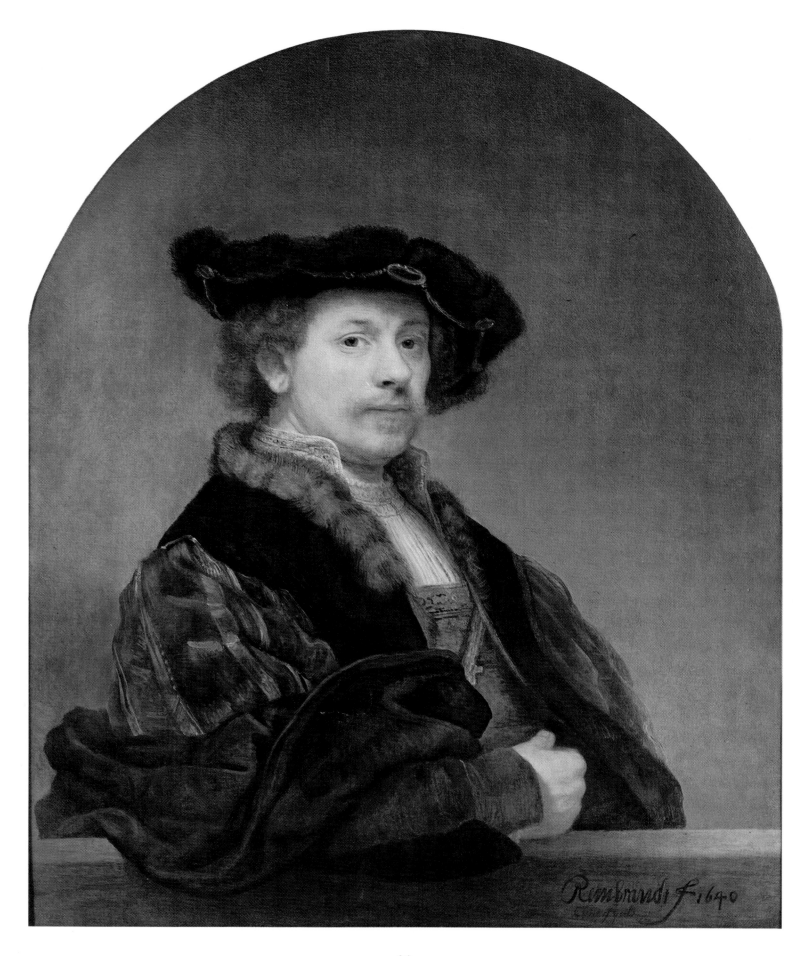

26
Self-portrait
1640
Rembrandt van Rijn 1606—69
National Gallery, London

and to presenting them favourably to the world. His devices were numerous and shrewdly calculated to appeal to the taste and artistic experience of the age. He put some sitters into fancy dress and cast others in the role of a god or goddess. He quoted from the style and composition of earlier masters so as to dignify the sitter, and gave his subjects not only flattering attire but such gestures, attitudes and expressions which made them seem handsome when they could not be intelligent, intelligent when they could not be gracious, and at least self-assured when they could be little more than that. One of his most impressive portraits was of Signor Baretti, the Italian tutor to the daughters of the Thrales who were

friends of Dr Johnson. It shows great imaginativeness in the design, colour and composition, and a penetrating grasp of the character of the diligent tutor. With his nose literally in his book, Baretti short-sightedly peers at the words. The light falls on the face, hands and paunch (no doubt a result of too many of Dr Johnson's dinners), and the curving chair arm, which juts out of the picture frame, draws the spectator right into the pictorial space. The absolute, silent concentration of the figure, who seems entirely unaware of our intrusion, is remarkably expressed.

Gainsborough could not command Reynolds's inventiveness, his variety of effect or his scholarly sense of art. He was

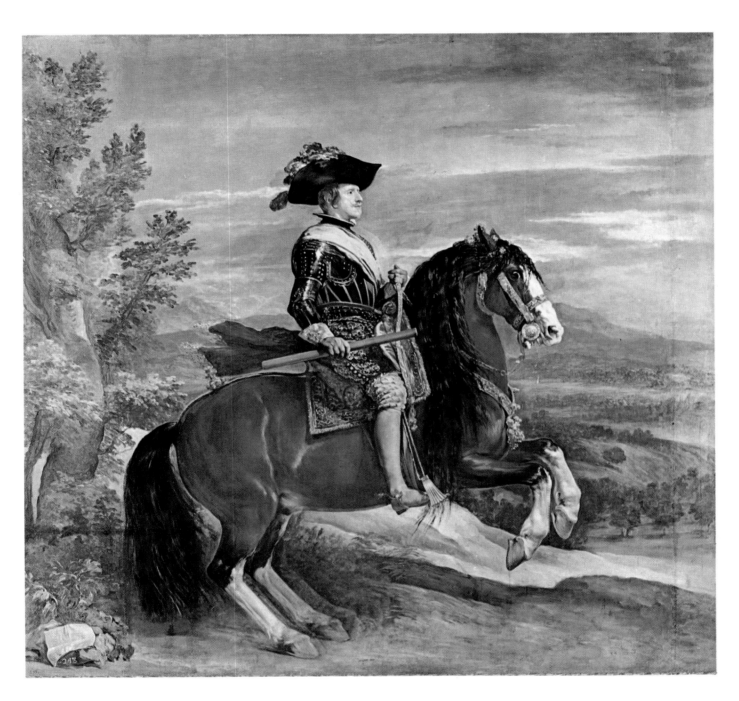

27
Philip IV on Horseback
1634—35
Diego Velasquez 1599—1660
Prado, Madrid

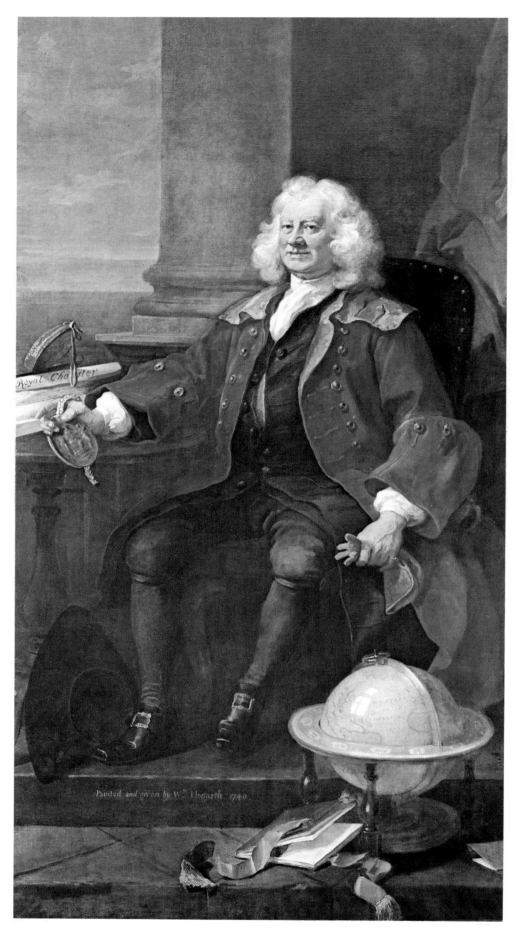

28
Captain Coram
1740
William Hogarth 1697–1764
Thomas Coram Foundation, London

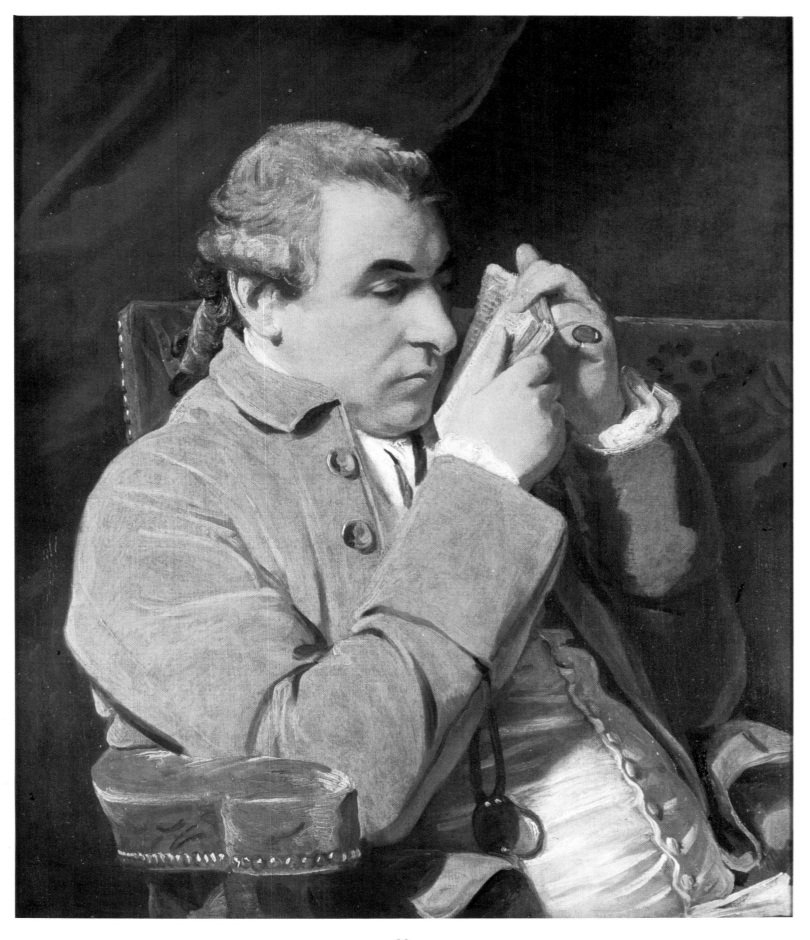

29
Portrait of Signor Baretti
1774
Sir Joshua Reynolds 1723—92
Private collection

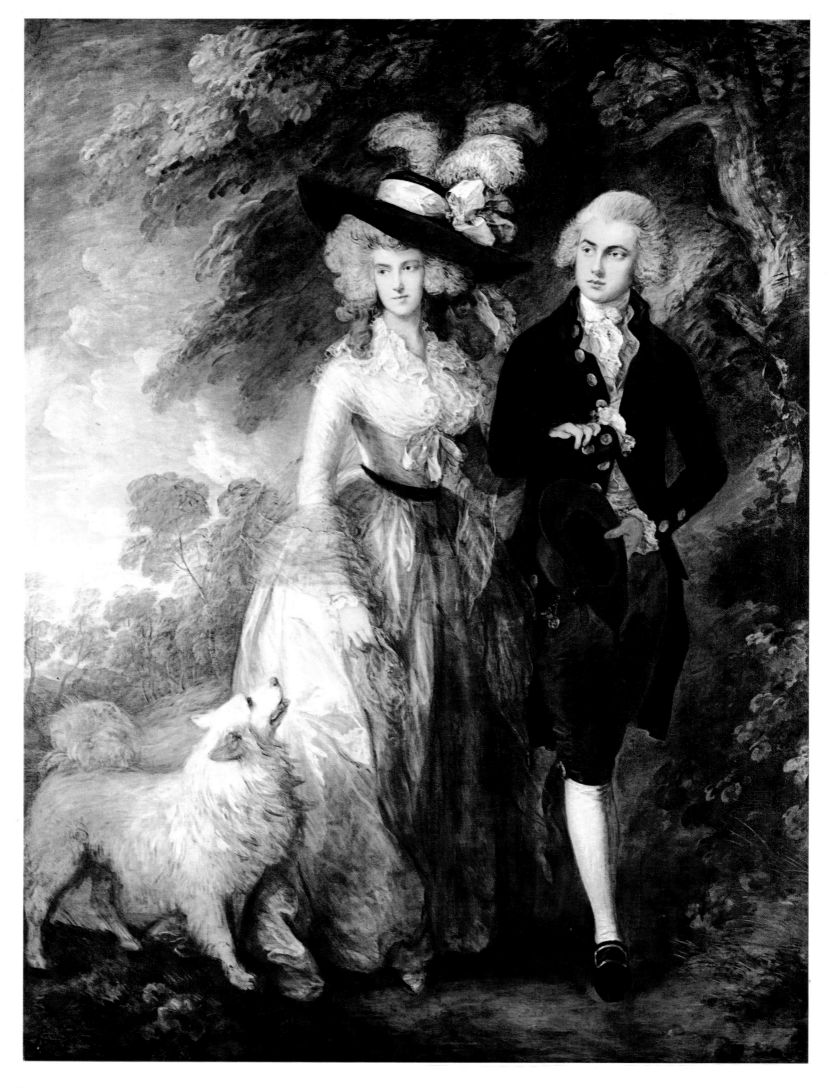

not dedicated to 'face painting' as he scathingly called it, and often a certain impatience with the sitter can be detected in the over-concentration on the landscape background. However the money was good, and when his interest was aroused he was capable of creating pictures of such poignant beauty that they remain unmatched. Nurtured in his native Suffolk on a diet of Dutch 17th-century landscapes, he began his career in Ipswich, moved to Bath where he became a celebrated portraitist, and then to London where he learned the then fashionable, eye-catching contours of the French Rococo style (as in the art of Watteau, plate 61). *The Morning Walk*, the quintessence of English 18th-century elegance and ease, shows him at the peak of his skill. Harmony of colour rather than vigorous line characterises the picture, and Gainsborough brilliantly catches the essence of silks and lace in motion. The cool lights on the dress and the shadows which lurk in its deep folds are painted with sensuous delight, and the whole creation moves with a rhythmic lyricism.

After the death of these two exceptional men only Sir Thomas Lawrence could sustain the tradition of formal portraiture. He had all the social aims of a successful professional man, but also a talent for expressing his insight into a character with an amazing dexterity of paint. His

portrait of Pope Pius VII is perhaps his finest. The 78-year-old Pope gave Lawrence nine sittings, and he wrote that, 'The people of Rome . . . are delighted at seeing this venerable and good being so faithfully, and (though it is not in the least flattering) so favourably represented'. Strength and sweetness merge in the best kind of idealisation. The enormous throne-like chair diminishes the Pope in size, and the creamy silk of the robes shows off the fine hands and the dignified and quiet face with its knowing but kind expression. The hair is grey and rather disarranged, and the eyes, which impressed Sir Thomas Lawrence in real life, are particularly fine.

'Charms, allures or deceives' is the Oxford Dictionary's definition of a siren's activity. For about half a century Boucher successfully charmed and allured artistic Europe. Then, almost abruptly, he was accused of being false, deceitful and dangerous, and died at a moment, about twenty years before the French Revolution, when his contemporaries were increasingly questioning the purpose of art. There was no place for the paintings of Boucher's decorative sirens in that moral, moralising and ultimately chilly climate. Yet his productivity, facility and energy had long been astonishing audiences, astonishing and delighting as he worked hard in his aim to please. His art was quite consciously artificial

30
The Morning Walk
1785
Thomas Gainsborough
1727—88
National Gallery, London

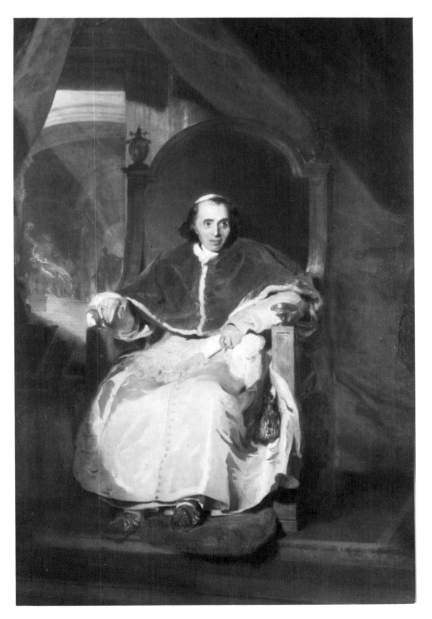

31
Portrait of Pope Pius VII
1819
Sir Thomas Lawrence 1769—1830
Royal Collection

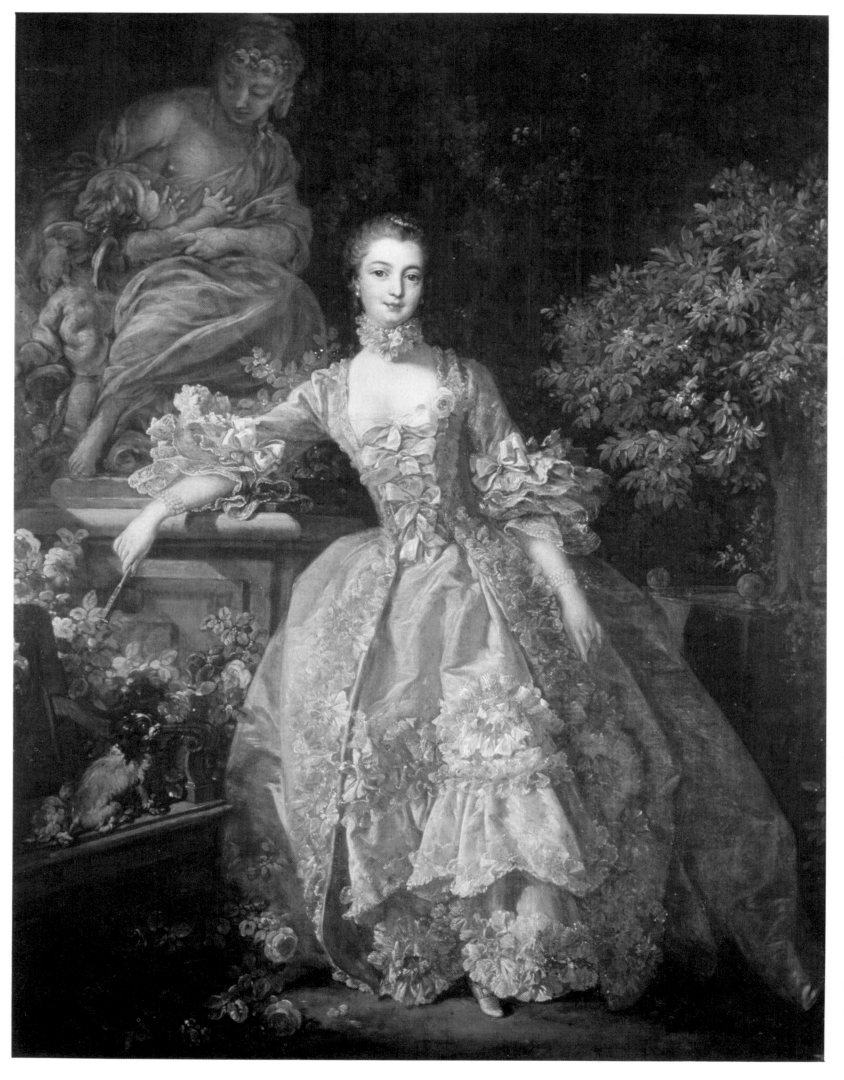

44

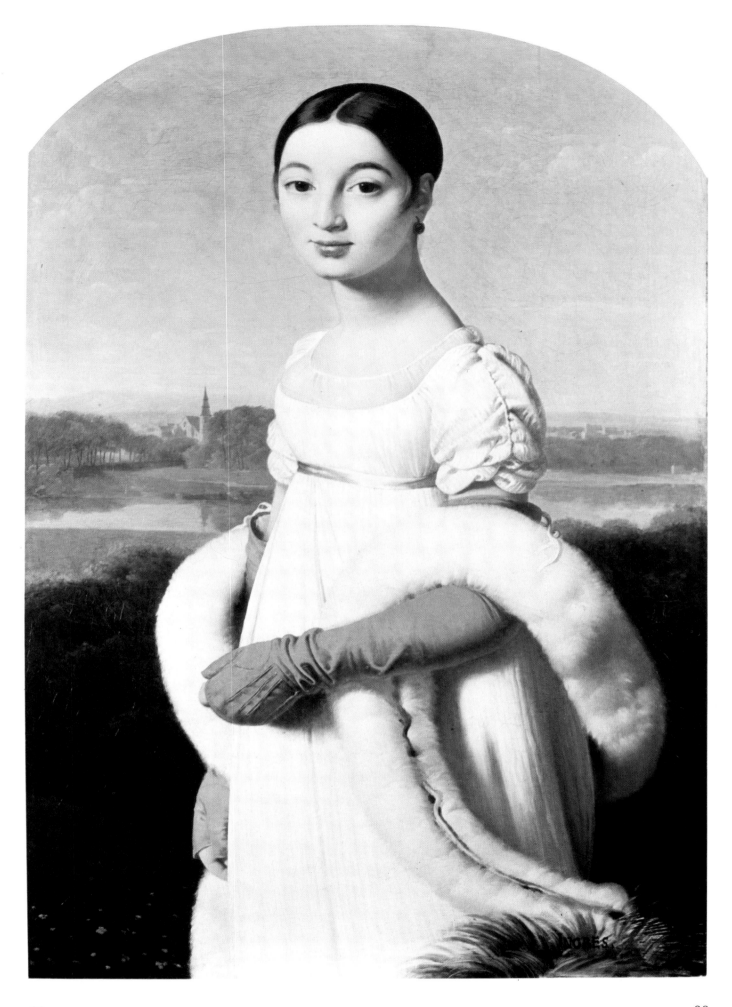

32
Portrait of Madame de Pompadour
1759
François Boucher 1703—70
Wallace Collection, London

33
Portrait of Mademoiselle Rivière
1805
Jean Auguste Dominique Ingres 1780—1867
Louvre, Paris

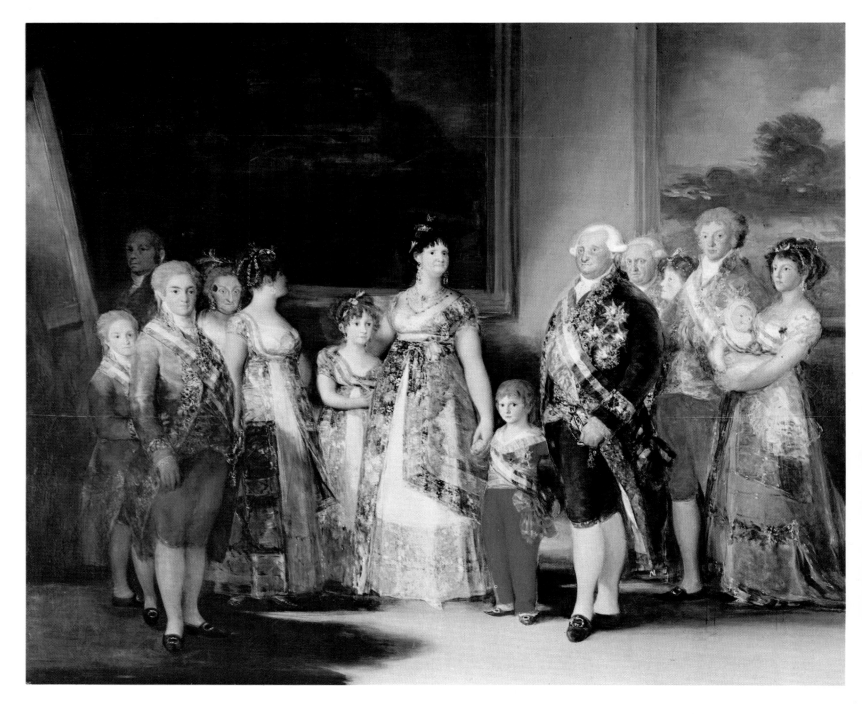

because he used imagination to create rival worlds to that which we know. However, his ability to recreate actual appearances is revealed in his gifts as a portrait painter. Boucher painted Madame de Pompadour in a series of portraits which seem neither flattering nor critical, and certainly not artificial. Touching no extreme, he saw a still bright-eyed woman living her private existence amid books or out in the open air, alone except for a pet dog or bird. Here she is accompanied by her dog, a statue, foliage and voluminous frills, and the painting is a triumph of graceful design and brilliant colour. We can well imagine that even this much-flattered lady must have been enormously pleased with the result.

After the airy, pretty and gay style of the 18th century came the first reaction: the Neo-Classic school headed in France by David and his pupil, Ingres. Neo-Classicism had many divergent sources, such as the discovery of the Roman towns of Pompeii and Herculaneum with their ancient statues and wall paintings, a revolt against the frivolity of the court of Louis XV, and a dawning sense of democracy

inspired by the writings of Jean-Jacques Rousseau. The result was an art that was intended to be logically sound, emotionally pure and morally improving. Ingres, whose work in the opinion of Delacroix was 'the complete expression of an incomplete mind', was a proficient organiser of form within the boundaries of his canvas and became human only when he had a portrait to paint. Then his sitter, together with his own supple sense of line, melted the hard Neo-Classic crust. The *Portrait of Mademoiselle Rivière* established a type that Ingres developed, perfected and hardly modified throughout his life. She is set against the sunlit openness of a landscape which throws the young and charming figure into relief. The elegant head with its severe hair style, the delicate expression of the face, and the simplicity and slight stiffness of the stance create an endearing image of purity and femininity. Although Ingres held colour to be secondary to drawing, the ruddiness of the cheeks and lips, the dazzling whiteness of the dress and swan's-down boa, and the contrasting golden gloves are impressive additions.

In Spain Goya formed a link between the 18th and 19th

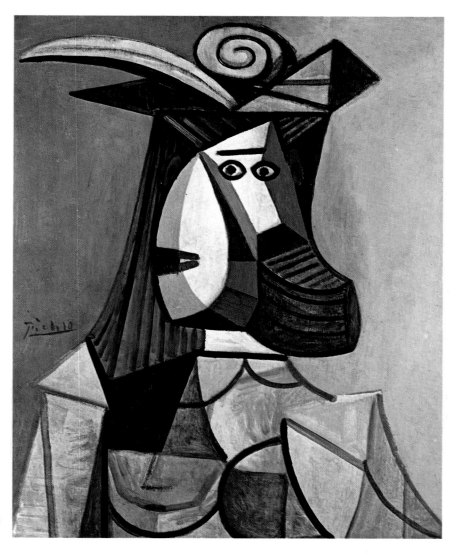

34
The Family of Charles IV
1800
Francisco de Goya 1746—1828
Prado, Madrid

35
Portrait of a Woman
1942
Pablo Picasso 1881—1973
Folkwang Museum, Essen

centuries much as El Greco did between the 16th and 17th. When looking at the group portrait of the royal family it must be remembered that it was not in the Spanish tradition to idealise, as we have seen in the work of Velasquez. However, faced with such ugliness as Goya reproduced here, it is amazing that what appears to be a near caricature was not noticed. If it were, the royal patrons were either too stupid to understand or too lazy to resent it. It is difficult to imagine Goya's private aim in this painting, but if it were to throw scorn on the degenerate court its execution is faultless. Charles IV is shown prominently in the foreground, bedecked with the regalia of royalty, standing next to the masterful and dominating queen, and surrounded by the other members of the royal family and household whose elegance of custom only heightens their weakness of character. The silks, jewels, velvets and lace are all painted with superb delicacy, and the varying lights and shadows which play over the richly colourful and vibrating textures are set off against the quiet spaciousness of the room. It is perhaps the most successful group portrait ever painted.

With the invention of the camera there was no longer any need for a portrait to be representational, and Picasso, in his *Portrait of a Woman,* made no concession whatsoever to human construction. If there is one quality which stands out in his work it is that plain man's virtue, courage. The nerve with which he dismantled the huge sacred machine of Renaissance art, the effrontery of his glaring colours and distortions, the daring which allowed him to let go of one discovery to grasp at the next, his commando raids into uncharted territory, are signs of a man and an artist of heroic stature. Apart from a few still-life paintings of great charm, the work of Picasso at the time of the Second World War is full of angry dark thoughts and of forms which are broken and jagged. His studies of the human head, as can be seen, go through violent distortions, sometimes combining the features of, perhaps, his companion over many years, Dora Maar, and the angular snout of his Afghan hound. Most of Picasso's portraits contain symbolic elements as he seeks the person behind the mask, and so it is his own personal response to what he feels rather than what he sees that produces such a portrait.

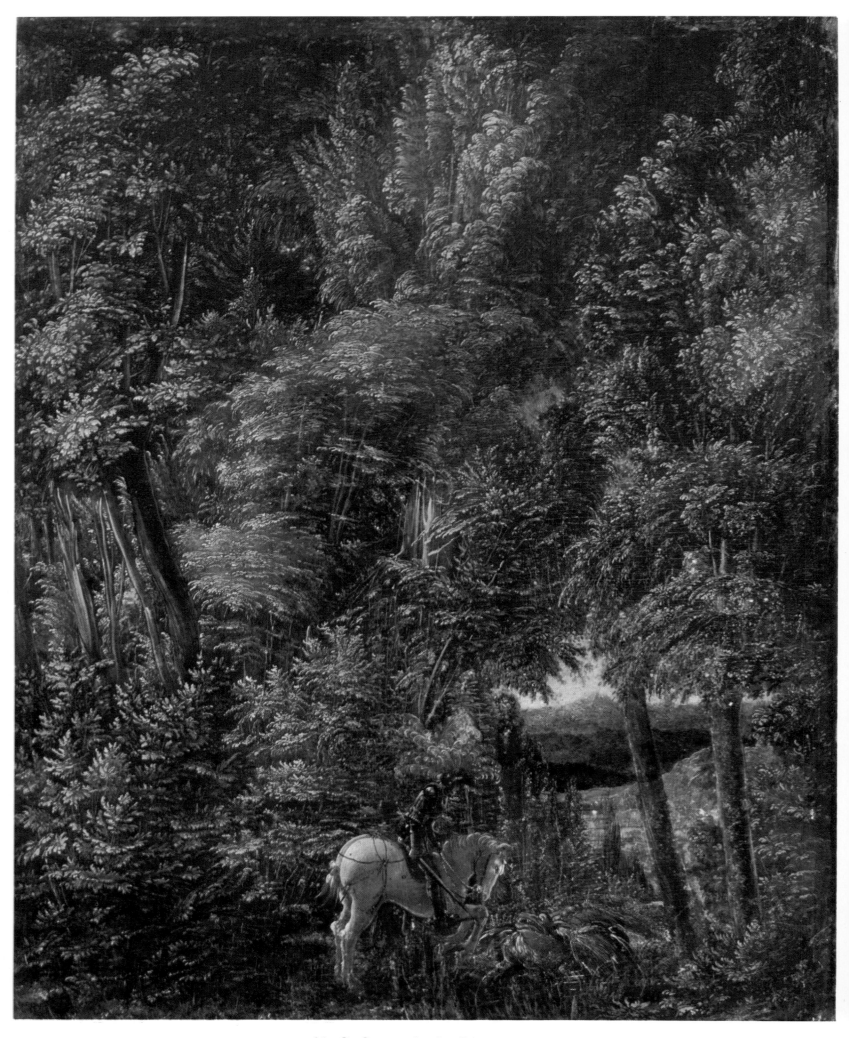

36 **St George in the Forest** 1510
Albrecht Altdorfer, about 1480—1538, Alte Pinakothek, Munich

48

Landscapes

The environment as an independent art subject was not instinctive to early Western man but from the days of Pompeii, when the Romans decorated the walls of their houses with scenes relating the activities of their gods and heroes, it had a modest standing as a setting for the human drama. In the Middle Ages, landscape was subordinate to the principal subject of a picture, and if there was a lot of sky in a painting it was usually busy with angels. However, during the early 16th century Altdorfer, a Bavarian painter, travelled along the Danube and visited the Austrian Alps where the scenery so moved him that he became the first landscape painter in the modern sense. As can be seen in *St George in the Forest*, the painting of the wild tangled trees of his native land shows an intense response to landscape, and the tiny figure of the saint is quite unimportant.

The challenge to depict a landscape under snow was first met with amazing skill by 15th-century Flemish and French book illuminators, and a hundred years later in Holland, Avercamp conveyed with stinging clarity the sensation of icy cold weather. As a landscape painter who was sensitive to all aspects of nature, he shows its most subtle gradations of colour and growth, and in his *Winter Scene with Skaters near a Castle* his painting is invigorating, lively and beautiful, full of movement and gesticulating figures.

The scene is presented so directly and naturally that the eye takes in the scene and mood at a glance. However, a few moments careful observation reveal that this apparent directness and naturalness are the result of a very precise organisation that controls every detail. Perhaps Avercamp's most valuable contribution to landscape painting was the way in which he saw man as an integral part of nature. The hundreds of observations, the almost countless people, are so skilfully distributed and controlled within the form of the roundel that the landscape is seen as a unit.

Never was a school of painters so single-minded as the 17th-century Dutch landscapists. No one artist can be considered either the founder of the school, or the dominant influence. They all aimed at faithfully rendering the various aspects of their country, yet each made his small, personal contribution to the school by interpreting the subject in his own way. Cuyp differs from Avercamp as much as from another painter years later, but what unites them is their serene contentment with life outdoors and the wonderful sensitivity to light. Cuyp, in his *View of Dordrecht*, achieves such a luminous atmosphere of light on water and light in the sky and the reflections of sky in water that it makes this picture one of his supreme masterpieces. His 'golden glow' for which he became famous stems from the fact that he was the first amongst the Dutch to set the sun in the sky and to actually paint sunshine.

After the relative restraint of the Dutch painters the Flemish Rubens comes as a complete contrast. Flamboyant, exuberant, afraid of nothing and accepting no limitations, he painted anything for whoever employed him and painted it superbly. If the Catholic Church wanted a Crucifixion or an Assumption he would paint a dashing interpretation. If a princely patron wanted a Toilet of Venus or a Bath of Diana he would set about it with equal vigour. But for his own enjoyment he painted landscapes every bit as sensuous, abundant and alive as his nudes. *Le Château de Steen* is one of his masterpieces in which emphasis is placed on the pure joy felt in, and the pulsating vigour of, nature. The rhythm of the peasants jogging along in their cart is repeated in the rhythmical, undulating fields which lead the eye far away into the distance. The viewpoint is high, and we can enjoy a saunter through that clear, sweet countryside. The sky is almost more remarkable than the actual landscape, with its soft lines of flecked cloud and the large disc of the sun low in the horizon. The trees are tipped faintly red, and reflected sunlight glitters bright yellow on the castle windows. Rubens was a consummate master of colour and the whole picture surface glistens with light. To the end of his life Rubens retained a deep understanding and love of nature and humanity, which was expressed in his work by his supreme spontaneity and almost unparalleled energy and vitality.

During all the time the West was discovering, experimenting, exploring and refining the business of painting, China had been producing works of delicacy and finesse for centuries. There, nature had always been the concern of the finest artists, and landscape painting was regarded as the

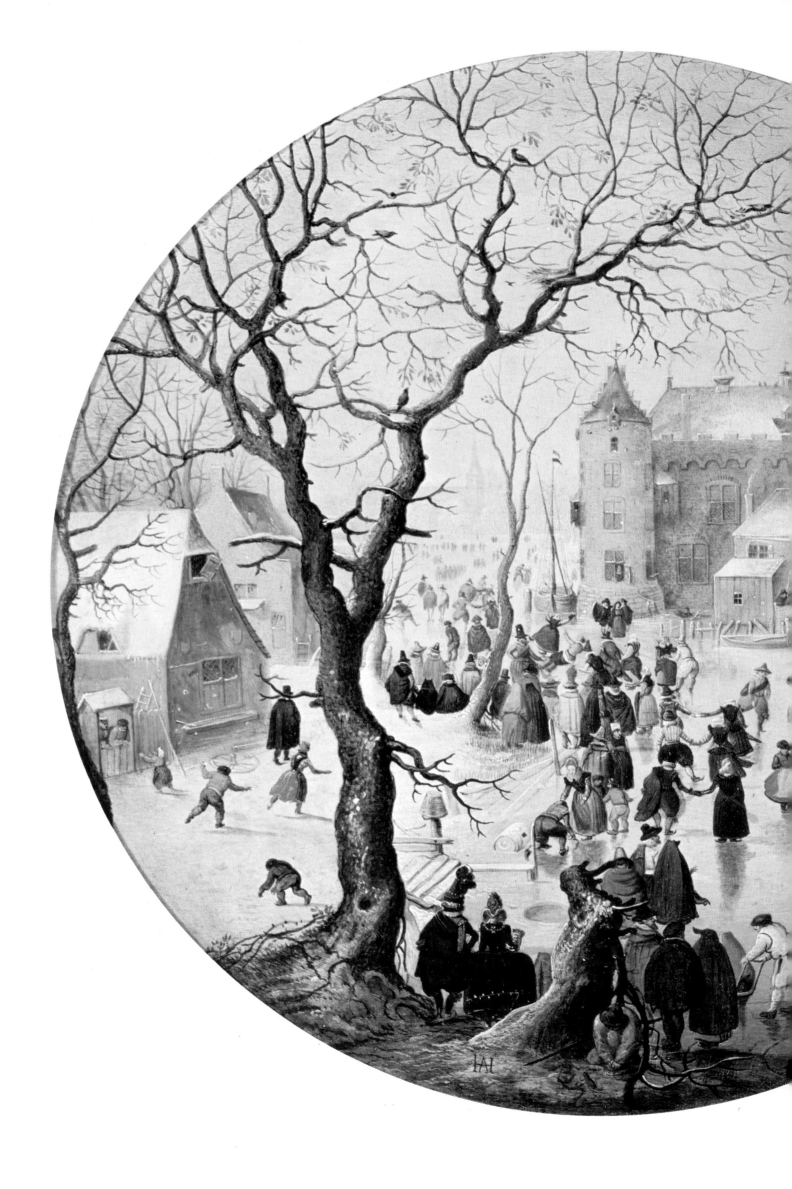

37
**A Winter Scene with
Skaters near a Castle**
about 1609
Hendrick Avercamp 1585—1634
National Gallery, London

highest branch of art. *The Emperor Kuang Wu Fording a River* by Ch'iu Ying portrays the grandeur of nature, its rugged strength as well as its tranquillity. In their paintings the Chinese sought to express man's relationship to nature, to portray their place in the scheme of things, and they showed man as a tiny part of it. Their approach to this task is quite unlike that of the later European painters. A painter-scientist like Leonardo, or Monet's studies of light and shade on a field, would be unthinkable in Chinese art. To the traditional Chinese artist such studies showed concern for mere outward appearances, the superficial phenomena of nature, while they themselves were concerned with the inner philosophical truths which lay behind the surface. This is why such insubstantial and impermanent things as shadows and reflections are absent from their paintings, and why a barely indicated city lost among mists seems to be animated by some mysterious, universal, half-divine life which can only be recognised, not understood.

Whereas in 17th-century Holland landscape was a recognised subject for painters, in France and Italy patrons were reluctant to accept it as the sole subject of a picture. So landscape painters used to include some Biblical or epic subject in their scenes to make them more 'respectable'. One artist who believed that landscape could in itself provide material for a satisfying picture was Claude, born in Lorraine but who, at an early age, went to Rome where he remained for practically the rest of his life. Claude was not a painter who offered instant sensations, who appealed by the intricacy of his narratives or who cut through to the viewer's emotions with some acute psychological insight. Although his pictorial themes are restricted, he arranged them in countless different ways and transposed them into different keys so that the exact mood of each painting is unique. In his landscapes there is a sense of all the attributes of a beautiful world being marshalled before us; a world which was created for the imagination to enter and wander about in. Most of his compositions consist of an open foreground like a stage, framed by trees on one side which are balanced by an answering motif on the other, small pockets of interest in the middle distance and a circuitous path taking the eye by easy and varied stages to a luminous horizon. The overwhelming impression of many of Claude's paintings is of silence and stillness, and as a result they give an extraordinarily calming effect. This is achieved in several ways. The colours are of exceptional luminosity and freshness, with rich greens and blues predominating and warm lemon colours for the sky above the horizon. Claude's extreme delicacy of touch creates a characteristic cool airiness, and the composition is placid. The ostensible subject, as in the case of *Hagar and the Angel*, could be rather stilted and contrived but it is Claude's use of light which makes his pictures so magical. The light which falls on the scene is so natural, and this naturalness is followed through in its effects on everything the light touches. The idyllic world of small figures, framing trees, water, bridge, and a far distance of breathtaking clarity and extent is bathed in cool mists which lie over the water and give an enchanted unreality to the distant hills. The sunlight on the bridge and water constitutes one of the most exquisite passages in any of Claude's paintings.

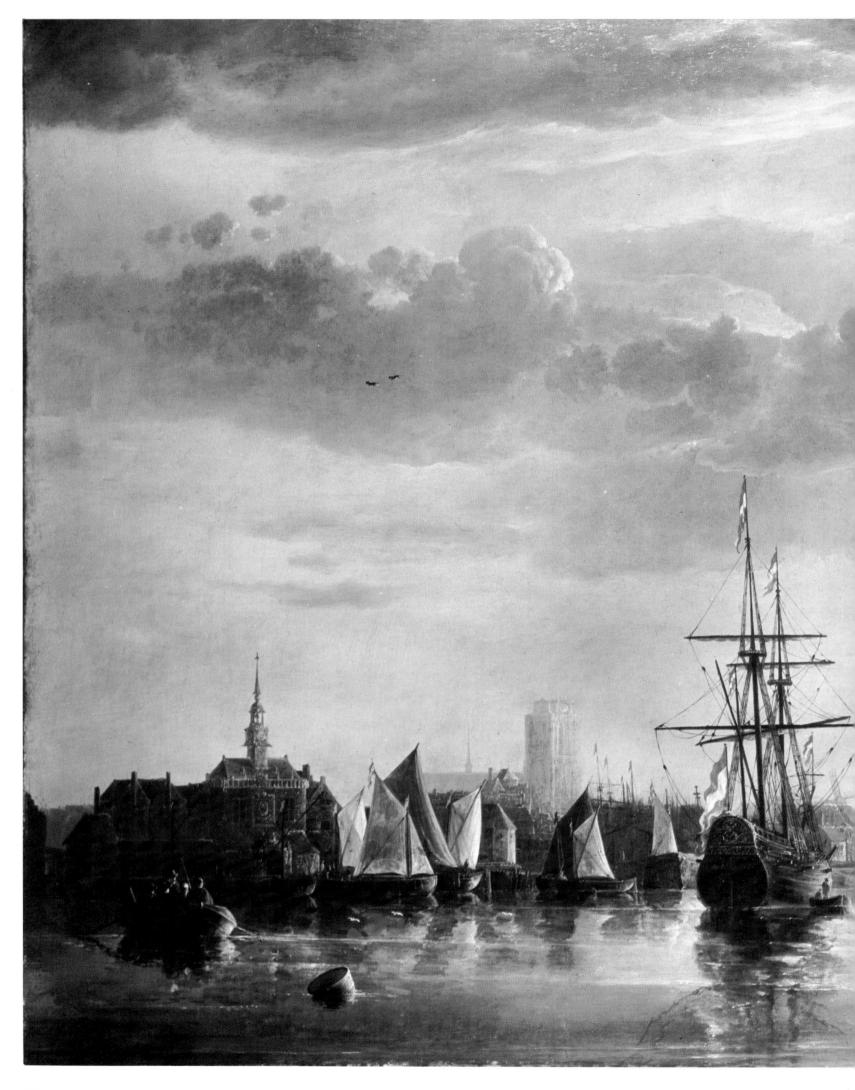

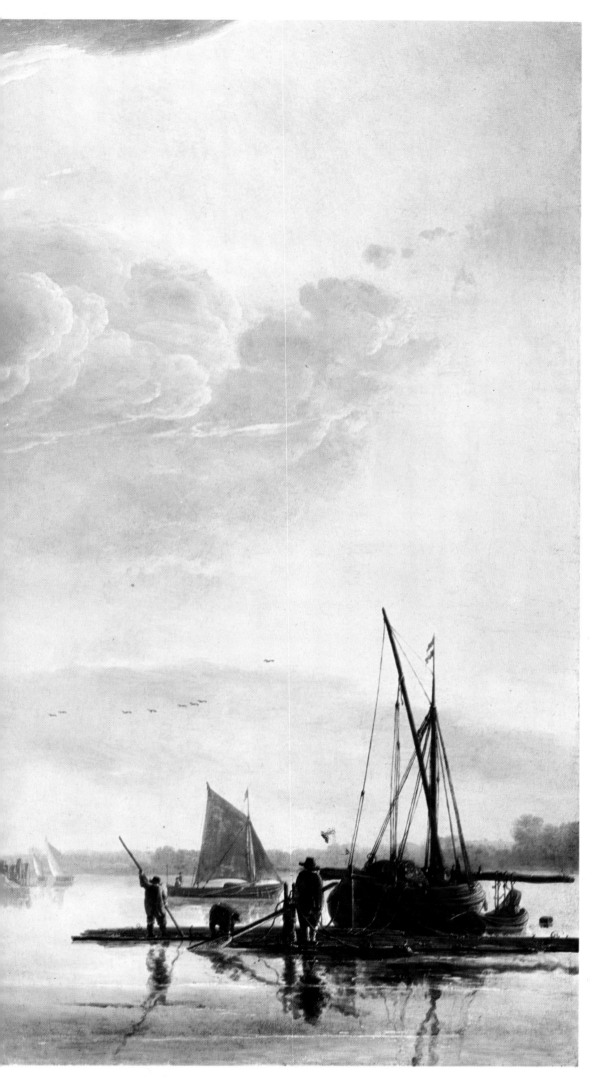

38
View of Dordrecht
Aelbert Cuyp 1620—91
Kenwood, London

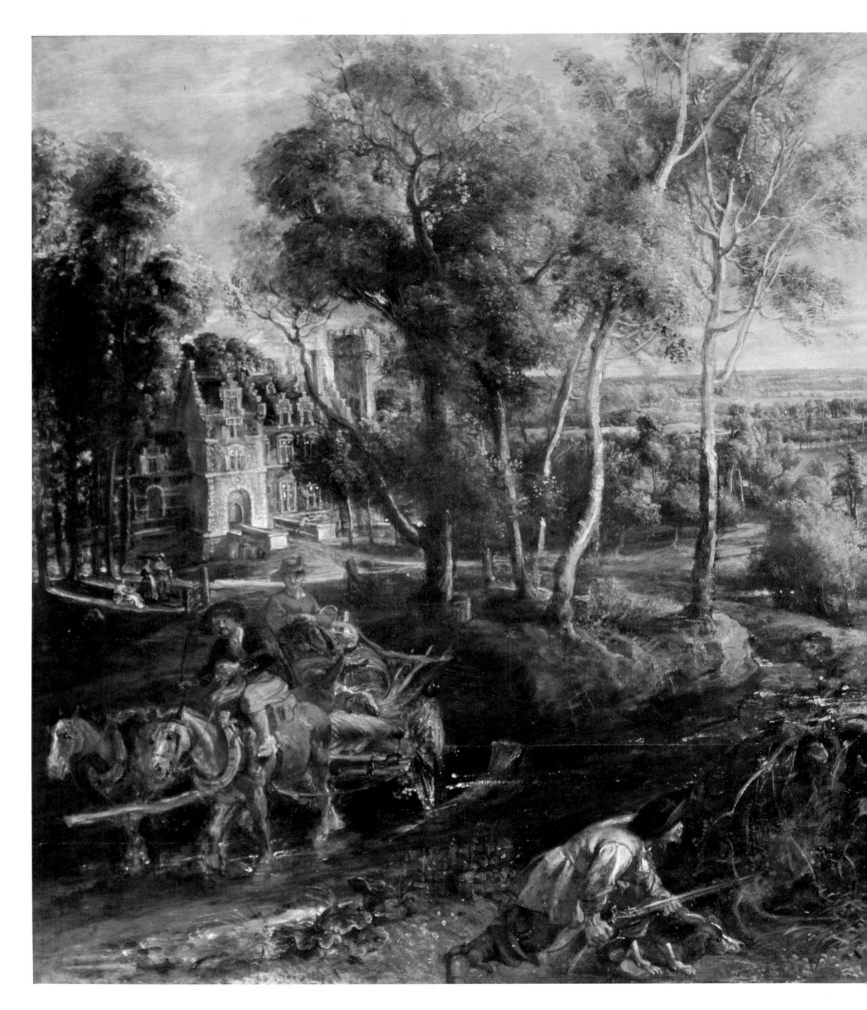

39
Le Château de Steen
1635
Peter Paul Rubens 1577—1640
National Gallery, London

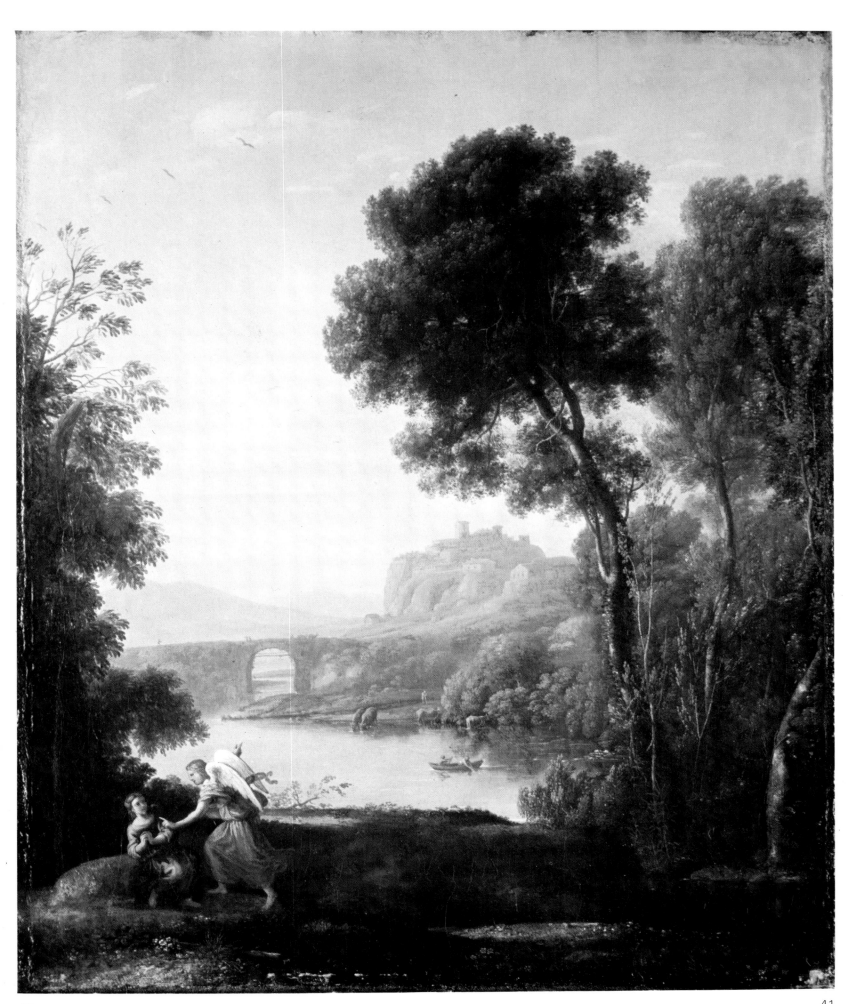

40
Emperor Kuang-wu Fording a River
Ming period, first half of the 16th century
Ch'iu Ying
colour and ink on silk
National Gallery of Canada, Ottawa

41
Hagar and the Angel
Claude Lorraine 1600—82
National Gallery, London

The Bacino di San Marco
about 1730–35
Canaletto 1697–1768
Museum of Fine Arts, Boston
(Gift of Miss Caroline Louise Williams French)

The Haywain
1821
John Constable 1776–1837
National Gallery, London

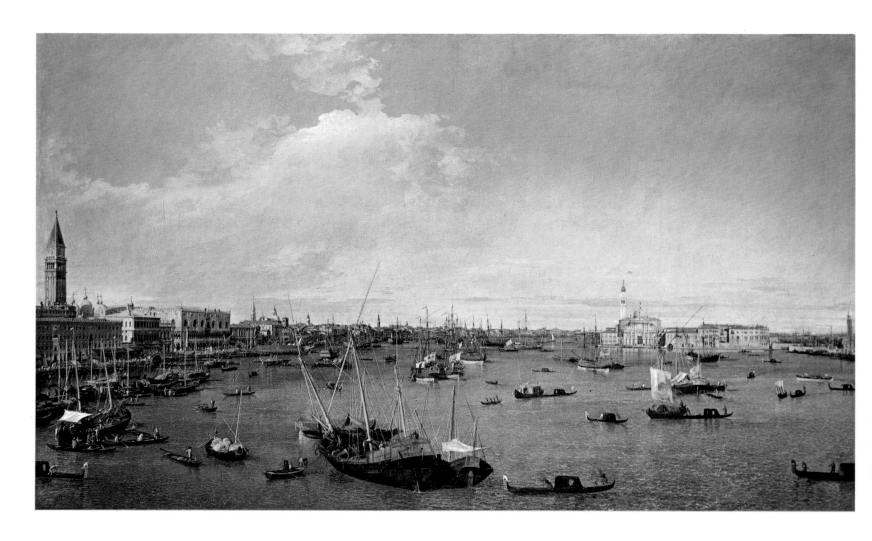

Dr Johnson once said 'a man who has not been to Italy is always conscious of an inferiority', and with Venice on the prescribed route of every gentleman's tour of Europe during the 18th century, the market for *vedute* (views, either real or imaginary) was enormous. Although many were churned out by competent craftsmen, some were masterpieces. In his pictures of Venice, Canaletto was one of the true creators of the urban landscape, and his early works have a poetic freedom in which an emotional view of a way of life was the subject and not merely a topographical record of a city. Canaletto's magnificent use of an expanse of water receding into nothingness as it retreats into the picture, drawing an emotional response by the force of the illusion alone, reaches its masterly culmination in the large *Bacino di San Marco*. The buildings, miracles of architectural form, curve to distant thinness behind San Giorgio Maggiore in a sweep of intricately diminishing light and shade, while the impasto highlights in the clouds and the transparent flags on the ships spread the colour in calculated diffusion. The pity of Canaletto's career is that all this brilliance was his undoing and he became a victim of his own success. His views of Venice became so popular that to fulfil orders his studio of assistants took on the functions of a factory, and his style eventually

lost its earlier vitality and became somewhat stereotyped.

Although the English are renowned for their love of nature and country life, as is evident in the work of many 18th-century English writers, landscape made a relatively late appearance in English painting. Claude was one of the most popular painters in England, and his canvases were eagerly sought after, but the first English artists who ventured to depict their own countryside were treated with indifference and even contempt. However, by the mid 19th century the mature work of Turner, the more impassioned pictures of Constable and the precious early watercolours of Cotman were to speak directly to the imagination and emotions at the profoundest levels expressed in English art. The development of landscape painting in England came at the same time as the beginnings of the Industrial Revolution. The first iron bridges had already been slung across the landscape. Soon industrialisation was to change it irrevocably and the balance of rural life was to be fundamentally affected. Artists seem to have been aware of this, and a note of nostalgia is apparent in their subjects as if they wanted to cling on to and reproduce something they felt was threatened.

Constable, who as Kenneth Clark says 'made the slowest start of any great artist before Grandma Moses', evolved his

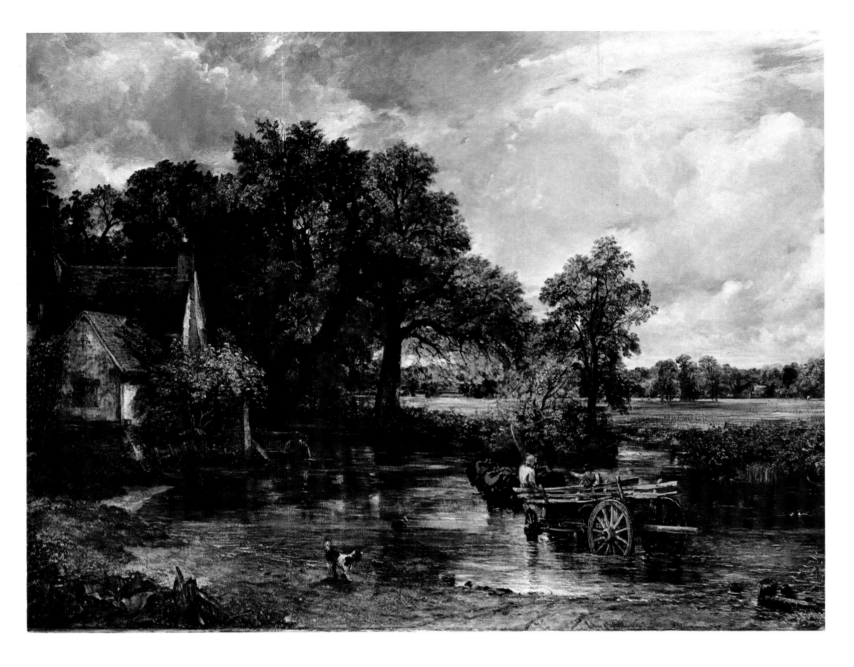

revolutionary naturalism, technical freedom and freshness of handling during years of hard work and little public acclaim. It is his audacity in the use of broken colour, and his brilliant use of chiaroscuro while conveying the movement and changes of light and colour in nature, that give his most startling effects. Whereas with Turner light permeates the whole fabric of the painting, in Constable it is fleeting and catches and highlights only certain areas. In *The Haywain* the ford is being laboriously crossed by the lumbering horses, and two ducks are the eager prey of a hunter hiding in the weeds (this same arrested action appears in Rubens' *Château de Steen*). Constable presents a vision of nature which is calm and benevolent. He stresses the idyllic unity of man and nature, but he paints with a restlessness, arising from his preoccupation with the vitality of nature, which nearly amounts to a fault. 'Painting is another word for feeling', he wrote, and it is this feeling which is the keynote to his work.

Turner, the greatest English painter and giant of European 19th-century art, started and continued throughout his life as a watercolourist. His use of this medium lightened his palette in oil (as it did later for Cézanne), and in his investigation of colour he anticipated the practice of the French Impressionists. As has been seen, from Claude to Cuyp,

Rembrandt and Velasquez, light is, again and again, one of the most important elements in painting and with Turner light itself was painted. Light to him was life. The magical effects of its atmosphere were the goal he pursued so relentlessly and with such miraculous success. In *Norham Castle* it seems as though the whole scene is encompassed in haze, moisture and yet more light, and the whole composition takes on an almost mirage-like quality. It is a serene, spacious and almost ethereal landscape in which the forms are so insubstantial they hardly seem to interrupt the continuity of the air. The pale, opalescent vision of the river, the faint touches of pink, blue and yellow, the pearly radiance of the whole painting answer to Constable's description of Turner's work as 'airy visions painted with tinted steam'. Turner had a passion for his art and such single-minded concentration that it made him indifferent to his surroundings. 'I paint what I see, not what is there' he said, and what he saw was nature as a unified organism.

In the 18th century watercolour was still a new art form in England. At first it was mostly topographical but with Turner and Cotman the West arrived at the simplicity, both in the brushwork and in the use of a limited range of colour, of the watercolour scrolls made during the Sung Dynasty

59

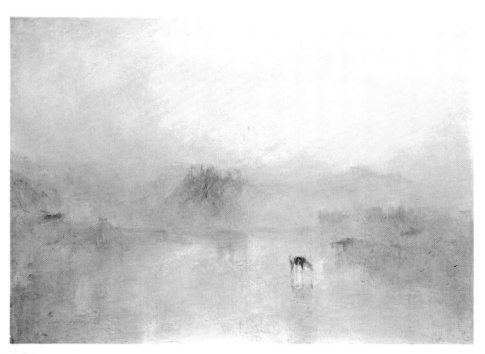

44
Norham Castle
about 1840—45
Joseph Mallord William Turner 1775—1851
Tate Gallery, London

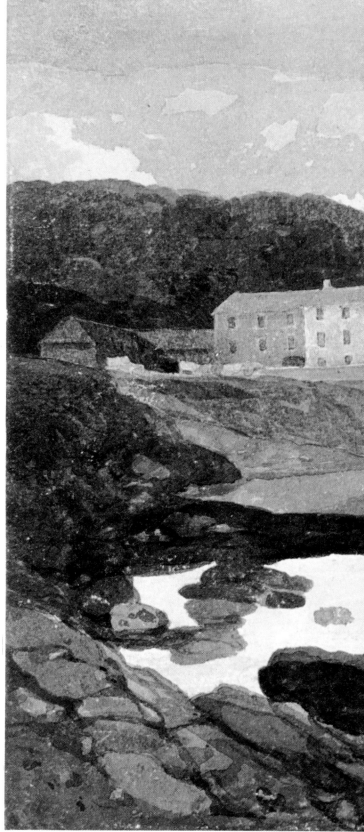

45
Greta Bridge
1806
John Sell Cotman 1782—1842
British Museum, London

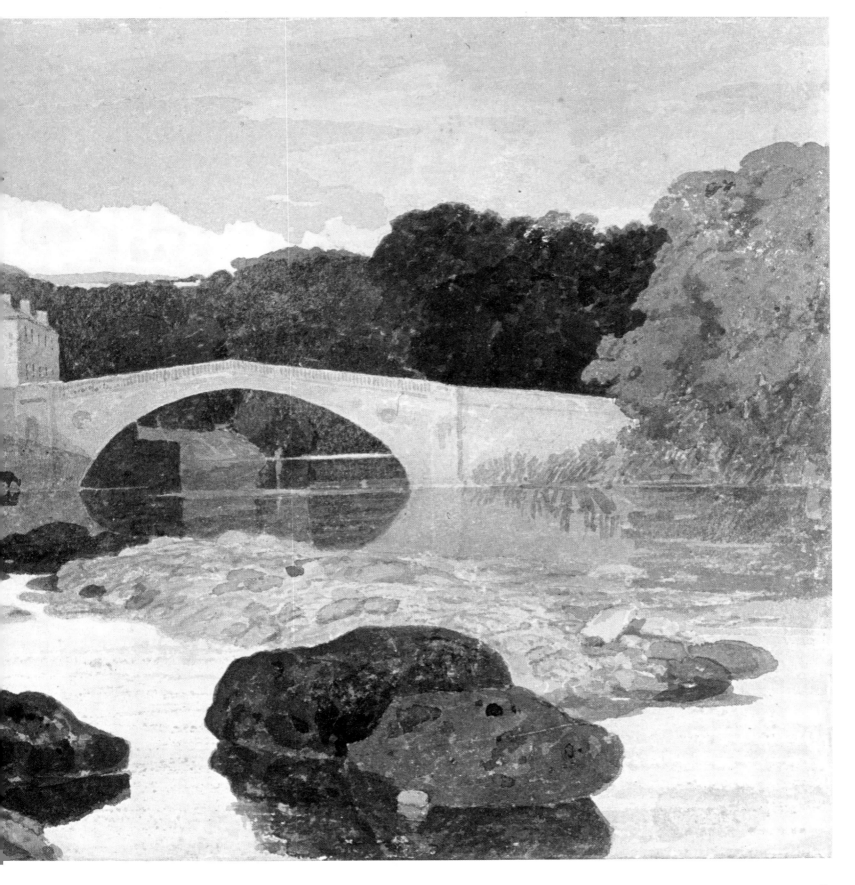

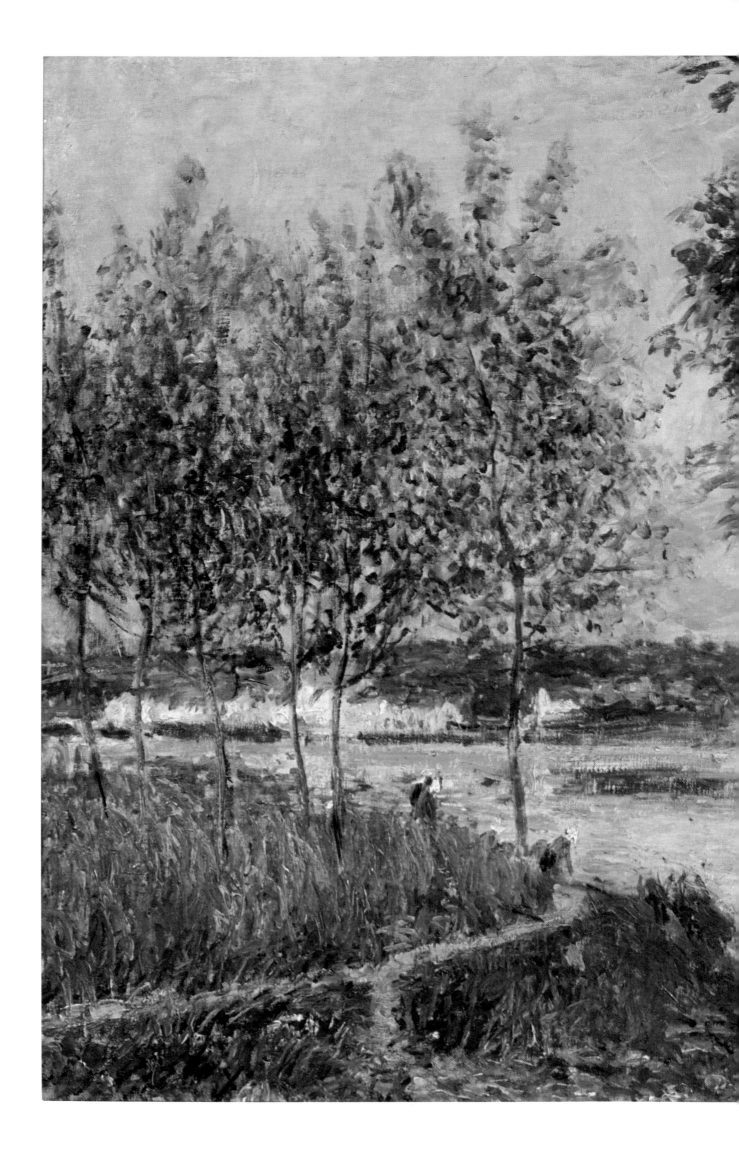

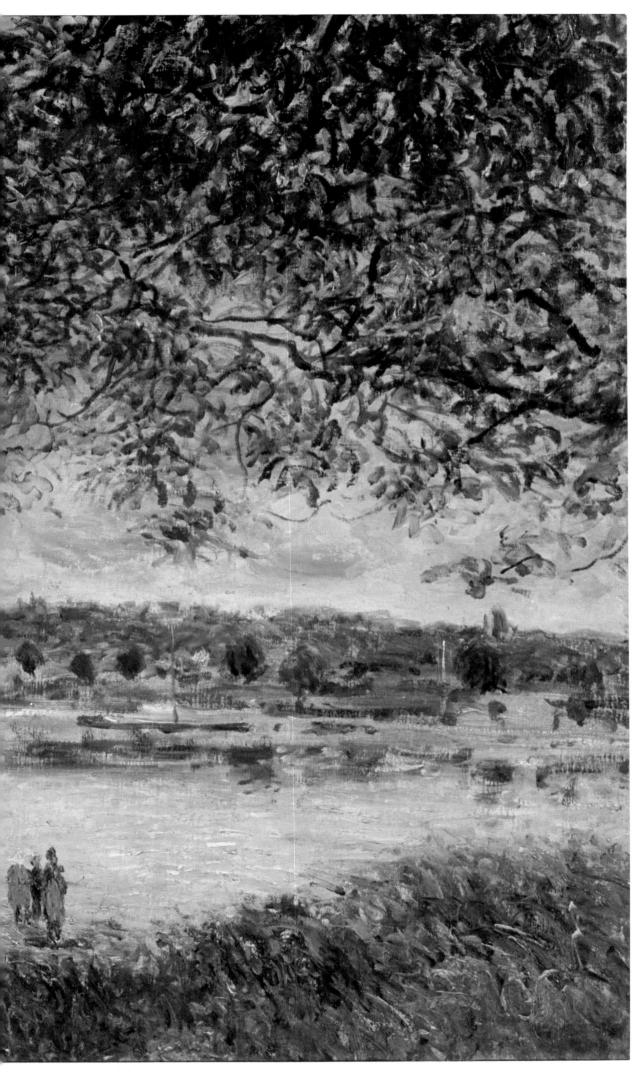

46
Way of the Old Ferry at By
about 1880
Alfred Sisley 1839—99
Tate Gallery, London

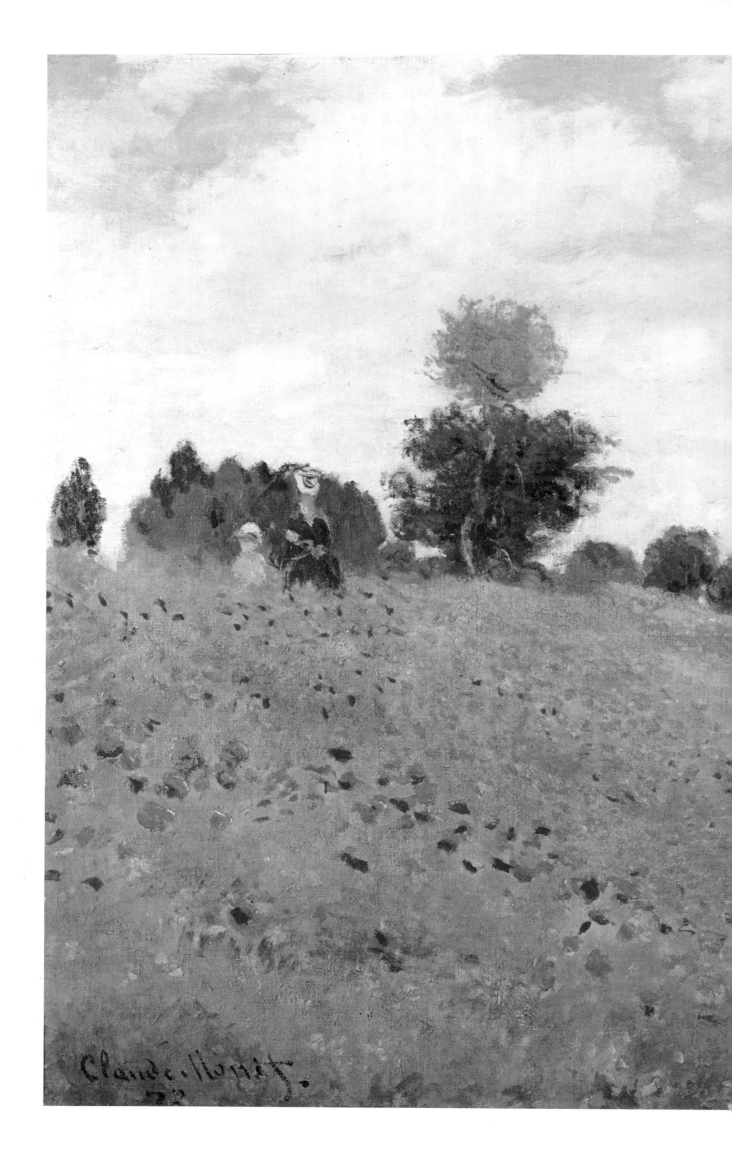

47
The Poppyfield
1873
Claude Monet 1840—1926
Jeu de Paume, Louvre, Paris

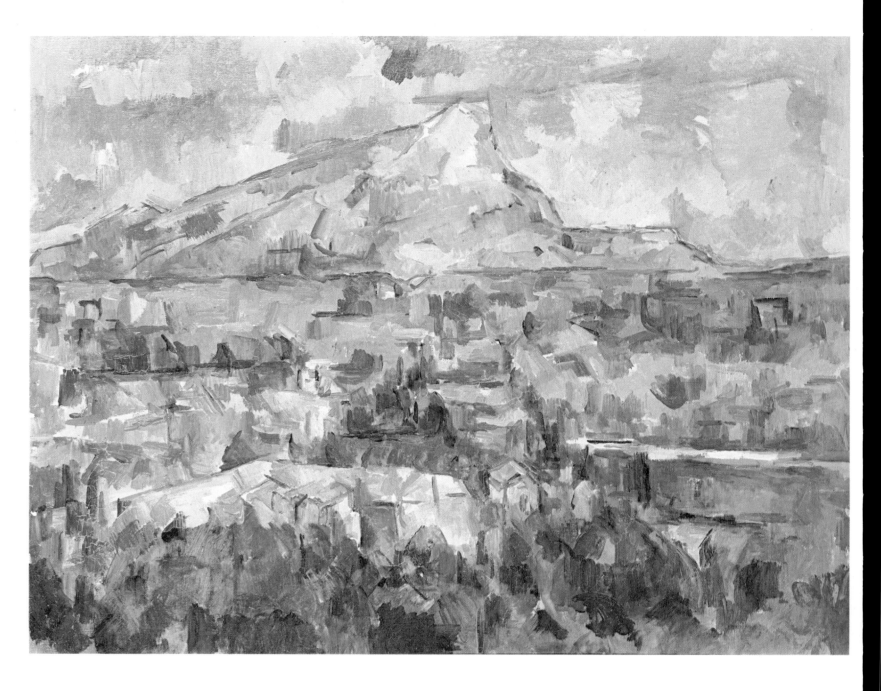

(960–1260) in China. John Sell Cotman's simplification and understatement, the feeling for abstract design are splendidly seen in the watercolour of *Greta Bridge*. The sharply silhouetted masses of quiet colour and severe patterns show his sure feeling for composition. His technique of a wonderfully crisp brilliance and facility is seen at its most accomplished.

At the first of eight exhibitions held in Paris between 1874 and 1886 by a group of young painters, a bewildered and angry journalist offered the word 'impressionist' as a contemptuous description for what he saw. This term derived from the title of a picture submitted by Monet, *Impression: Sunrise*, which showed the light of the rising sun playing on water. The group followed the 19th-century commitment to nature, but it was not concerned with just the explanation of nature itself but with our way of apprehending it through physical vision. This meant understanding the constitution of colour, the structure of light and the psychology as well as the physiology of human vision. For example the Impressionists mixed their paints not, as the Neo-Classical painters David and Ingres did, on the palette but on the canvas by placing brush loads of different pure colours side by side so that they merged when seen from a distance of a few feet.

Moreover they discovered that shadows are not simply black or grey but contain the complementary colour of the object that creates them. Black was almost abolished from their canvases and their paintings are among the brightest and most spontaneous in European art. A true Impressionist picture then presents nature as a mosaic of coloured patches with colour divided so that its surface might glitter. What the Impressionists did, almost without knowing it, was to realise the phenomenon of transitoriness. In order to paint *Way of the Old Ferry at By* Sisley carried his canvas out into the open air and aimed to record every nuance of what his eye saw. His eye perhaps was no more searching than the artist who constructed his picture in his studio from a series of preparatory sketches, like Constable and Claude, but it brought the freshness of the momentary effect. The time of day, the season of the year, the precise strength of sunlight and the density of the atmosphere are all expressed in this selected moment by a river.

Great effort is always admired, and these apparently hasty sketches made up of a few daubs of colour splashed on to the canvas were scorned and laughed at. Monet was the most convinced and consistent Impressionist of them all. He

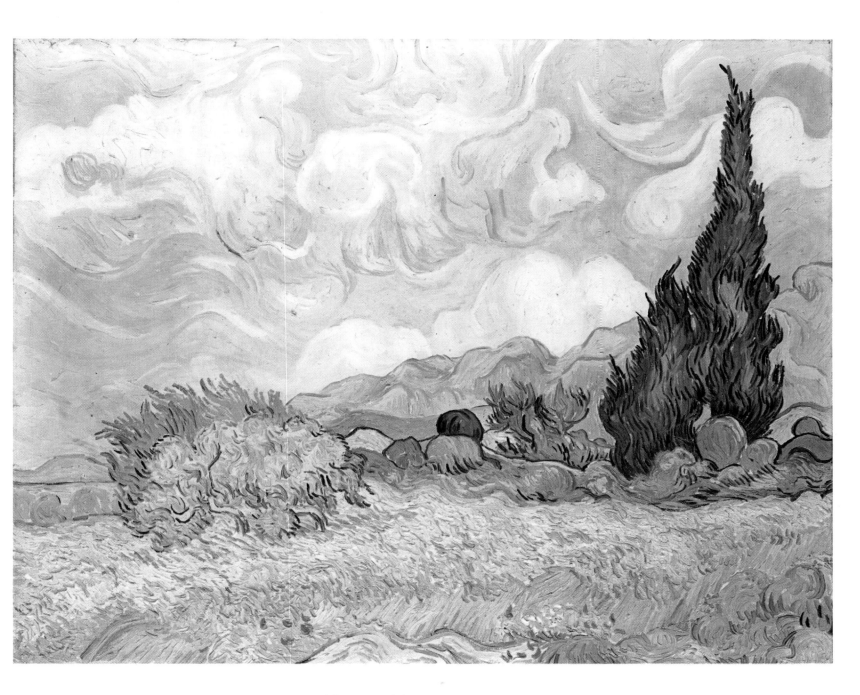

painted the world about him solely in terms of light, and in his pursuit of this objective created the most carefully constructed compositions. He excluded the narrative element from painting and expressed only the exhilarating beauty and splendour of nature.

Most artists since Cimabue (see plate 2) had tried to create an illusion of reality by a variety of devices: the use of perspective, the ability to render the weight of solid objects and the different textures of their surfaces, and lastly the understanding of the nature of light. All these helped the spectator to forget that he was looking at a canvas, or a piece of paper, or a wall covered with patches of paint. Unlike his predecessors, Cézanne accepted the squareness and flatness of a canvas. So his even brushstrokes and almost square patches of paint not only describe the object and the space around it but also stress the fact that one is looking at a two-dimensional canvas.

The art of Cézanne is a great and complex achievement. His career was a struggle to reach self-imposed artistic objectives, and perhaps the greatest single accomplishment is the series of paintings of Mont Sainte-Victoire, a theme that preoccupied him in his later years. As though under some kind

48
Mont Sainte-Victoire
1904
Paul Cézanne 1839–1906
Philadelphia Museum of Art,
Pennsylvania
(George W. Elkins Collection)

49
Cornfield and Cypresses
1889
Vincent van Gogh 1853–90
National Gallery, London

of compulsion, he returned repeatedly to this site in Provence and produced over twenty-five versions in oil and countless watercolours and drawings. By painting this subject so frequently Cézanne seems to have been seeking some principle of permanence in nature, and it is with Mont Sainte-Victoire that his searching ends. But once he had found this form of utmost stability he charged it with his own churning creative energies, which have something of the elemental force from which the mountain itself evolved. In this, as in all the paintings of this subject, Cézanne adheres to a palette of ochres, greens and blues, an austerity forced, as it were, on nature. From this limited range of colours, Cézanne creates a surface of extraordinary richness. As in all his works there is an in-

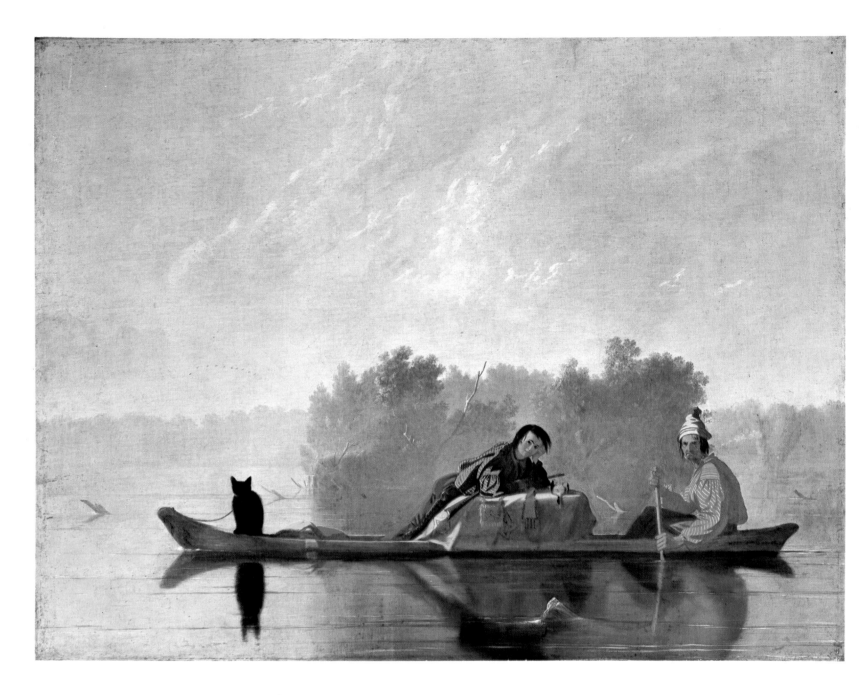

herent tension as our perception fluctuates between the objects depicted, in this case the mountain, valley and sky, and the sensuous brilliance of the paint itself. Cézanne succeeds in reaching the essence of his art where these dabs of the brush, the colour patches, become the key to sensation and the faithful recorders of experience. He goes beyond the need to grasp nature in literal or tangible terms, and with this and other late paintings the threshold of modern art was crossed and the revolutionary forces of 20th-century painting unleashed.

Cornfield and Cypresses was painted at St Rémy in Provence in the year before Van Gogh's death, and it reveals a very different approach to landscape painting from that of either the Impressionists or Cézanne. With the same element of restless movement found in Constable, Van Gogh's colours set up tensions within the picture, and take on an excited existence of their own as if the artist were trying to express his own inner conflicts. Colour, to Van Gogh, was all important and he aimed to express a particular mood by a particular colour. He had a dizzying perception of space. He filled the picture surface with elements (trees, bushes etc.) which he linked together by roads or paths or mountain

ranges, and far from flattening the picture surface he scooped it out and reached into the farthest depths, linking the background with his contorted, lyrical foregrounds by the extreme vigour of the restless, muscular rhythms of his brushstrokes. Van Gogh expressed himself with furious intensity, and discovered on his canvases the visual equivalents of that intensity.

The movement which saw landscape painting elevated to prime importance in Europe in the 19th century was profoundly felt in America too. Throughout the century the Americans acquired vast stretches of territory until they owned the entire continent north of Mexico, except for Canada, and their painting reflects their pride in the size and grandeur of their country. George Caleb Bingham was one of the most distinctive of the mid-century painters. In *Fur Traders Descending the Missouri*, the clearly defined image of the boat, with its three occupants mirrored in the water, seemingly miles from anywhere, is a vivid expression of the stillness, silence and emptiness of the unexpected reaches of the land.

One of the most influential of the late 19th-century American painters was Winslow Homer. He revolutionised

50
Fur Traders Descending the Missouri
1845
George Caleb Bingham 1811—79
Metropolitan Museum of Art, New York (Morris K. Jessup Fund, 1933)

51
Gallows Island, Bermuda
about 1899—1901
Winslow Homer 1836—1910

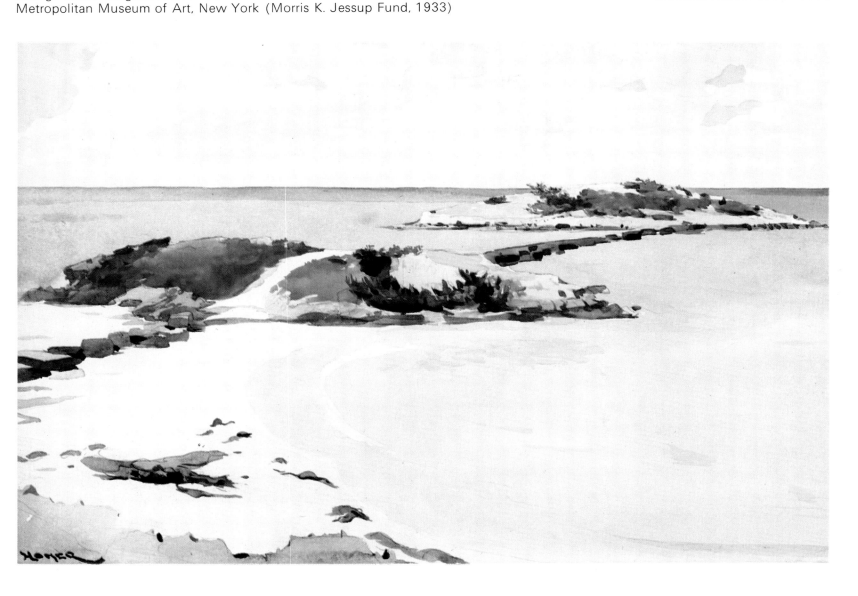

American painting by the quasi-Impressionist style of his
·paintings of the sea, and shooting and fishing subjects. Most
of his work shows the rough, often dangerous, outdoor life of
people living on the Maine coast, and the conflicts and con-
tests of nature. However, in his later years, Homer took one
or two trips to the Bermudas and produced a series of
sparkling watercolours. *Gallows Island, Bermuda* is unusual in
that the scene contains no hint of the dangerous forces of
nature but is given over entirely to portraying the bright
yellow sand melting into the clear blue water. It is a brilliant
evocation of scenery; it is also a good example of the direct-
ness and economy of his method.

The art of transplanted cultures always seems to follow a
similar pattern. First it is highly imitative, then it is literal,
and finally, in its flowering, it integrates the old traditions of
the mother-cultures into the new environment. Painting is
one art in which many Canadians believe their transplanted
culture has reached genuine maturity. Modern Canadian
painting, in the sense that it reached the people and
showed them the nature of their environment, began with
the discovery in about 1907 by Tom Thomson of the real
north country, especially its rivers and forests. He expressed

the dramatic decorative elements of wild, Canadian nature
with a force that revolutionised art in Canada. Thomson,
whose short career tragically ended in a drowning accident,
painted the wild colours of a Canadian autumn, the solitary
lakes of the north land, the monolithic islands of Lake
Superior, the glacier-tortured landscape of the Laurentian
Shield, and the grim exhaustion of a hillside emerging from
four months of winter snow. He painted Canada as it is and
Canadians have recognised it as their own.

With characteristic boldness and tremendous awareness
of their surroundings, painters in Australia have brought a
new and exciting element to the art of landscape painting.
They express the vast distances, soundless plains and the
relationship of man and nature in vivid terms. Arthur Boyd
demonstrates this in *Irrigation Lake, Wimmera*. The land is
parched and bare, the trees are blanched and dead, and the
water is unmoving; but there are signs of life in the bridges,
sheep, and the man in a ramshackle cart. The wide sky, the
curve of the bank and the tree give a feeling of distance and
space, and a curious calm contentment. The colours are pale,
and the fragile yellows, greys and greens contrast strongly
with the black of the crows.

52
In the Northland
1915
Tom Thomson 1877–1917
Montreal
Museum of Fine Arts

53
Irrigation Lake, Wimmera
1950
Arthur Boyd 1920–
National Gallery of Victoria,
Melbourne

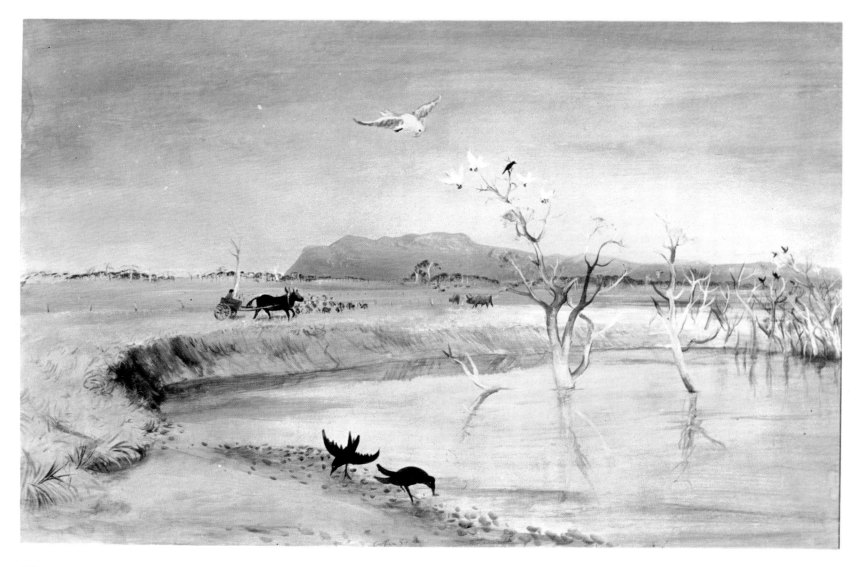

Heroes, Myths and Allegories

European mythology is rich with tales of gods and heroes, maidens and monsters and imaginary lands of peace and plenty. Often the stories are allegorical, that is they symbolise a moral truth, or perhaps explain one of the mysteries of nature. From time to time real people and real events have captured the popular imagination and become idealised until they too achieve legendary greatness. Writers, composers, sculptors and painters have all helped to turn history into an epic sometimes barely distinguishable from myth and legend.

Uccello's painting of *The Rout of San Romano* is one of the first of hundreds of heroic paintings which were to be commissioned for the walls of European castles, palaces, mansions and civic buildings up to the present day. *The Rout* was originally painted for a Florentine house to celebrate a recent local victory over the neighbouring and rival town of Siena. Already the event and the characters taking part have become idealised in the minds of the patron and painter alike. Although two knights have pushed forward with lowered lances and are engaged in battle, the young knight with golden hair a few yards behind has not put his helmet on, nor perhaps intends doing so. He sits erect and calm as if he were at a hawking party. Although soldiers dash about in the background, horses rear and corpses and armour litter the battlefield, the whole effect is disarmingly decorative. Uccello has allowed his preoccupation (obsession would be a better word) with the linear perspective to dominate his composition. He has been so anxious to show off the effect that the result seems wooden and contrived. Yet he cleverly contrasts the concentration of men in battle with the quiet charm of the country road in the background, and the hedge of wild roses whose peace is disturbed. His evident pleasure in the decorative patterns made by the lances and banners, and his daring use of colour all combine to make this a delightful and imaginative work.

The stories and characters from Greek and Roman mythology were much better known five hundred years ago than they are now, and undoubtedly the choice of a certain subject often had a special significance for a patron, or was particularly relevant to the philosophical ideas of the day.

Uccello's contemporary, Botticelli, painted a number of subjects from Classical mythology including the *Primavera*, an allegory of spring. The picture shows Venus in the centre with Cupid above aiming his arrow at the three Graces and Mercury their leader; on the right Zephyr, the west wind, is pursuing the nymph Chloris, and as he catches her she is transformed into the herald of spring. The figures move freely in an airy landscape, and have a natural roundness of form, but although Botticelli paints in the new 'natural' style, he does not abandon his love of line and pattern. Instead he makes use of sensitive line to emphasise a graceful form, the flow of hair and the swirl of garments, and so enhances the vitality and movement of the whole picture.

Few Old Masters have the power to capture the imagination to the extent of the Venetian Giorgione. The very mention of his name is enough to evoke an image of poetic painting and mysterious subject-matter. Giorgione was a very individual master and the nature of his art suggests that he was an intellectual. He lived in a city which has been considered 'the largest and most active intellectual and publishing emporium of Europe and the Renaissance', and the circle in which Giorgione moved consisted of scholars and collectors of works of art. He was also in touch with the poet Bembo, whose writings express the sentiments and way of life of refined and cultured young people who liked to inhabit an Arcadian world where they could forget their pressing troubles. Yet the ideal existence which Giorgione evokes in a painting such as *Le Concert champêtre* is not one of frivolous entertainment. On the contrary, this evocative and puzzling work suggests a mood of reflection and seriousness; this is art that appeals to the reason as much as to emotion. His picture is tender and meditative, the first to express the sublime effect of man being in perfect harmony with nature.

The myth used by Titian in his *Bacchus and Ariadne* expresses the pagan delight in sensual pleasure. The artist captures the moment when Bacchus, the wine-god, returning with his revellers from a sacrifice, finds Ariadne on the seashore. Ariadne has just been deserted by Theseus, her former lover, whose departing ship is seen in the distance.

She is unconsciously already under her fated star as above
is the constellation of Ariadne's crown, the crown later given
to her by Bacchus. Also important astronomically is the
figure with the serpent; he is the serpent-bearer who was to
be translated to the skies with Bacchus and Ariadne. The
marriage of the couple took place in the spring and is
symbolised by the flowers which deck the path. The colour is
superb: the marvellous crimson, bronze and blue draperies
are set against the bluest of skies and a rich green landscape
which drops towards the sea. The leap from the chariot, the
swirl of the cloak, the raised hands of the revellers, the

twisted posture of Ariadne and above all the clamour of the
cymbals and the barking dog make this picture overwhelm-
ing in its movement and sheer *joie de vivre*.

During the 18th century, the vogue for large-scale epic
paintings which had begun with the Renaissance spread
throughout Europe, and with Tiepolo the golden tradition
of Venetian decorative art found its final expression. Gifted
with an inexhaustible inventiveness and versatility and un-
daunted by the thought of massive ceiling paintings, he rose
to the occasion by creating masterpieces of great pomp and
splendour. In his ceiling painting for the dining room of the

54
**Niccolò da Tolentino
at the Rout of San Romano**
1457
Paolo Uccello 1396/7—1475
National Gallery, London

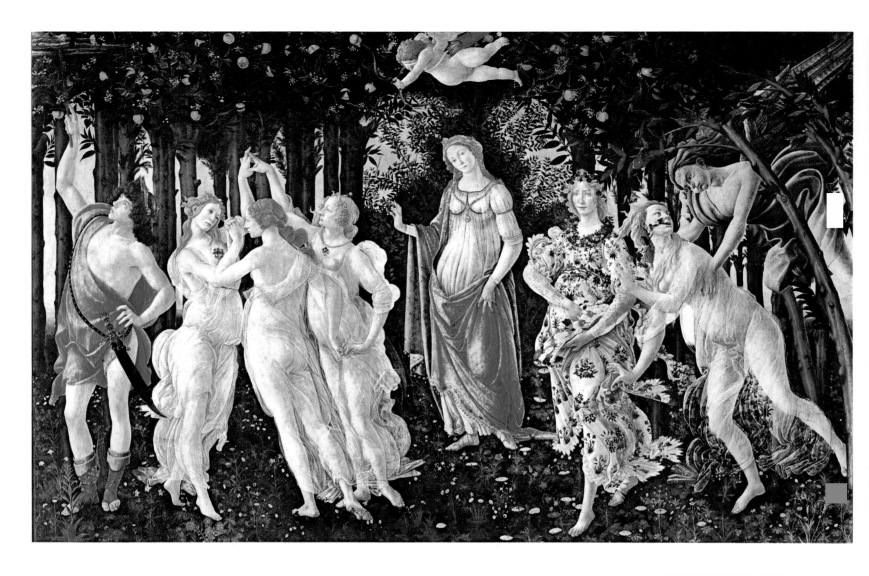

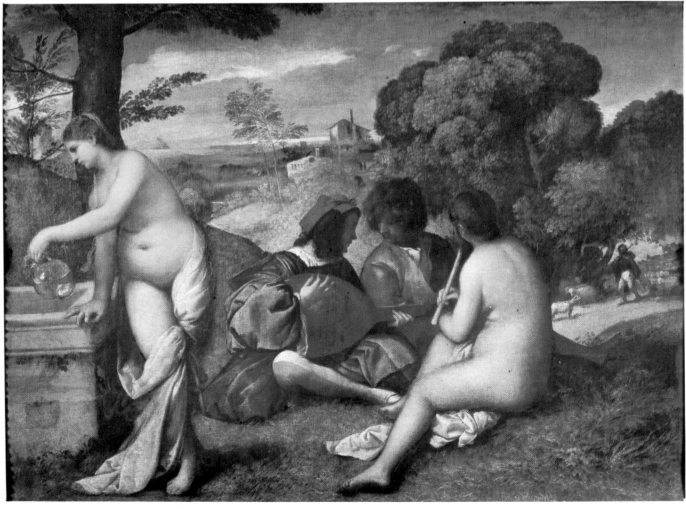

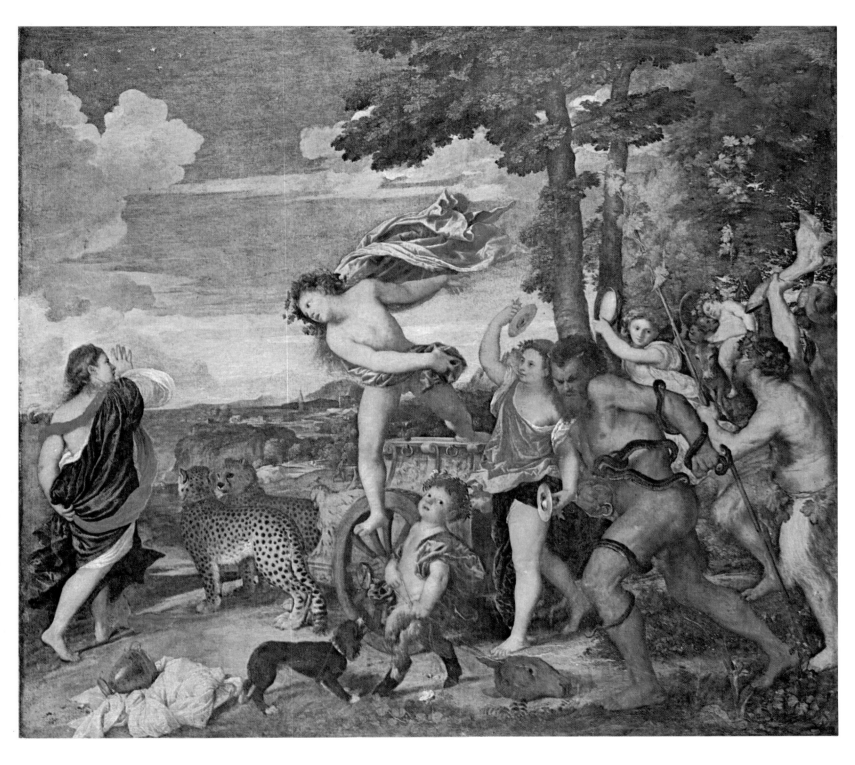

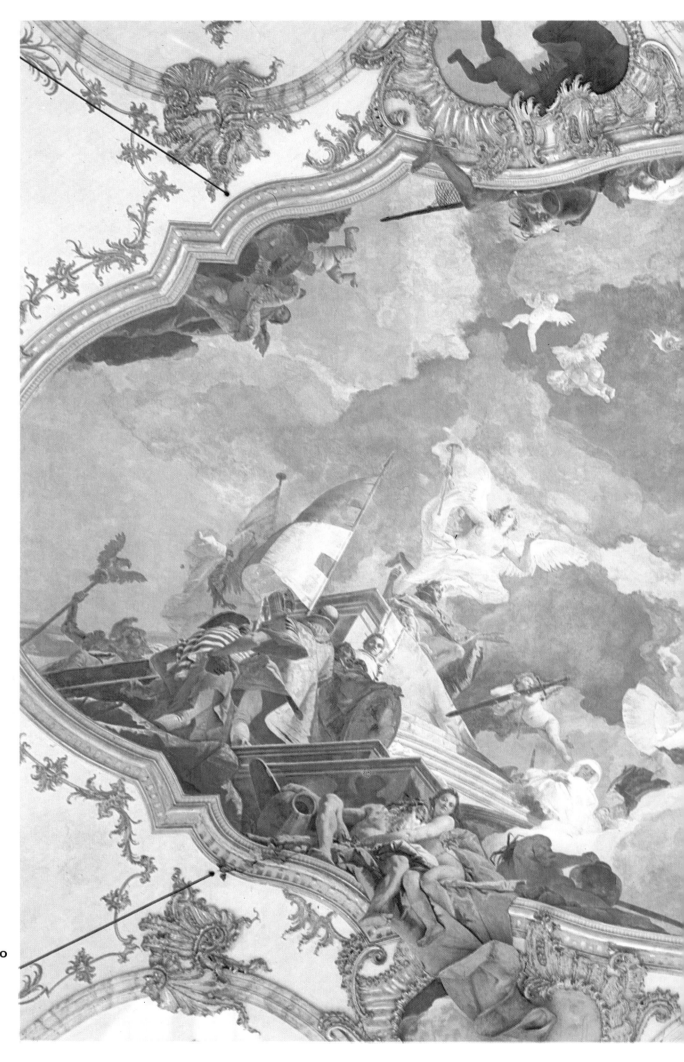

58
**Apollo Conducting
Beatrice of Burgundy to
Frederick Barbarossa**
1751—52
Giambattista Tiepolo
1696—1770
fresco
Residenz, Würzburg

76

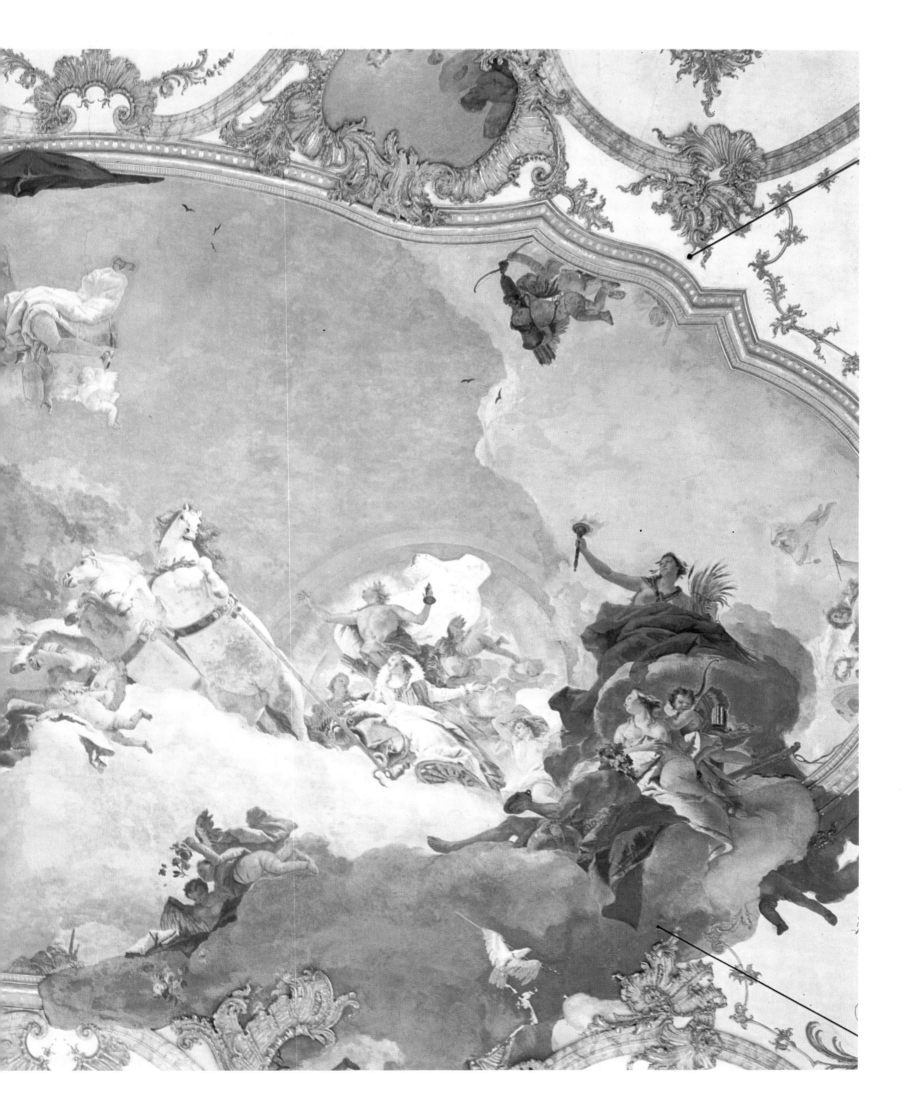

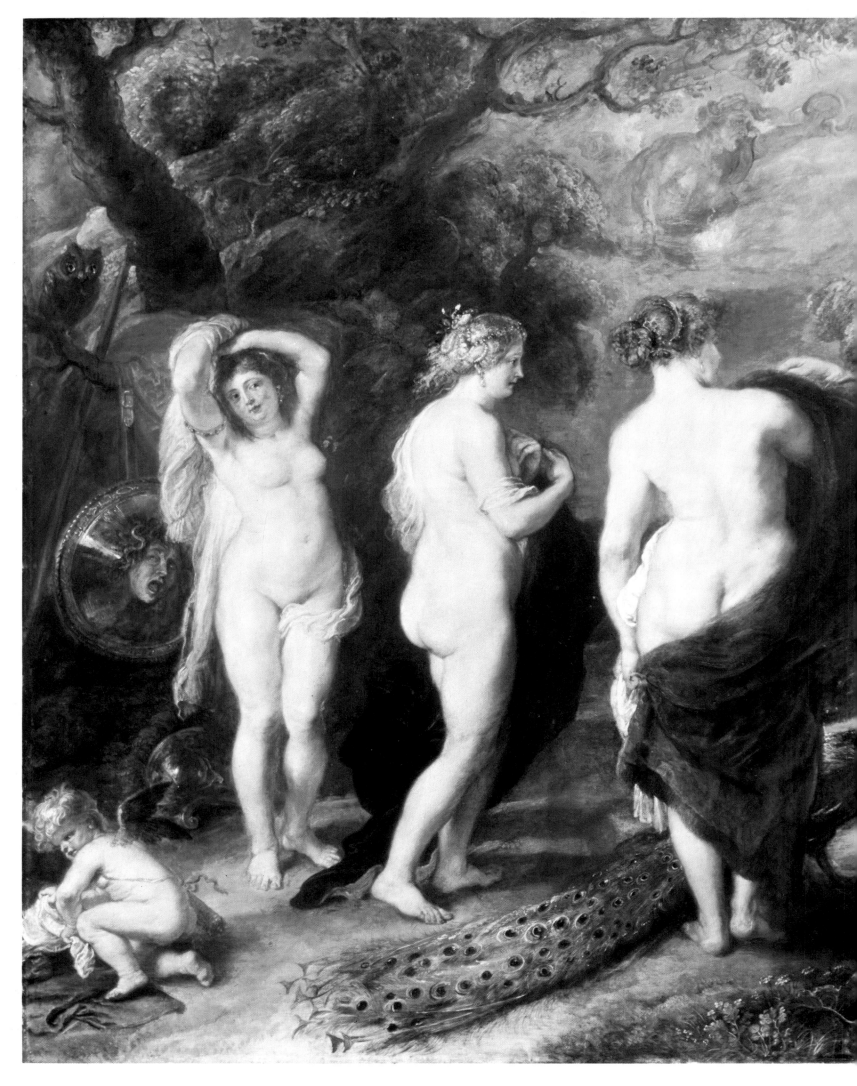

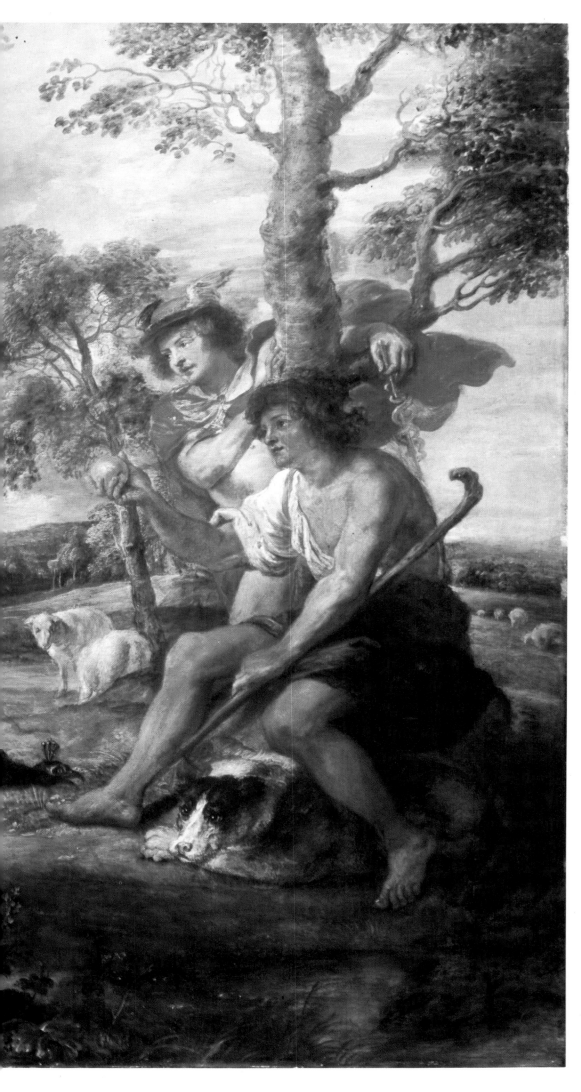

59
The Judgement of Paris
about 1629—30
Peter Paul Rubens 1577—1640
National Gallery, London

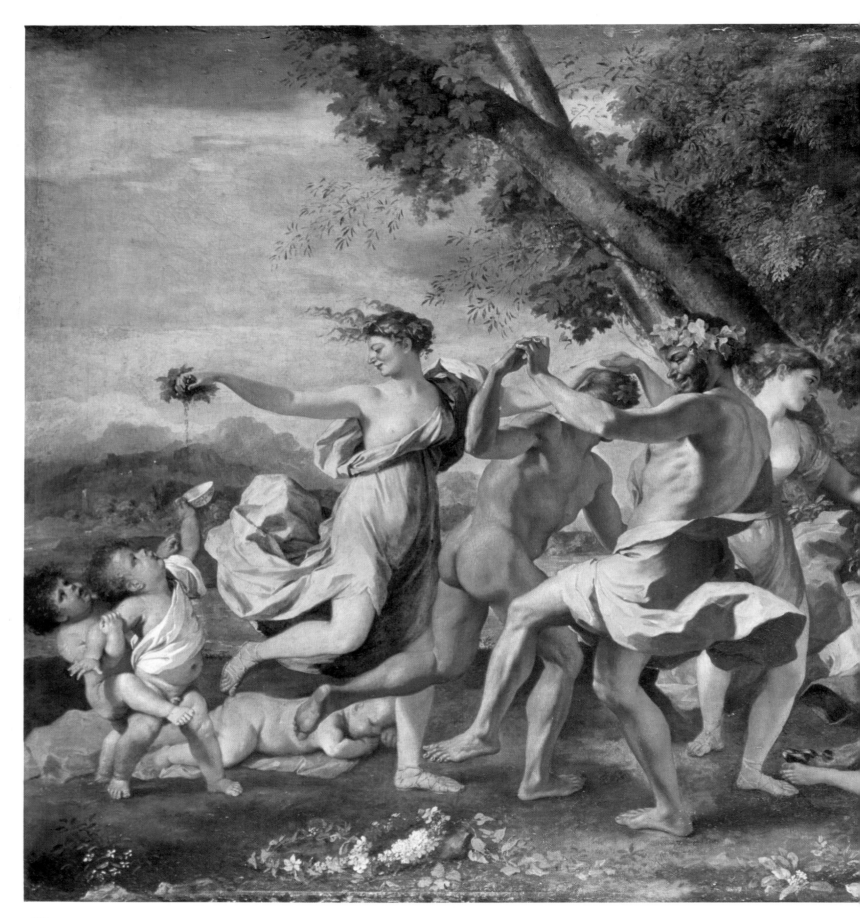

60
Bacchanalian Revel before a Term of Pan
about 1630–32
Nicolas Poussin, about 1594–1665
National Gallery, London

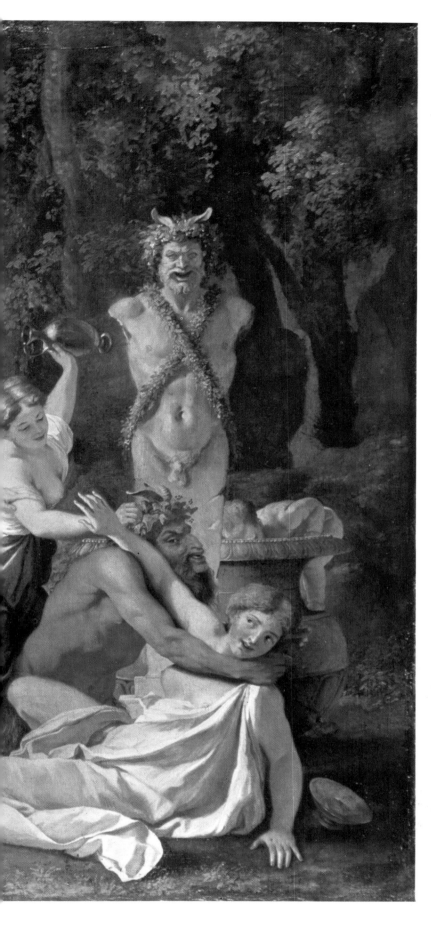

Würzburg Residenz, historical and mythological figures mingle with ease. This is an enchanted world in which effortlessly superior beings float weightlessly in space. Characteristic of Tiepolo is the light-toned palette which bathes his work in eternal sunlight only tempered by the shade of summer clouds. In this painting the groups of figures turn and sway as if performing a silent dance, their movements echoed by the curls and twists of the gilded plasterwork decoration. The illusion of the ceiling being open to the sky is achieved by Tiepolo's consummate mastery of trompe l'oeil, and the whole decorative effect is a magnificent union of sculpture, architecture and painting.

Rubens was also employed to glorify princely families and to paint pictures to decorate their palace walls. Like Tiepolo, he travelled and worked in many countries and was often asked to paint subjects from Classical mythology. In *The Judgement of Paris*, we see the young shepherd boy, Paris, with Mercury by his side, about to award a golden apple to the most beautiful of the three goddesses. In the centre is Venus, goddess of love and beauty; on her right is Juno, queen of the heavens and goddess of power and wealth, with her peacock at her feet; and on the left is Minerva, goddess of wisdom, with her owl perched behind her. Paris chose Venus and therefore love instead of power or wisdom, and from his choice came, so the story goes, all the disturbance to domestic peace involved in the Trojan War. The goddess of discord, already assured of her victory and its consequences, hovers in the clouds above, spreading fire and pestilence. The subject is purely legendary and symbolic, but Rubens paints it with such evident enjoyment and skill that the painting throbs with life.

Bacchanalian revels appear again in Poussin. His art was nourished in Rome and the spirit of Greek and Roman culture hovers around all his pictures whether they are Classical in subject or not. Poussin's knowledge of Classical antiquity was a source of both strength and weakness. For while on the one hand it gave his work harmony and clarity, on the other it tended to make his painting too restrained and cold. Logic, economy, order and clarity of presentation are the keynotes of his art. He wrote: 'My nature leads me to seek out and cherish things that are well ordered, shunning confusion which is as contrary and menacing to me as dark shadows are to the light of day.' Poussin is not a painter whose works can be hurriedly enjoyed by a casual glance but each of his major paintings gives more pleasure the more fully it is explored. They may at first sight seem dry and uninspired, too calculated and contrived, but finding your way into and around them is to appreciate the force and grandeur of the Classical temples Poussin so much admired.

It was not until the end of the 17th century that France began to produce an art that, instead of echoing the faded glamour of Renaissance Italy, reflected the gay if equally artificial life of Versailles. Such a lively art could not be the outcome of stern adherence to serious Classical creeds and the grand manner. Watteau's short life makes a bridge between the 17th and 18th centuries as he combines the worldliness of the one with the playfulness of the other but like Mozart, by the alchemy of his art, he hints at depths beneath his neat and formal patterns. Taking his lead from the

81

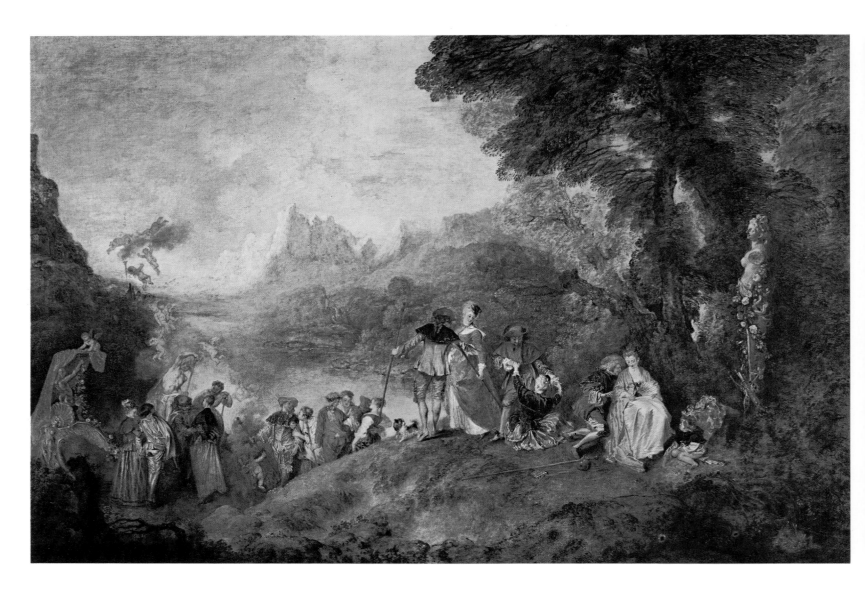

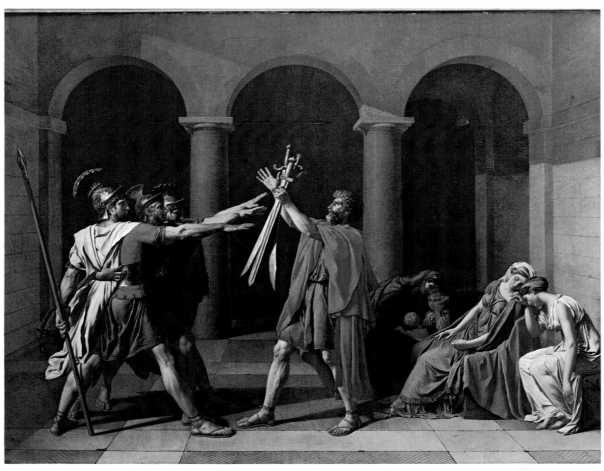

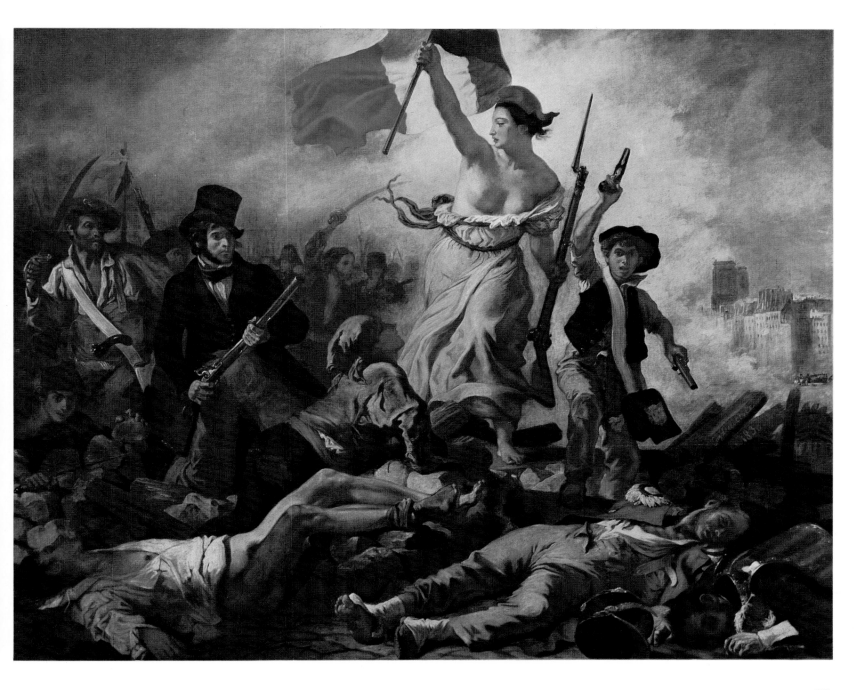

62
The Oath of the Horatii
1785
Jacques Louis David 1748—1825
Louvre, Paris

63
Liberty Leading the People
1830
Eugène Delacroix 1798—1863
Louvre, Paris

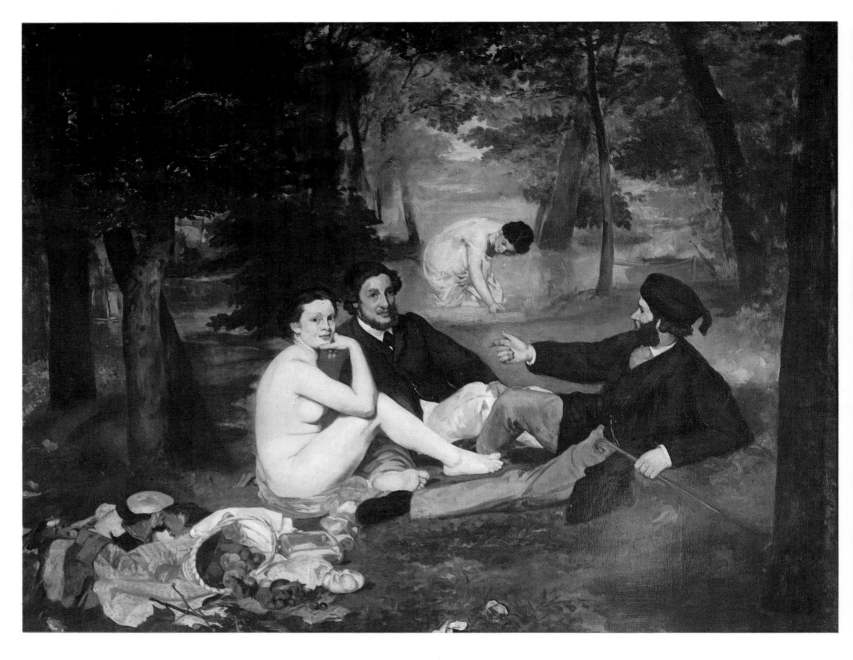

theatre Watteau conjured up an ideal existence in an idyllic setting, and this sense of make-believe permeates all his pictures. No painting is more typical of his style than *The Embarkation from Cythera* (in Classical mythology the island of love). In it he catches attitudes of relaxation, graceful detachment and nonchalance, poses that indicate whispered secrets, fond confessions, groundless anticipations and aimless departures and the feeling of the transitoriness of pleasure. Here, in an atmosphere of acute nostalgia, his characters snatch at the fading moments before they leave the enchanted island. They form a sinuous garland over the undulating hillocks and convey their inner thoughts by means of graceful gestures. No master in all 18th-century art painted with greater feeling for the delicate nuances of colour and line than did Watteau, and the Neo-Classicism of David comes with as much of a stylistic shock as did the physical one of the French Revolution to the court at Versailles.

Neo-Classicism was a movement of the late 18th and early 19th centuries which aimed to purify and redefine a classical style. The changed climate, with the preference for realistic and committed pictures of historical incidents, generally Greek or Roman, might be most obvious in France, but history painting was a growing preoccupation with artists all over Europe. David was an enthusiastic supporter of the French Revolution and consequently in revolt against the French 18th-century tradition of painting which to him symbolised the frivolity of the *ancien régime*. He wanted to invigorate an art which, in his opinion, was emasculated by convention and over-deferent to patrons' tastes. He believed that art was a public servant and could make deliberate, moral and political statements. *The Oath of the Horatii* is the supreme picture of revolutionary action and republican virtue, not only in its subject but in its treatment too. It was intended as a call to contemporary sacrifice of all private interest in the cause of revolution. It depicts an incident from Roman history when three brothers swear before their swords to fight until death to defend their city against the enemy; they spare no thought for themselves or their family, symbolised by the group of grieving women on the right. The figures are sharply defined as is the drapery, and no distracting detail detracts from the solemnity of the event. At a stroke David might be said to have abolished Rococo art and to have forged a propaganda weapon for the new republic of France.

Colour in art, which the Neo-Classicists had considered secondary to drawing, was for Delacroix the essence of

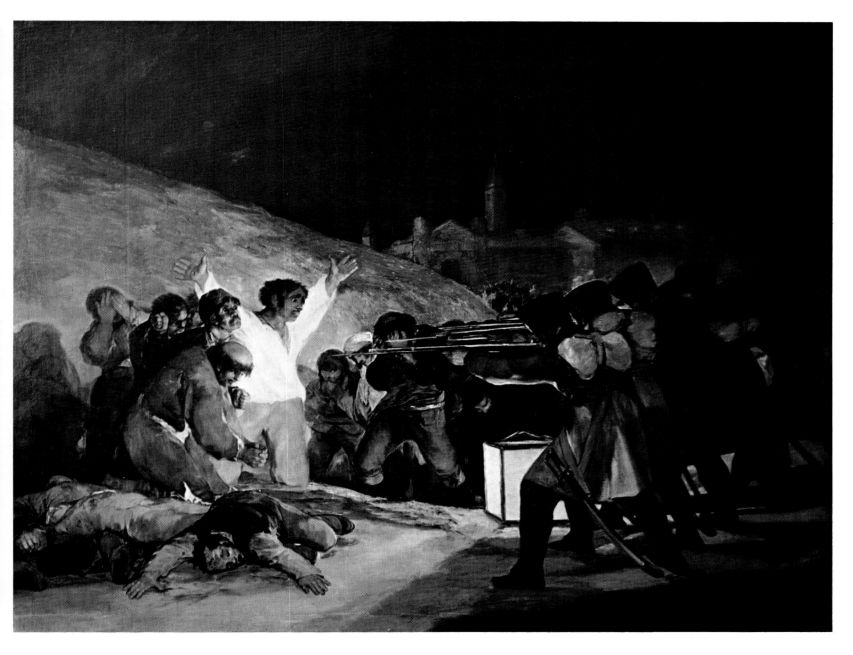

painting. In *Liberty Leading the People* the tragedy of suffering is felt in the depth of pulsating colour more than by the literal rendering of the scene. Although he began his vast canvases with the feeling that he was taking 'a road that had been cleaved by giants', he believed, and in fact proved by his own example, that it was possible to move forward from the point at which Titian and Rubens had left off. Although usually eschewing political subjects, the Revolution of July 1830 moved Delacroix to paint his *Liberty*, a picture which is at once an incident from contemporary life and the embodiment of an ideal. It is an allegory of liberty, liberty for the people and, perhaps, liberty for art.

Giorgione and Titian were the first artists since antiquity to paint a nude figure in a landscape setting. The subject represented an Arcadian ideal derived from the poetry of Ovid and Virgil and the myths of the Golden Age, where man is at one with nature, and perhaps more important, at one with himself.

In 1862 Manet announced his intention of painting a modern version of Giorgione's *Concert champêtre*. *Le Déjeuner sur l'herbe* shows a female nude seated in a grove in the company of two men in contemporary dress. The theme harks back to Giorgione and the pose of the group in the fore-

64
Le Déjeuner sur l'herbe
(Luncheon on the grass)
1862—63
Edouard Manet 1832—83
Louvre, Paris

65
The Executions of the Third of May
1814
Francisco de Goya 1746—1828
Prado, Madrid

ground has been taken directly from an engraving after Raphael. Nevertheless when Manet first exhibited the painting the public and critics were outraged, in spite of the subject's classical lineage. That Manet used nudes in his picture has been claimed as a sort of joke against academism but in fact it was an acceptance of its value. But it was not only the subject that was considered outrageous, it was the treatment too. Instead of the smooth, sleek surface and carefully defined forms found in the work of David and Ingres, the colours are laid on in broad flat areas with scarcely any modelling, and the brushwork seems rough and crude. Although the painting is largely unsuccessful in that it hardly

85

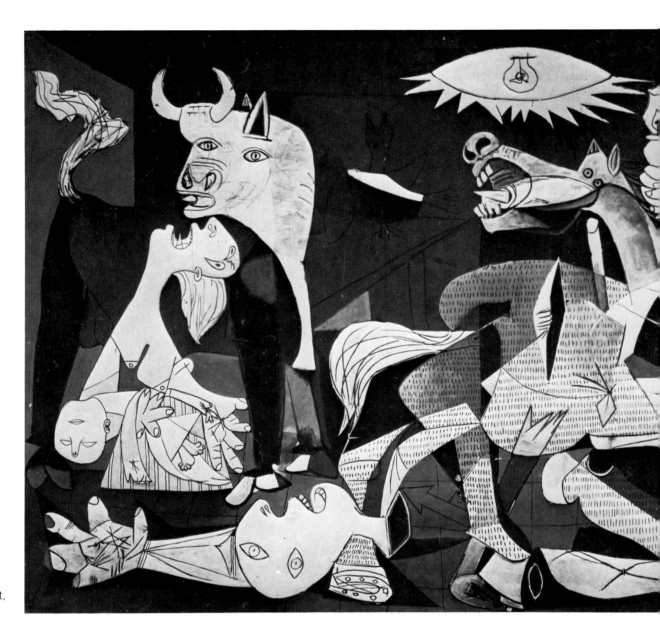

66
Guernica
1937
Pablo Picasso 1881–1973
oil on canvas,
11 ft 6 in × 25 ft 8 in
On extended loan to
The Museum of Modern Art,
New York

suggests the light and atmosphere of the open air which Manet intended and there are awkward differences in the scale of the landscape and the figures, it was nevertheless a bold attempt to re-evaluate the work of the Old Masters. The bold technique and manner of painting what the eye sees rather than what the mind knows to be there was important for the later development of Impressionism. The fact it raised a storm of protest is of no special significance in its understanding, but it shows the increasing gulf that was developing between the artist and a public with mixed and contradictory opinions about art.

To express his revolutionary fervour David illustrated a scene from ancient history, Delacroix used a semi-allegorical theme, but Goya expressed his feelings about the nature of war and revolution with contemporary and absolute realism. Realism, as is seen in portraits by Velasquez and Goya, is a characteristic of Spanish painting and it is never used to better effect than in Goya's *The Executions of the Third of May, 1808.* The events of the third of May were a result of a rising the day before by the Spanish people, infuriated by their own terrified and selfish rulers, against Napoleon whose armies had invaded their country. The rising was suppressed with horrifying brutality, and the following day reprisals and executions were carried out. This event aroused Goya's

passion and it is this passion which gave form to his masterpiece. He had learnt much of his mastery of technique, light and colour from Velasquez, but whatever he may have learned from the past he was a man involved in the present and concerned for the future. The scene is lit by a lantern on the ground so that the light is low down as if on a stage. It throws its beam directly onto the terrified, crucifixion-like figure about to receive the stigmata of rebellion. This is to be administered by the anonymous line of soldiers, the blind machine crushing human values. The merciless conformity and repetition of the faceless line of the military clearly symbolises the anonymous enemy, as it is strongly contrasted with the highly individual representation of the victims. This is a heroic picture in the noblest sense of the word. Goya makes a precise statement with clear intentions.

Like Goya, Picasso, another Spaniard, made no compromise when expressing his disgust at man's inhumanity to man, and he painted with the same passion and conviction. The Civil War in Spain aroused the deepest feelings in Picasso, and *Guernica* is a proof, if one were needed, that he was a socially conscious artist. He believed that the artist, like anyone else, is a political being constantly alive to contemporary events. Painting, he once said, 'is not done to decorate apartments but is an instrument of war for attack

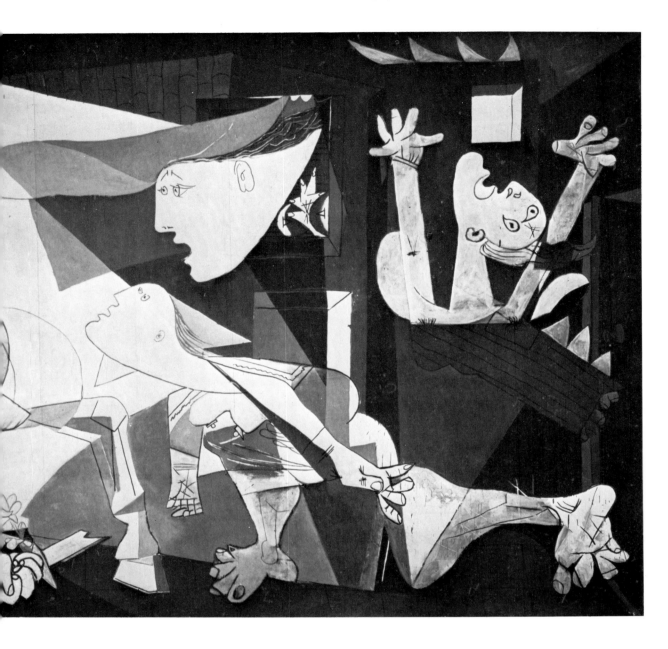

and defence against the enemy', and the 'enemy' is the man who exploits his fellow human beings from motives of self-interest and profit. *Guernica* was painted as an immediate reaction to the news of the destruction by German bombers of the Basque town of Guernica on 28th April, 1937. The tragic nature of the subject is immediately apparent in the sombre tones of the painting: black, white and grey. The images of violence are Picasso's own, developed over many years, and derive in part from the world of the bullfight. Stricken women and a screaming horse are shut in a room from which there seems to be no escape, and over the figure of a mother carrying her dead child looms a bull, symbol of brutality and violence. The distorted, fragmented forms to which humanity is reduced, and the overcrowded and confined space lit only by a naked light bulb and a feeble candle, emphasise the terror aroused by the enemy in the sky, from whom they can find no refuge.

Together with the Spanish, Russian, German and other foreign artists who came to Paris in the early years of the 20th-century and evolved such modern movements as Fauvism, Expressionism and Cubism were the young Mexicans who were to play a momentous part in the cultural renaissance of their country. One such artist was Diego Rivera, who worked in a Cubist style until the political events in Mexico, in particular the Revolution of 1910, turned his attention towards social issues and convinced him of the necessity for a national and revolutionary art. Back in his own country, he and a number of other artists formed a syndicate to co-operate with the government in decorating public buildings. Rivera's murals, with their strongly outlined, solid yet stylised figures and vivid colours, show a heroic view of Mexico's native heritage and the country's future. Yet the poetic and imaginative treatment of the revolutionary subject-matter saves these murals from being merely propaganda, unlike much socialist art.

A British official war artist in both World Wars, Paul Nash has painted with passionate vehemence the full range of emotions aroused in him by collective violence and destruction. In *Totes Meer* (Dead Sea), painted in 1940, a frozen dead sea of shattered, twisted wreckage of German aircraft lies under a pitiless moon and by the contrast of the peaceful, delicate landscape on the horizon, the artist imaginatively expresses his horror at the way in which war distorts and devastates.

The gods and heroes of the 20th century are very different from those found at the beginning of this chapter but as long as men have ideals there will be artists to translate them into paint.

67
The Conquest of Mexico
1931
Diego Rivera 1886—1957
Cortez's Palace,
Cuernavaca, Mexico

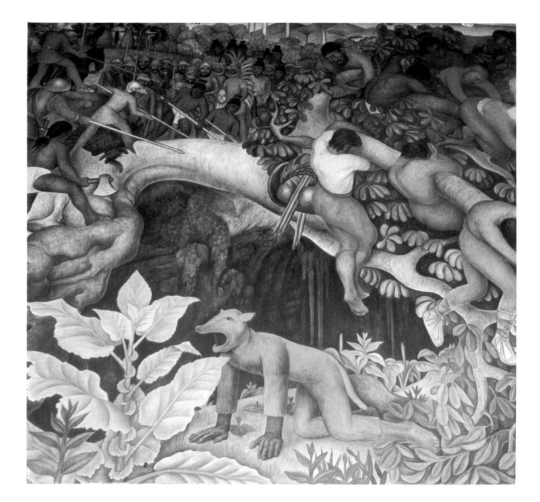

68
Totes Meer (Dead Sea)
1940—41
Paul Nash 1889—1946
Tate Gallery, London

Everyday Life

Although we can sometimes detect homely touches of everyday life in the background of paintings of the Italian Renaissance, it was in northern Europe that such genre and still-life scenes became popular in their own right.

Everyone enjoys eating and the feast theme seems to interest artists too, from the elaborate feast by Veronese (see plate 9), to Bruegel's *Wedding Feast* and Hals' Haarlem militia celebration (see plate 25). In the scene by Bruegel what looks like an unappetising gruel is being handed round to satisfy rustic greed, but the colour, the movement in an organised yet crowded space, and amusing details make the spectator's enjoyment complete. Bruegel expresses more of the quality of humble affection in his paintings than any other artist. He is rollicking but never flamboyant. He gives his evidence with an unswerving respect for truth but he gives it with bucolic relish. It is activity that excites him — children at play, peasants dancing, farmers at work. The seasonal ritual of the celebration of the harvest, planting time and marriage are focal points revealing the zest for life common to all people, and Bruegel painted them more explicitly and with greater assurance than any other artist.

Having won its centuries' long conflict first with foreign powers and then against the encroaching sea, Holland in the late 16th century set about enjoying its freedom and prosperity. In the bare Protestant churches there was no call for showy altarpieces or religious paintings, so Dutch painting functioned outside the orbit of the Church. As a result, ordinary life was the theme of a whole range of pictures unparalleled elsewhere, though a hint of it is apparent as early as Van Eyck's Arnolfini portrait where the room and the objects in it are painted with as much care as the couple themselves. With de Hooch and Vermeer the art of genre flowered in profuse response to the needs of a rich and energetic middle class Protestant society.

De Hooch painted small pictures which were to decorate small rooms and these small rooms also appear in his pictures. He chose an interior with two or three figures engaged in some household task and then concerned himself with expressing the fall of sunlight on the various surfaces. His favourite effect was that of a dark foreground with an open door leading through into a second area which is brightly lit. Sometimes the outside sun was merely suggested as it crept along the tiled passages, past the curtains or through the half-open shutters. In *The Boy Bringing Pomegranates* there is the usual tiled floor and open doors which draw the eye right into the far reaches of the picture. The light pours in, flooding the room and permeating every corner of it. There is nothing monumental or of particularly profound significance about the picture but a great deal that is quietly human. The chief interest is the way in which de Hooch gives the feel of the interior. The bright light coming through the windows emphasises, by contrast, the dimmer light inside, and this gives a living impression of an air-filled space. The colours de Hooch uses are warm browns, reds and yellows. No hurry or rush is expressed in these quiet scenes of domestic life; everything is in order and everything has its place.

Vermeer seemed to crystallise everything that had gone before in Dutch art, yet in his whole career he produced only about forty known works. His paintings are quiet, unconcerned with narrative or social events, and twenty of the pictures contain only one figure. A sense of silence and remoteness pervades all of them as Vermeer gave an emotional detachment to his figures and stripped their world of non-essentials. His backgrounds are always flat, unlike de Hooch's, and his careful selection and placing of his subject-matter gives his compositions an almost abstract formality. A figure, usually a woman, is doing some household task, or reading or writing. In the *Young Woman Reading a Letter* the figure is seen against the flat wall which is broken by a map and by silhouetted objects in the foreground. Vermeer did not search for new or startling pictorial effects but simply gave the feel of a room flooded with light. It is his supreme mastery of light as an actual presence in his pictures which makes Vermeer's work so extraordinarily beautiful. He makes us feel its movement and loved to show it passing over a white wall or a slightly crinkled map, resting for a moment on the figure which is treated almost as a still-life, and picking up details such as a pearl necklace on a table. Following a particular interest in the new science of optics, Vermeer took into account the normal processes of seeing and in his

69
Wedding Feast
about 1567
Peter Brueghel the Elder 1525/30—69
Kunsthistorisches Museum, Vienna

<div align="right">

70
The Boy Bringing Pomegranates
1664—65
Pieter de Hooch 1629— after 84
Wallace Collection, London

</div>

paintings presented nothing that deviated from ordinary perception. The result is a heightened reality not only of light and colour but of fabric textures, cool linen and the weight and density of wood and parchment. As with Georges de la Tour (see plate 14), all of Vermeer's works offer a uniquely precious experience through a far from simple simplicity.

Taking advantage of the taste for Dutch and Flemish still-life in France in the early 18th century, Chardin was one of the few artists to paint everyday subjects in the age of Boucher and artificial court art. He translated the themes which the Dutch treated so well into a French idiom and painted simple objects with a consummate skill and dignity. However, there was a difference in spirit between the two as the Dutch pictures deliberately reflect a philosophy, a way of life, whereas Chardin sheds no real light on French 18th-century attitudes. His pictures are masterpieces of arrangement, and no one has ever had surer taste in colour. At first sight, a Chardin painting is apt to give an impression that the painter's only concern was to faithfully represent what he saw before him. Actually he was a most skilful and subtle colourist and gifted with a rare ability for painting effects of texture. In *Le*

Bénédicité (The Grace) the luscious creamy whites, tender pinks, shining brass and the delicate grey shadows of the background make a contrast and harmony between textures and colours. In the terms of Watteau, Chardin never painted a love scene but he painted things he loved.

In France, on the death of Louis XV, a gay and amorous society emerged from a ceremonious one. 'The quintessence of the agreeable' was its aim and as a result, everything was subject to the taste for ornamentation and coquetry; prettiness was its symbol. Fragonard expressed the spirit of the age in his pictures of refined elegance and delicate voluptuousness, and became the representative of this society dedicated to pleasure. He displayed all the wit, buoyancy and easy accomplishment of the French manner, and his outdoor scenes were laid in the shadow of those arched structures, low vaults or arcaded alleys which provided the region of Provence with shade and coolness. Following a pastoral life was a new game for the aristocracy, and duchesses were to be seen performing the parts of shepherdesses in mock country cottages, and playing blind man's buff in rural country settings.

Dainty maidens of the privileged class were also pictured

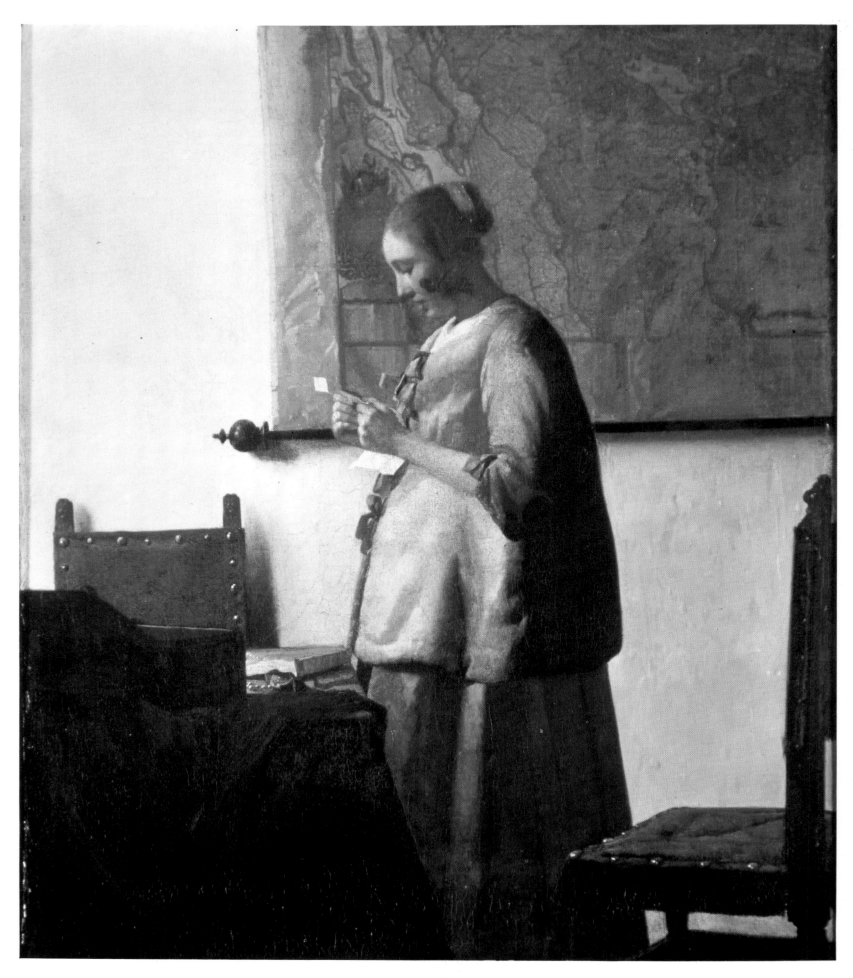

71
Young Woman Reading a Letter
about 1665
Jan Vermeer 1632—75
Rijkmuseum, Amsterdam

72
Le Bénédicité (The Grace)
1740
Jean Baptiste Siméon Chardin 1699—1779
Louvre, Paris

73
Blind Man's Buff
about 1775
Jean-Honoré Fragonard 1732—1806
National Gallery of Art, Washington
(Samuel H. Kress Collection)

74
The Swing
about 1810
School of Kāngrā
Victoria and Albert Museum,
London

enjoying themselves thousands of miles away in India. In a scene every bit as charming as that evoked by Fragonard, this Rajput painting of the Kāngrā school uses brilliant colour, a marvellous decorative treatment especially in the flowers, and a flowing sense of movement. The Westerner, first plunging into the study of Indian art, is likely to feel a vague sense of strangeness and aesthetic uneasiness as the new world of forms and references are unfamiliar. Indian art has remained essentially religious and its iconography is as complicated as any other. However, the native folk art expressed the pleasures of the earth, and religion was replaced by a heaven on earth of flowers, palaces and beautiful women.

And how were they passing the time of day in England? In Victorian times the 'picture with a story' (which in fact meant a strong moral) spoke particularly to the condition of the age. Respectability was the keynote of paintings at this time and contained warnings of any falling from grace. It was a boom time financially for the painters, as dealers were beginning to promote the work of living artists, and the main source of profit lay in the copyright of each painting for reproduction purposes. The improved technique of steel-engraving now made it possible to publish editions running into thousands, and no doubt every home would want a copy of the salutary tale told in Egg's *Past and Present 1*, the first of three pictures illustrating the downfall of an unfaithful wife. The wife is confronted by her husband with evidence in a letter of her infidelity. He sits hurt and grim, and she is stretched on the floor sobbing. The apple (Eve's?) which she has been peeling lies half on the table, half on the floor where in her confusion she has dropped it. The little girls are building a flimsy house of cards, the elder one looking frightened and wide-eyed at her parents. The pictures on the wall are of 'The Fall' on the left, and on the right a painting of 'The Abandoned' being ship-wrecked. Under each hangs a portrait, the man's under the ship and the woman's under 'The Fall'.

A subject that immediately springs to mind at the mention of the name of Degas is the ballet. Degas often turned to this aspect of contemporary life because it provided so many opportunities to study the human body in action. Although he exhibited with the Impressionists, Degas' technique and aims were different. He never allowed himself to be regarded as an Impressionist, and did not share their preoccupation with landscape and the study of light. The originality of Monet lies in his technical method; Degas' originality lies in his idea of how human activity and behaviour, which were the focus of his art, should be seen by an artist of modern sensibility, and all his models are depicted in energetic poses of some kind, whether dancing, riding or washing clothes.

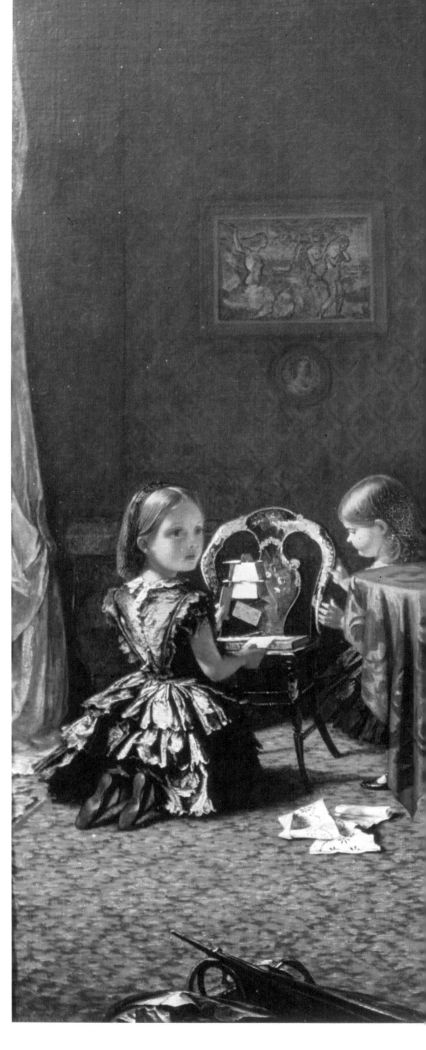

75
Past and Present 1
1858
Augustus Egg 1816–63
Tate Gallery, London

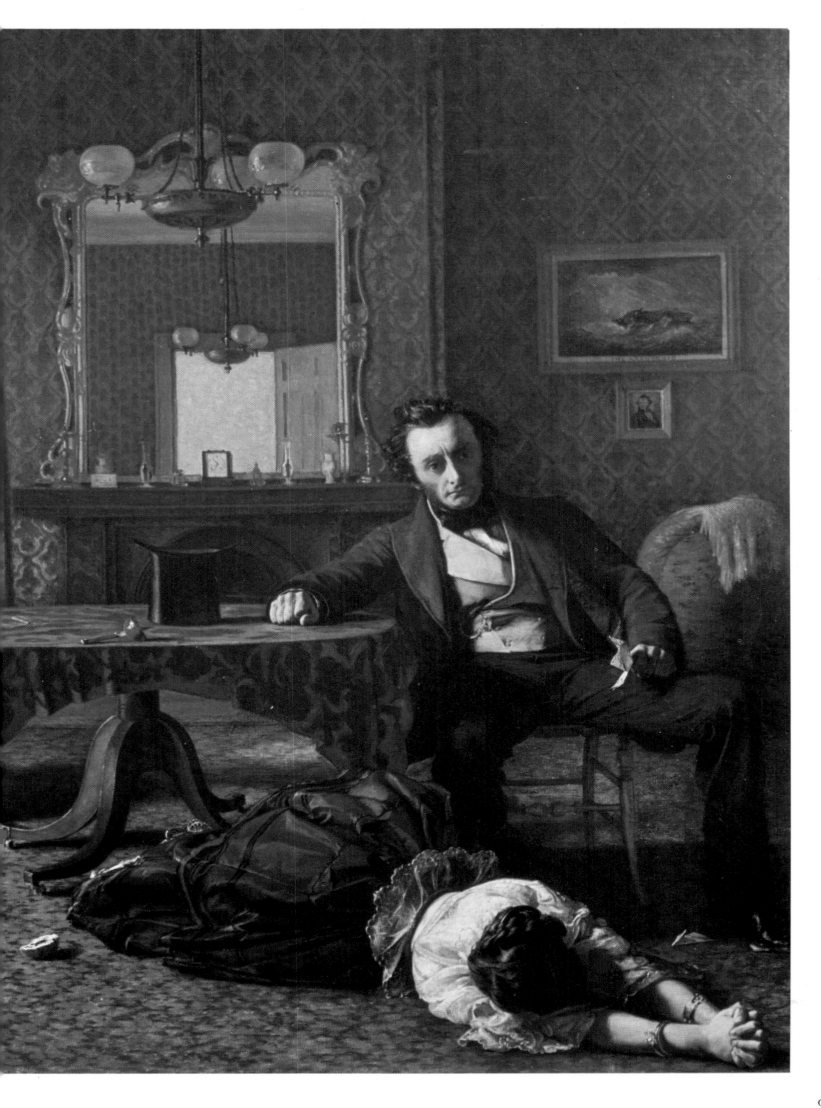

He also chose to depict scenes from odd, unexpected angles, which gives the feeling that the action is actually taking place before our eyes rather than having been organised and then presented to us by the artist. For example, look where he places the frame of his painting. The figures on the left of *Répétition de ballet* seem to be curiously crowded, as if they can hardly get into the picture, whereas the dancer on the right is fairly isolated. In this Degas suggests the spontaneous quality of a snapshot, and he was certainly influenced by photography. But the informal, life-like elements of his designs are always ordered into a perfect composition, recalling his statement that 'a picture is something which requires as much knavery, trickery and deceit as the perpetration of a crime'.

La Grenouillère was a popular restaurant and bathing establishment on a small branch of the Seine between Chatou and Bougival not far from Paris. In the 1800s, it was frequented by a crowd of artists, students, boatmen and pretty girls who came on Sundays and holidays to dance and swim. 'It was a never-ending party, and what a jumble of social sets!', Renoir later told his dealer Vollard. *The Boatmen's Luncheon* was the crowing achievement of a long series of pictures, studies and sketches made by Renoir on many visits there. In the painting he set out to capture colour and light. His treatment is lyrical and imaginative, and in his use of broken colour he suggests the vivacity and movement of sunlight as it breaks through the awning and dapples the faces and figures of the young people enjoying themselves in the open air. It was a very personal picture for Renoir, as many of his closest friends are seen in it and the pretty young girl with the dog was to be his wife. Renoir was always more interested in people than landscape, appreciating their sensuality, and sensitive to the reality of human relationships in his pictures of contemporary society. Jean Renoir in his delightful biography of his father describes his visit to the picnic spots years later. 'The boatmen, the carefree young girls have all disappeared from this part of the river. They live now, for eternity, in the imagination of those who love painting and dream of days gone by as they gaze at *The Boatmen's Luncheon.*'

Cézanne was one of the first modern painters to make still-life a major theme in his work and he treated it with such seriousness that these paintings rank among his greatest achievements. *Still-life with Apples and Oranges* shows a series of round objects set off by the horizontal lines of the table edge and the elaborate cloth behind. The composition becomes a contrast between three-dimensional round figures and two-dimensional straight lines; the simple household objects are treated to the rigorous principles of geometry.

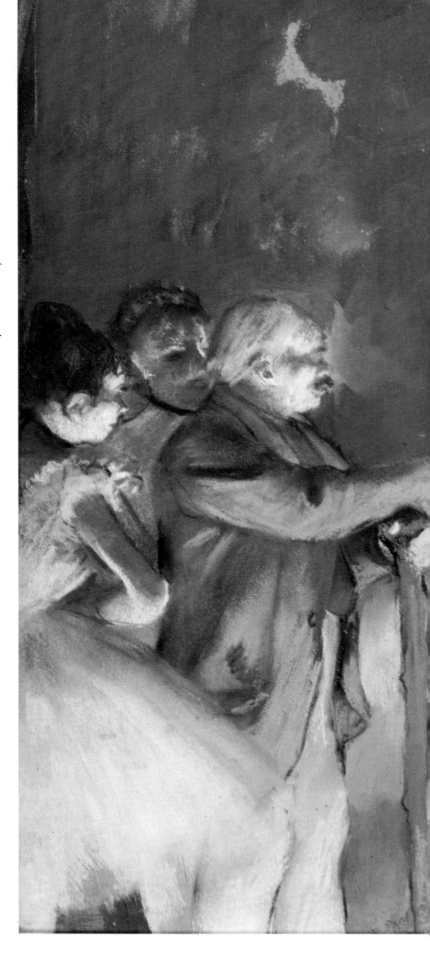

76
**Répétition de ballet
(The ballet rehearsal)**
1875
Edgar Degas 1834—1917
G. Frelinghuysen Collection, New York

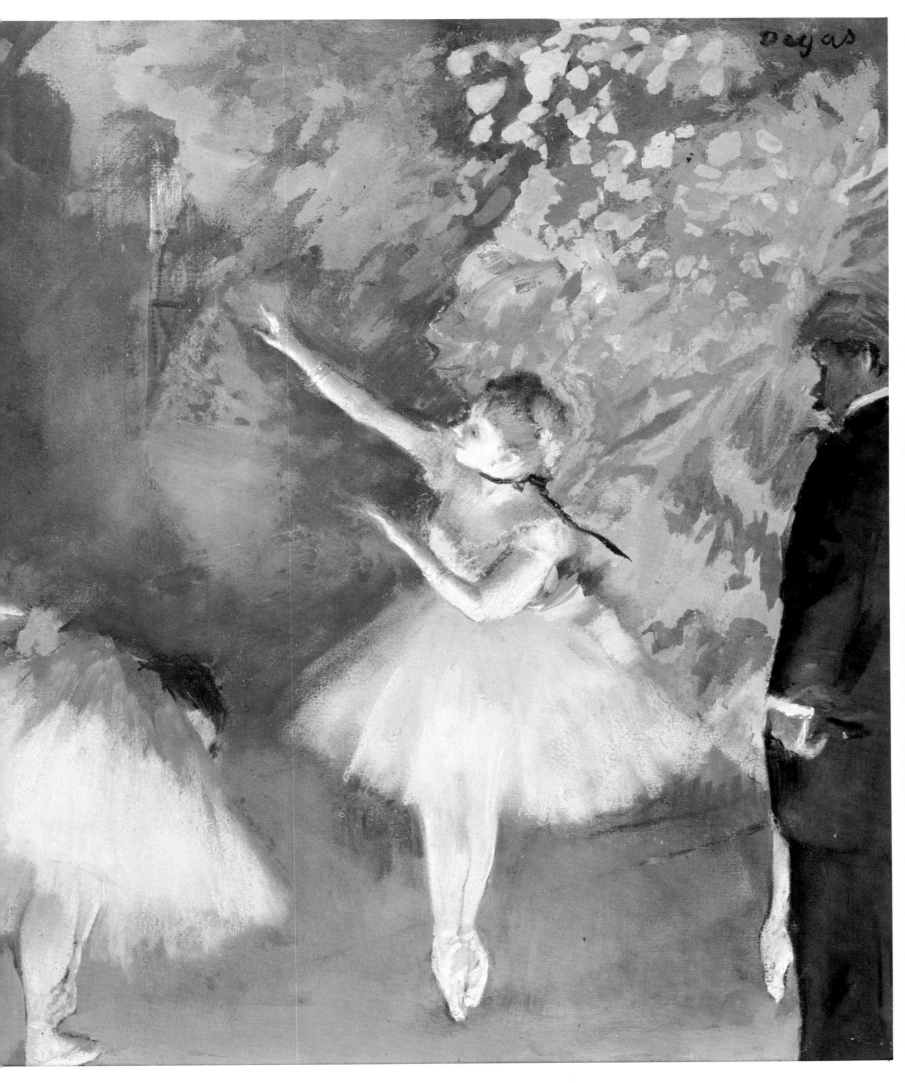

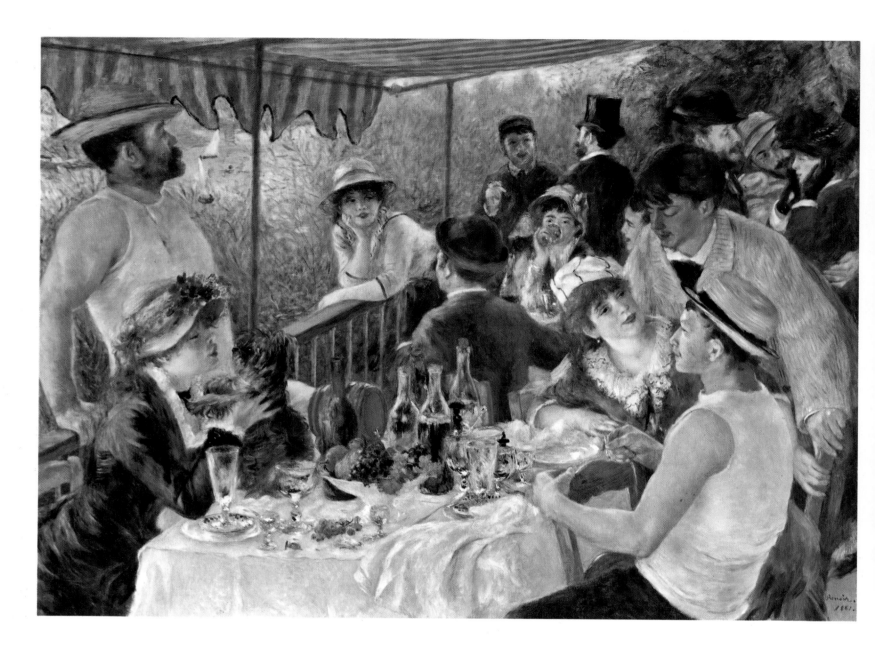

The apples and oranges seem to press on one another with a force unknown in nature, and the white napkin is modelled with the enduring solidity of Mont Sainte-Victoire (see plate 48) In contrast to the groundward thrust of the fruit are the baroque curling forms of the patterned jug and background. The picture is remarkable in its brilliance of colour and in the voluptuousness of its forms.

Cézanne once said that painting was merely a pretext for a game with lines and colours and Matisse makes it just that in his *The Dessert, Harmony in Red.* Matisse was also deeply influenced by Cézanne's belief that structure is given to a painting by the considered relationship of its constituent colours, and he shared Cézanne's ambition to reveal structural harmony while maintaining the purity of colours and not splitting them up in the way of the Impressionists. The choice of colours depended on what colour he felt best fitted his sensations, and were not necessarily those of nature. But Matisse was not only a remarkable colourist, he was also a master who simplified his subject into a dynamic form and design. In *The Dessert,* the vigorous yet harmonious pattern on the tablecloth is continued on the wallpaper in the background. Into this pattern is incorporated the fruit, bowls

and decanters on the table without any feeling of unease. Moreover the view out of the window on the left is also treated in the same stylised and simplified way, and so does not disturb the harmony of the whole painting. In considering his method of expression Matisse emphasised the importance of order and clarity which he had appreciated in Cézanne. No one has exploited the potentialities of the artist's language with more joyful elegance than Matisse.

Cézanne's acceptance of the two-dimensional nature of the canvas has been responsible for one characteristic of much modern art: the abandonment of perspective and of the portrayal of volume in space. In about 1907 Pablo Picasso and the Frenchman Georges Braque started painting pictures in which objects are broken down into simple planes which are then placed side by side on the canvas, with little attempt at naturalistic representation. In Braque's *Bottle, Glass and Pipe* the objects are merely sketched in and so are reduced to their simplest two-dimensional forms. Little if any depth in space is suggested and some of the objects even merge into one another, for example the bottle and the doorway suggested by the architectural moulding. Nor are these simple household objects arranged one behind the other as

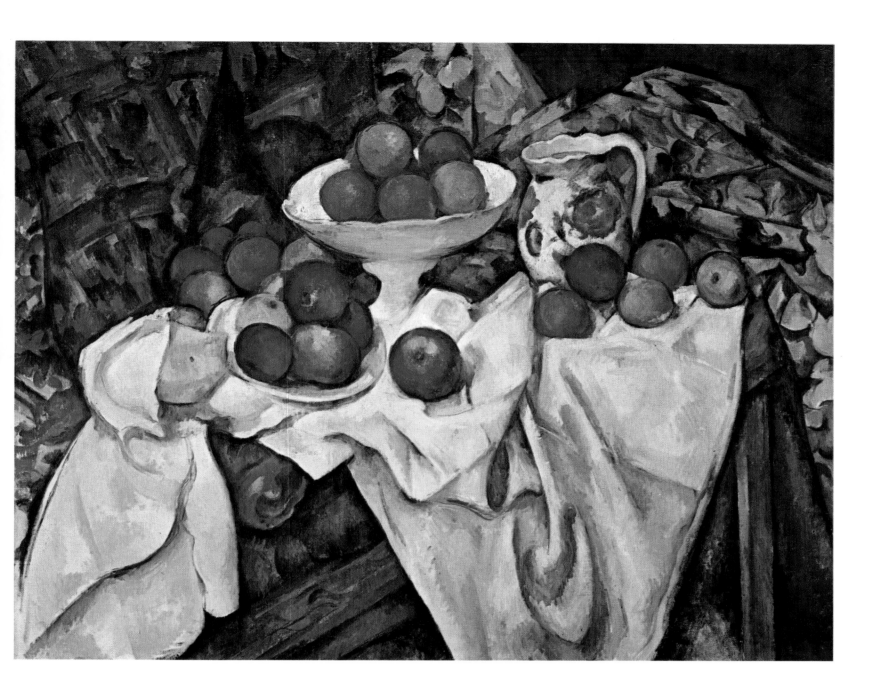

77
**The Boatmen's
Luncheon** 1881
1881
Pierre Auguste Renoir
1841–1919
Phillips Memorial
Gallery, Washington

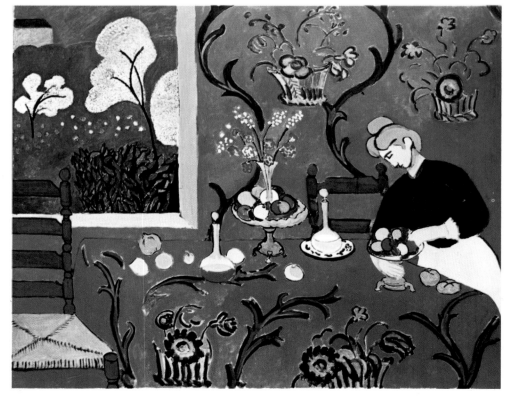

78
**Still-life with
Apples and Oranges**
1896–1900
Paul Cézanne 1839–1906
Louvre, Paris

79
**The Dessert,
Harmony in Red**
1908
Henri Matisse 1869–1954
State Hermitage Museum,
Leningrad

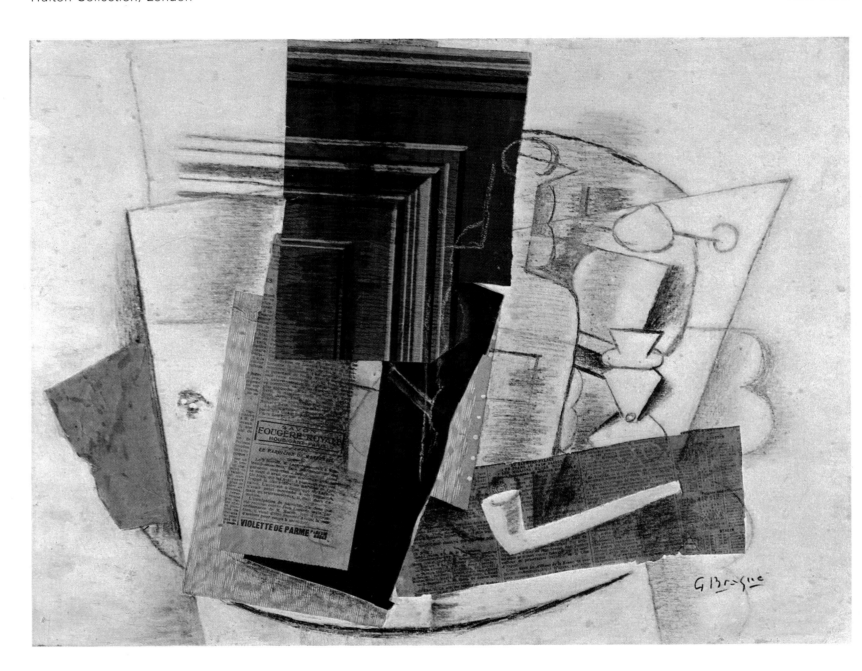

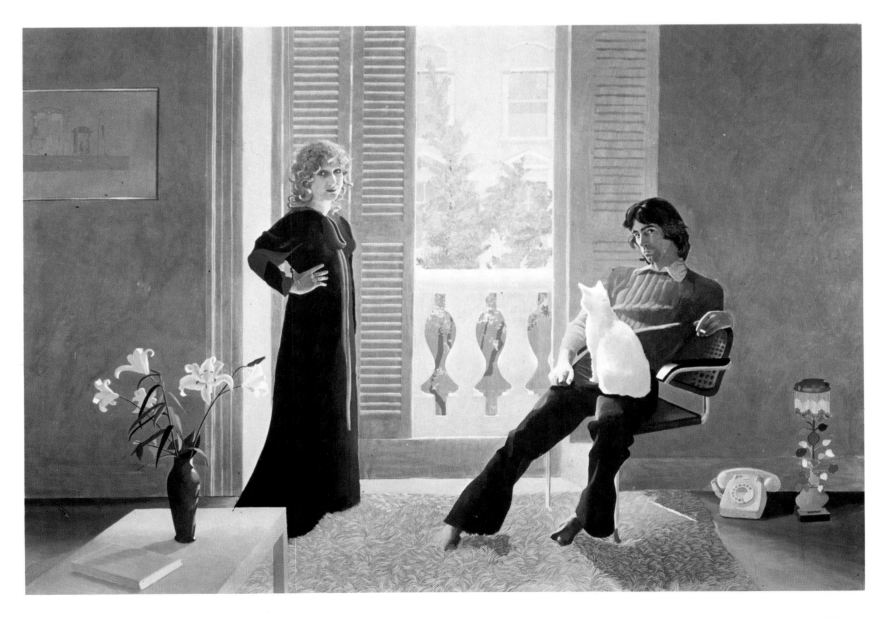

they might be in real life but seem to fan out from the centre of the canvas. These objects exist in infinite space and have no reference to anything beyond themselves. Whereas Matisse emphasised the surface of the canvas with his large areas of bold colour, Braque rejected colour in favour of two-dimensional line and form. Nevertheless this arrangement of lines and shapes creates an intriguing pattern.

Unlike Braque, who tied no object down to any one sort of reality, Warhol makes us conscious of everyday objects by their exact reproduction. His purpose in doing this is not merely to deceive the eye by his startling realism but to enlarge the eye's awareness of everyday things and to broaden our experience of our surroundings. He makes us look closer at things we take for granted such as a Coca-Cola bottle. 'That's not a work of art' we can say, but why shouldn't it be? A pot painted by Chardin, an apple painted by Cézanne is considered to be one, so perhaps a soft drinks bottle in our own age can deserve the same attention. The elegance and facility of line with which Warhol woos our senses are every bit as graceful as those used by any other artist. And if we do not at the same time smile at his audacity the joke is on us.

Crystalline reality is also found in David Hockney's extraordinarily appealing *Mr and Mrs Clark and Percy*. It is curiously reminiscent of the open vistas of de Hooch, and the interiors of Vermeer, in particular the flat walls broken by the gilt-edged frame of a picture or the sharp edge of a table, and the light pouring in through the open shutter. The figures, however, pose consciously for the occasion and even the cat, sitting prettily, shows its glossy white back with justified pride. Whereas the camera is now normally used to represent such a scene of domesticity, this picture, with its arresting but soft colours, graceful lines, carefully selected and placed objects and almost stagey lighting is a superb achievement in paint.

Whereas Hockney goes beyond the capabilities of a photograph, Ralph Goings is a 'photographic realist'. He takes as his subjects various everyday American settings, as seen by the eye of the camera, although the colours are not those that would be recorded by a camera. The technique of painting from photographs has given the artist the opportunity to remain true to his subject, as it is there in front of him as an unchanging, arrested moment in time. The arrangement of the elements in the picture, the advertisements, buildings, cars, roads, etc., and the reflections on the shiny surfaces, are flawlessly worked out. This flawlessness is unsettling but the style exactly captures our synthetic environment.

83
Hot Fudge Sundae
1972
Ralph Goings
Gallerie Ostergren, Sweden

Fantasy

The element of imagination is always present to a greater or lesser degree in a work of art, but the fantasy world of dreams and nightmares, fairies and monsters has always had a special appeal. This tendency can be seen from very early times, for example, in the monsters and fanciful creatures of Greek and Roman mythology, and the grotesque hybrid animals and figures which decorated the pages of the illuminated Bibles and other theological works in the Middle Ages. Fantasy is just as much a part of the human mind as reason. The extreme rationality of the Neo-Classic Age had its other side in the vogue for the mysterious, the macabre, the exotic and the terrifying which was to be given full rein in the next century in the Romantic Movement. In our own day of science and technology one of the most important and influential movements, Surrealism, started from the recognition of the validity of the images produced by the subconscious mind.

In 15th-century northern Europe the hardships of life were many. Wars were constant, barbarities abounded, and religion was more concerned with Hell and damnation than hope and resurrection. Hieronymus Bosch died over 450 years ago but his largest painting, known as *The Garden of Earthly Delights*, has remained for nearly five centuries the world's supreme masterpiece of imaginative painting. Over seven feet high, nearly thirteen feet across, it arouses in an audience the kind of shocked fascination normally reserved for street accidents. It attracts and disconcerts. It is a painting which returns to trouble your dreams. The subject is Sin, more specifically the sins of the flesh, and the theme evolves over three panels. The first depicts the Garden of Eden and man's imminent fall, the large central one fulfils the prophecy laid down in the first panel and the final panel depicts the Hell which man, through his uncontrolled licentiousness, has brought on himself. Bosch is the artist *par excellence* of the late Middle Ages. The work of Van Eyck, a few generations earlier, had seemed to herald a new set of values – a delight in the world and its pleasures – but no ray of Renaissance optimism found its way through to Bosch. His work is pessimistic and his outlook almost hopeless. Disaster is treated as though it were man's inexorable fate, the only

possible alternative, the only escape from Hell, being a total denial of all worldly activities and pleasures. All the demonology of Bosch is harnessed to his moral purpose: to frighten men from satanic preoccupations towards a true religious life. The late Middle Ages were characterised by a rude contrast between professed ideals (of conduct, love, war, faith) and the extreme coarseness and corruption of life as it was actually lived. This contrast between an ideal world and the real one is a recurring theme in Bosch. Whereas earlier painters, in particular Van Eyck, were themselves courtiers and so inclined to view life from the vantage point of the court Bosch, a man of the Church, took a darker, more pessimistic view.

Henry Fuseli, Swiss by birth but who worked in England, was one artist of the late 18th century and early 19th who indulged his fancy for the thrills of the mysterious and the terrifying. His art is the antithesis of the calm rational work of Reynolds (see plate 29) and the charm of Gainsborough (see plate 30) who were his immediate predecessors. He explored the murky depths of fear and horror that lie in the imagination. He was fascinated by the subject of the nightmare and during his life many stories were told of how he would eat a hearty meal (some said even a plate of raw beef!) before he went to bed in order to improve his dreams. Nevertheless, compared with the work of his friend and contemporary Blake, his vision is somewhat prosaic. In *The Nightmare* a woman swoons as she dreams of an almost Gothic demon who crouches on her chest while a ghostly horse looks on. His work may be compared with the so-called Gothick novels of 'Monk' Lewis and Mrs Radcliffe which Jane Austen so amusingly parodied in *Northanger Abbey*.

Blake is, without doubt, the most individual of all English artists. He was a mystic from early childhood and his private visions left their stamp on much of his work. Art for him was a spiritual activity, and he was not so much a painter as a seer and poet who used visual means of recording his extraordinary imaginings. He was a rebel against the materialism of the 18th century, and the growth of the industrial towns was odious to him. He saw himself as a latter-day saint, consorting with archangels, removed from the material to a

84
The Garden of Earthly Delights
(Detail of right panel: Hell)
1510
Hieronymus Bosch about 1450—1516
Prado, Madrid

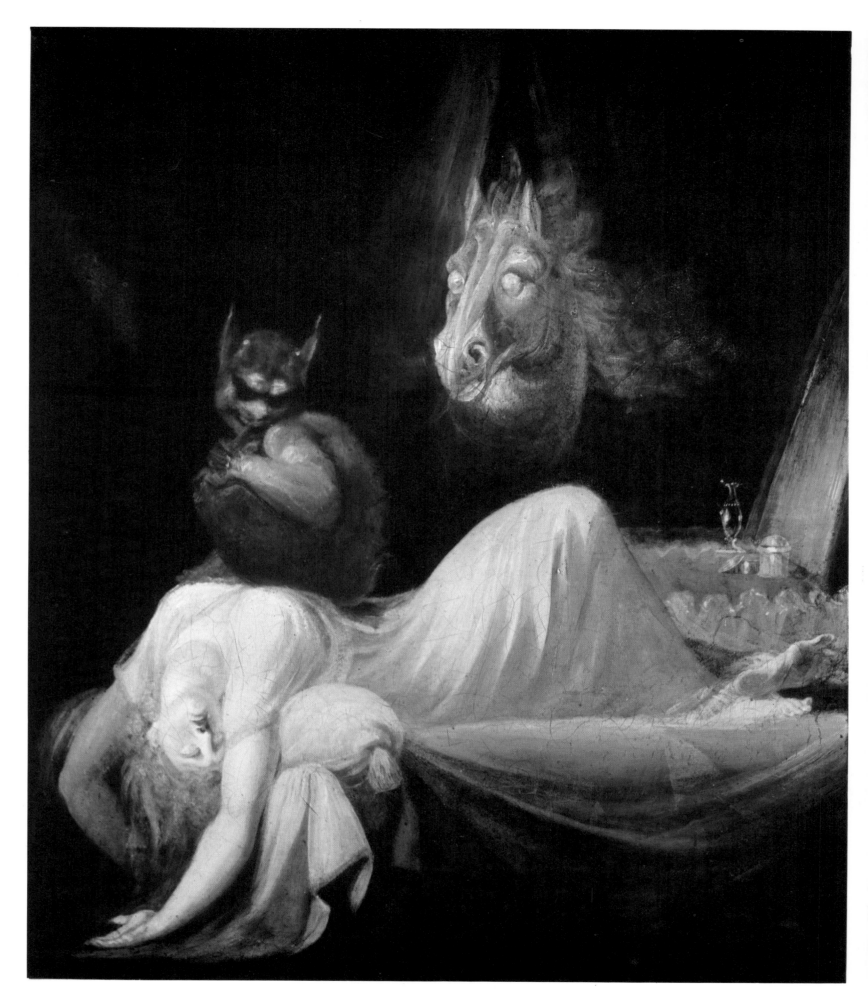

85
The Nightmare
1782
Henry Fuseli 1741—1825
Goethe Museum, Frankfurt

86
Nebuchadnezzar
1795
William Blake 1757—1827
Tate Gallery, London

more elevated world. Although he maintained that he saw in a vision every one of the figures he depicted in his paintings, and that his art was merely a transcription of what he saw, in fact he was influenced by medieval sculpture (Westminster Abbey) and engravings of the work of Michelangelo. The latter is certainly in evidence here in the heavy muscularity of the body of Nebuchadnezzar. He was also trained as an engraver and his work has the clarity of outline characteristic of a draughtsman.

At the same time as Blake was painting his visions, Goya in Spain was depicting the monsters and phantasmagoria that obsessed his waking dreams. All Goya's work is stamped by the successive crises of his life, each of which quickened powers beneath the threshold of his consciousness and speeded up his artistic development. The first shock was of a physical nature: the sudden loss of his hearing in 1792. Then, in 1808, came a disaster of a national order which shook Goya to the very core of his being and which he depicted in his masterpiece *The Executions of the Third of May* (see plate 65). From that time, apart from the official portraits, he also produced works which, he said, were 'to make observations for which commissioned works generally give no room and in which fantasy and invention have no limit'. The pessimism engendered by the events of the Peninsular War remained and became more intense as Goya pondered on the nature of man. How little he resembled the rational creature glorified by the philosophers of the Age of Enlightenment! Towards the end of his life he executed a series of paintings, known as the black paintings, of which *The Colossus* is typical. Perhaps the brutish monster who looms above the horizon symbolises the darker aspects of man's nature which had wreaked such havoc not so very long before, in the French Revolution and the Napoleonic Wars. It is almost monochrome in colour, a far cry from his portrait of the bejewelled and finely dressed royal family (see plate 34).

After examining the work of Bosch and Goya, it is refreshing to turn to the canvases of Henri Rousseau with their delightful candour and spontaneity. Rousseau was a French customs official, hence his nickname Le Douanier, and a completely untutored Sunday painter. He always said that he had served as a regimental bandsman in Mexico from 1861–67 and that the memory of the tropical jungles he had seen there had lasted a lifetime. But there is no evidence that he ever left France, and it seems more likely that he was inspired by the tropical plants at the local botanical gardens. He is best known for his jungle scenes, which are filled with strange and improbable trees and plants, and exotic wild beasts, like the tiger here. It is almost a child's idea of the jungle and its life, for the wild tiger bounding through the undergrowth, its teeth permanently bared, might almost be an illustration to a fairytale or children's adventure story. Rousseau's work has been alternately acclaimed and dismissed by critics. Do his naïve forms and distortions merely show incompetence or are they deliberate? The argument still goes on, but meanwhile we are free to enjoy Rousseau's highly imaginative, lively and decorative canvases.

Paul Klee has a very special place among the 20th-century artists who have explored the world of fantasy and imagination in their painting. He is one of the most unpretentious and original spirits in the modern movement. His paintings may look at first like doodles, but after a while many contradictory impressions arise. They seem to be at once childlike and profound, innocent and mysterious, sad and gay, fantastic and direct. *Fish Magic* is such a work. The beautiful fish surrounded by delicate flowers aim for the tantalising clock which is suspended from a taut line. Is it a trap? No one can analyse precisely the meaning of his paintings, but no one has linked more imaginatively than Klee the fine technique of the artist with the unconscious levels of human experience.

Chagall was born in Russia but travelled to Paris in 1910 where he met many of the avant-garde artists of the day: Picasso, Braque, Matisse and Derain. In *Self-portrait with Seven Fingers* the sharp lines and angles and the fragmented form of the artist derive from Cubism, but they have nothing to do with the analysis of form nor the rigorous intellectual art of Picasso and Braque. Somehow they seem to remove the figure from reality, and instead we have a glimpse of the fanciful mind of the artist. Chagall took to Paris a poetic vision of Russian life and folklore. Here we see the artist painting a folk or fairytale theme, while echoes of Russia can be seen in the domed church in the top right-hand corner, and of Paris in the Eiffel Tower in the left. Chagall has often been linked with the Surrealists but his paintings contain none of the disturbing elements, nor the wit, of Surrealism. Instead he paints elements from the world of the fairytale and legend with a rather child-like vision.

As stated at the beginning of this chapter Surrealism has been one of the most influential of all 20th-century art movements. The Surrealists differ from their predecessors in two important ways. Although the artists discussed previously relied on their imagination to provide them with subjects and images, all used the conscious mind to control and improve their art. The Surrealists, however, tried to portray images direct from the subconscious mind, no matter how bizarre. The work of most earlier artists reflected some aspect of the outside world; Bosch's painting, for example, made a moral statement which would have been understood immediately in the 16th century. Few artists painted fantasy for its own sake. But the Surrealists maintained that the images from the subconscious mind have far more relevance to our real existence than the traditional subject-matter of art.

The Belgian Surrealist, René Magritte, led an outwardly mundane life and he resented and deplored those commentators who read into his paintings a whole theory of symbols. He said he painted whatever image floated into his mind, and he worked in a bland, ordinary and often awkward manner. Why then is he one of the most significant, interesting and enthralling artists of the 20th century? Primarily because he was a painter of the recognisable impossibility, the paradox, the irrationality presented in a rational way and vice versa. The very lack of pretension about his aims and skills underlines the amazing capacity of his work to communicate his vision of his subconscious. His paintings give a sense of almost exquisite shock, as does *La Reproduction interdite* with its solemn depiction of a man looking into a mirror

87
The Colossus
about 1808—12
Francisco de Goya 1746—1828
Prado, Madrid

and seeing the reflection of his own back. Magritte is a rare artist who has succeeded in sharing his images of fantasy and showing he has something in common with all of us who have had dreams full of deserts and seashores, apples as big as a man, a comb as big as a wardrobe or boots with toes. His paintings are assaults on the scientific rationalism of 20th-century man to whom every odd event has a reasonable explanation.

Launching a style which he called 'paranoiac-critical' Dali began his excursion into a fantasy world which fascinates, repels, annoys, but never bores. His aim was to institute a permanent state of psychological disturbance by stepping up the artist's sensibility to fever pitch, and to promote a deliberate, systematic exploitation of 'objects functioning symbolically'. Dali shows great personal skill in using hallucinations, the vagaries of memory, and all the distortions of visual experience suggested by a close study of psychological aberrations and pathological disorders. By fixing your eye on any given object you induce a sort of hypnosis and this, to Dali's thinking, was a pointer for the artist. By concentrating on some object in the outside world he is able simultaneously to express the obsession it exercises on him and to liberate his subconscious from this obsession and the object itself from its normal connotation. Dali aims both to transcend and to exhaust the utmost possibilities of the real in a single operation.

A painter who was influenced by Surrealist ideas but who made a very personal and independent contribution to fantasy painting was the Spanish painter Joan Miró. His art is governed by a system of rhythms and harmonies which stem from his origins and native soil, and from his knowledge of primitive art. Over the years he developed a kind of short-hand in which simplified forms represented everyday objects. Eventually they no longer related to the real world but existed in their own right. He once said that in a painting a rich and robust theme should be present to give the spectator an immediate blow between the eyes before a second thought can interpose. In an early painting, *Carnival of the Harlequin*, a mad party is in full swing in the kitchen, with music and games and a number of rather more mysterious things going on. The painting zings with life, and the semi-abstract style enables Miró to include many amusing and whimsical anecdotes. More perhaps than any other modern artist Miró's paintings are an embodiment of youth and happy freedom, combining sophisticated design and gaiety of spirit.

The British painter Francis Bacon is above all an artist of the 20th century, concerned with portraying violence and mental anguish. He is preoccupied with man's inhumanity to man, and to all animal life, and is obsessed with the frailty

88
Tropical Storm with a Tiger
1891
Le Douanier Rousseau 1844—1910
National Gallery, London

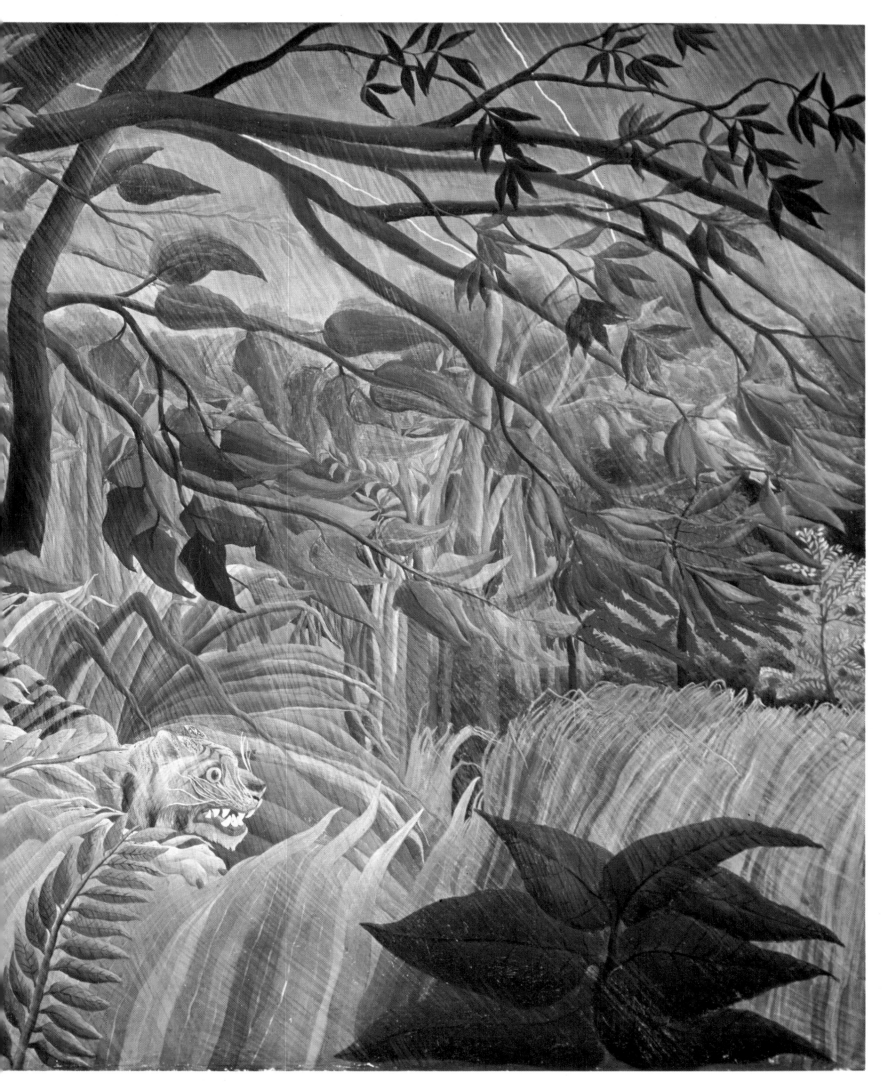

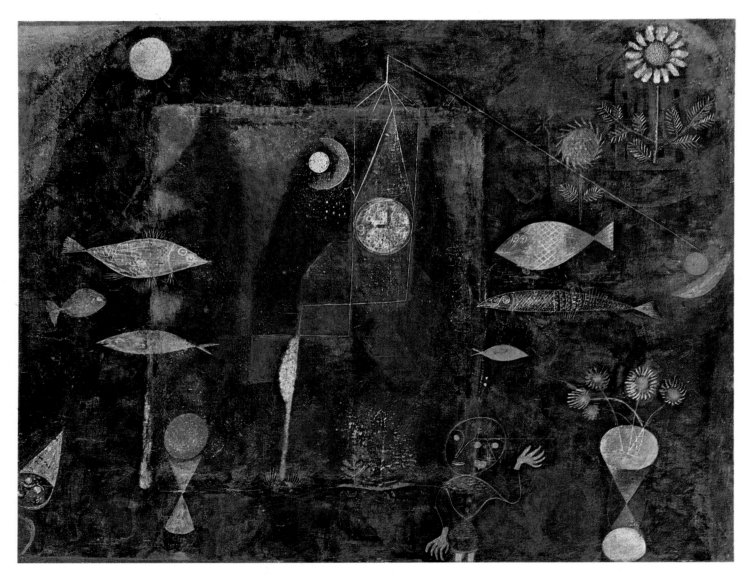

89
Fish Magic
1925
Paul Klee 1879—1940
Philadelphia Museum of Art
(Louise and Walter Arensberg Collection)

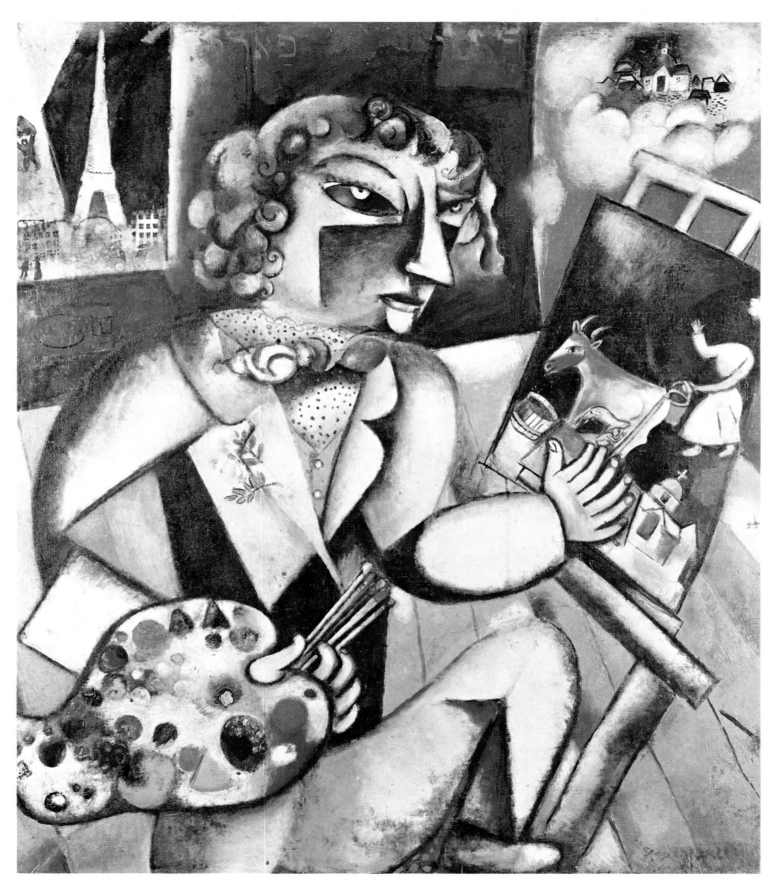

90
Self-portrait with Seven Fingers
1911
Marc Chagall 1887 –
Stedelijk Museum, Amsterdam

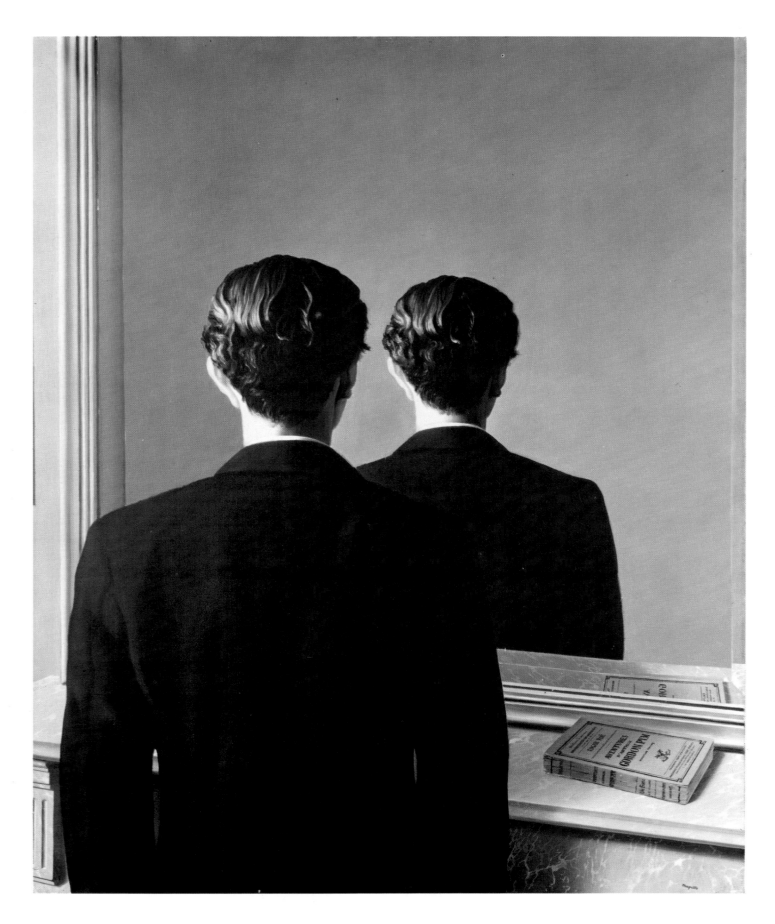

91
**La Reproduction interdite
(Reproduction forbidden)**
1937
René Magritte 1898—1967
Edward James Foundation, Sussex

92
The Persistence of Memory
1931
Salvador Dali 1904—
Museum of Modern Art, New York

93
The Carnival of the Harlequin
1924—25
Joan Miró 1893—
Albright-Knox Art Gallery, Buffalo, New York

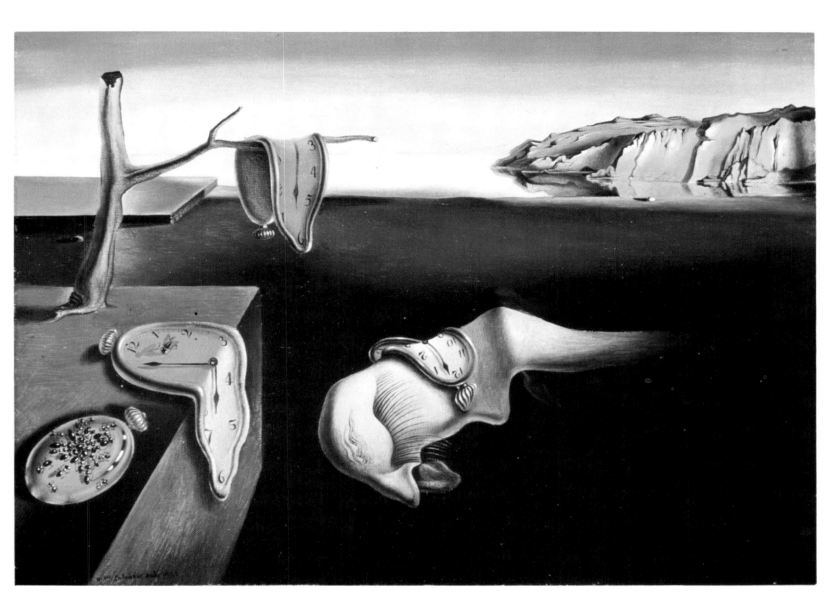

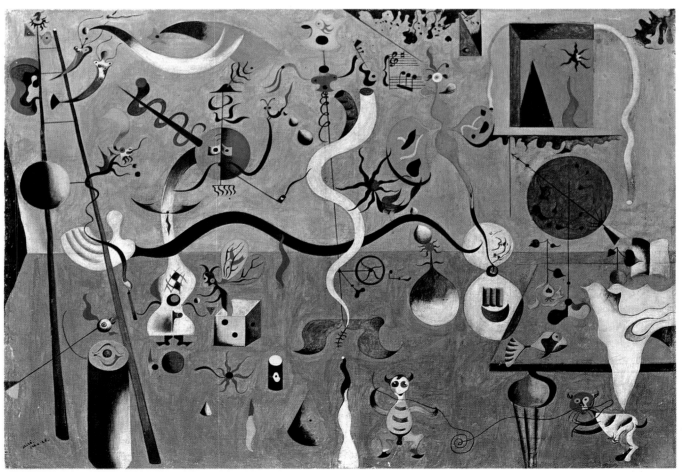

94
Study for Bullfight no. 1 1969
Francis Bacon 1909–, Royal College of Art, London

of the body, with how quickly a man or an animal can be reduced to a mass of pulpy flesh through physical or mental ill-treatment. Typical of Bacon's work, both in subject-matter and composition, is *Study for Bullfight no. 1*. The toreador and the bull are locked in a pointless combat in the centre of an arena. Absorbed in their struggle, their isolation from the rest of the world is symbolised by the blank areas of solid colour which surround them. The spectators, unable to help or stop the slaughter, seem to be seen through a glass wall in the background. A formless brown mass in the foreground is all that remains of the previous victim. Such is the skill with which Bacon evokes our horror and disgust that it raises the problem of the relationship between art and enjoyment. His paintings are strongly individual expressions and obviously make no compromise with what he is saying and a pleasurable response.

Abstract Painting

Every painting is an arrangement of lines, shapes and colours, because there is always a degree of selection, stylisation, refinement and simplification of the subject. No great painter has ever intended merely to imitate reality. In this century, many artists have felt that the very existence of a recognisable 'subject' detracts from the importance of the fundamental elements of a painting, the canvas and the paint, so they have discarded altogether the tradition of having a subject.

Without a subject to guide us, unless absolute proof is available as to what the artist had in mind when he created the picture, all we have to rely on are a few check list headings like use of colour, juxtaposition of masses, form if any, and our own personal response. Even then, as Ernst Gombrich warns us, 'response should not be mistaken for understanding'. This is perhaps what it is that makes looking at abstract painting such an adventure. Each of us has to

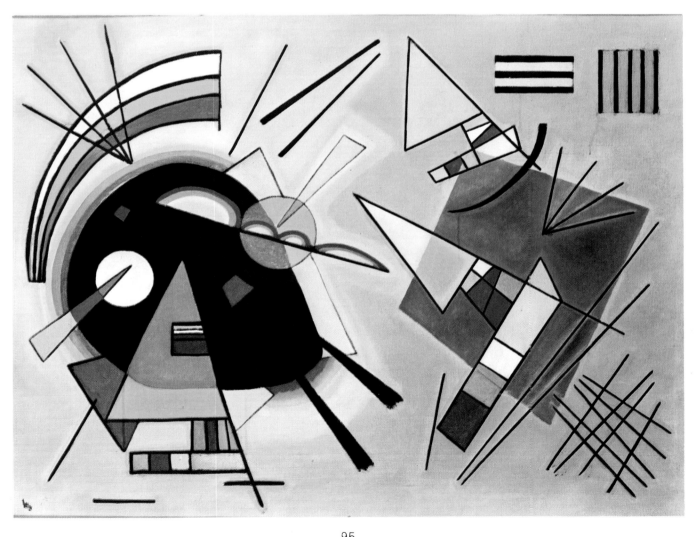

95
Black and Violet 1923
Wassily Kandinsky 1866—1944, Hans and Walter Bechtler Collection, Zürich

Composition with Red, Yellow and Blue
1930
Piet Mondrian 1872–1944
Alfred Roth Collection, Zürich

Mauve and Orange
1961
Mark Rothko 1903–
Marlborough Fine Arts, London

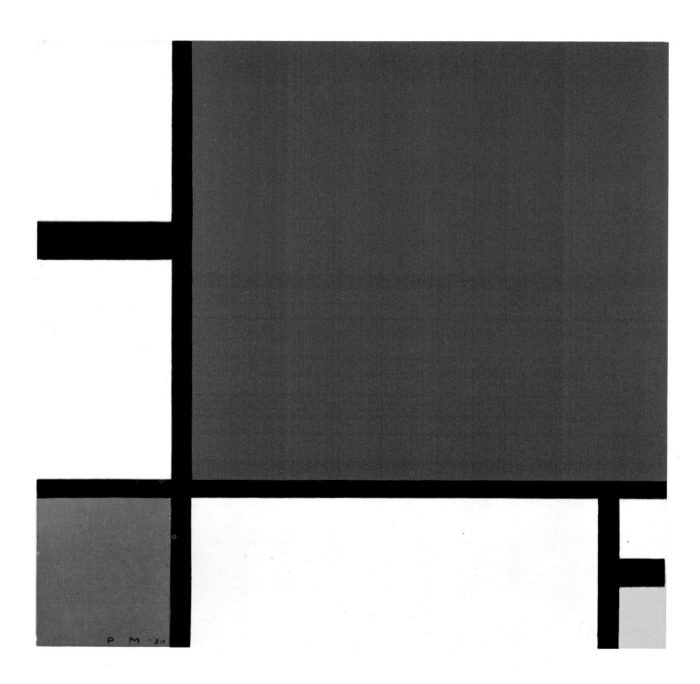

respond, or not, in our own way, without the evaluations of past ages backing us up.

Kandinsky is generally regarded as the first artist to have painted a purely abstract picture, although as we have seen (see plate 48) Cézanne was moving in that direction in his use of evenly spaced and shaped brushstrokes which create a pattern on the canvas independent of the subject they describe. Kandinsky was inspired, so it is said, by the sight of one of his pictures hanging upside down, and he came to believe that a subject was a positive hindrance to the enjoyment of the true qualities of a painting: shape, colour and line. But Kandinsky also tried to define precisely what he was doing. He formulated an elaborate theory of colour and what it expressed, making a kind of grammar of colour and shape. Starting with the fundamental distinctions of warm and cold, light and dark, he attributed to these qualities of

emotion, mood and movement. He believed that colour in itself is an element of expression and does not need to be attached to an object in order to have meaning. In spite of their abstraction and geometry, Kandinsky's paintings are full of tremendous joy and energy. He was forever inventing ways of conveying the feeling of weightlessness, forms and colours affecting one another through their own energies in an endless dance in space.

Like Kandinsky, Mondrian was a great theorist and purist. He restricted his forms to purely geometrical shapes and his canvases became more and more simplified in an attempt to create paintings which could be universally appreciated. His rectangles of three primary colours, with white or grey, were painted as smoothly as possible and with the areas of colour divided by thick black lines, a form which scarcely changed throughout his life.

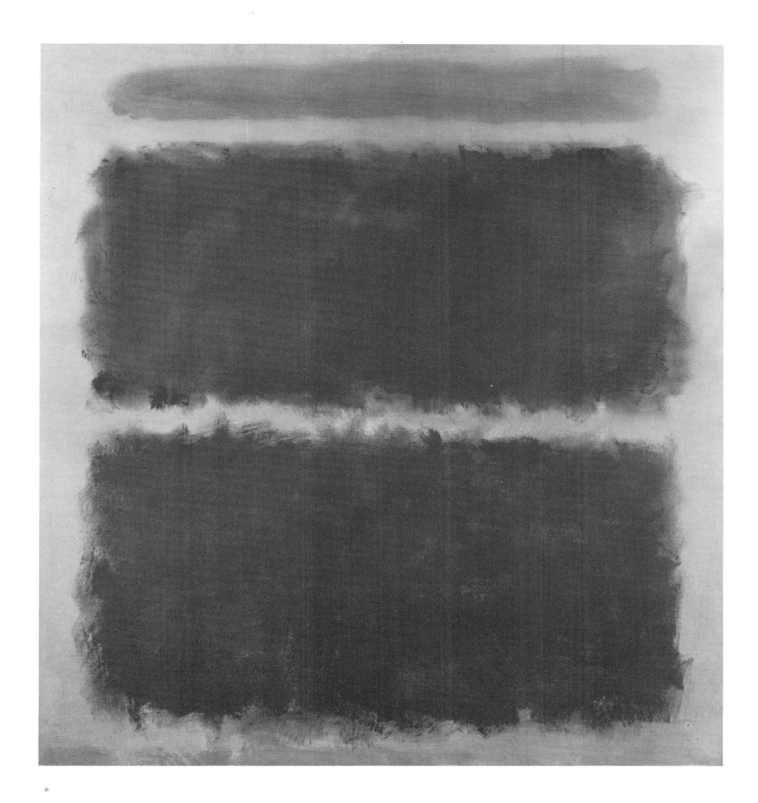

No period in American painting has offered a greater variety of styles than that since the Second World War. The dominant trend, far overshadowing any other, has been the emphasis on some form of abstraction. Even within the limits of abstraction, individual aspects of the idiom are numerous, the most distinctive being associated with Mark Rothko and Jackson Pollock. Like Mondrian, Rothko uses rectangles of colour but they have muzzy edges. His *Mauve and Orange* provides a colour sensation which is quiet and restful. The mauve is placed in a thin strip above the two bands of orange and they are separated and framed by areas of pink. The monumental dimensions of the colour areas give the spectator the feeling of being directly involved in their creation, and in the presence of such a painting as this no one can be unaware of the powerful impact of sheer disembodied colour.

Pollock has said of his work: 'My painting is direct . . . I want to express my feelings rather than illustrate them . . . When I am painting I have a general notion as to what I am about. I can control the flow of paint; there is no accident, just as there is no beginning and no end.' His technique of painting by pouring, spraying, whirling and dribbling paint from a scaffold raised above the canvas on the studio floor was, to say the least, unorthodox and the term 'action painting' that is often applied to Pollock's work is apt. His work is an experience of paint and of its texture, and the prevailing dynamic rhythm is a direct expression of the particular medium used.

Though himself the master of an art of order and clarity, it is characteristic of the British painter Ben Nicholson that he considers action painting as 'a particularly healthy, free painting development'. As an artist Nicholson is impressively undoctrinaire. His own work is one of balance but not

98
Untitled
1946
Jackson Pollock 1912—56

99
1967 (Tuscan Relief)
Ben Nicholson 1894—
Tate Gallery, London

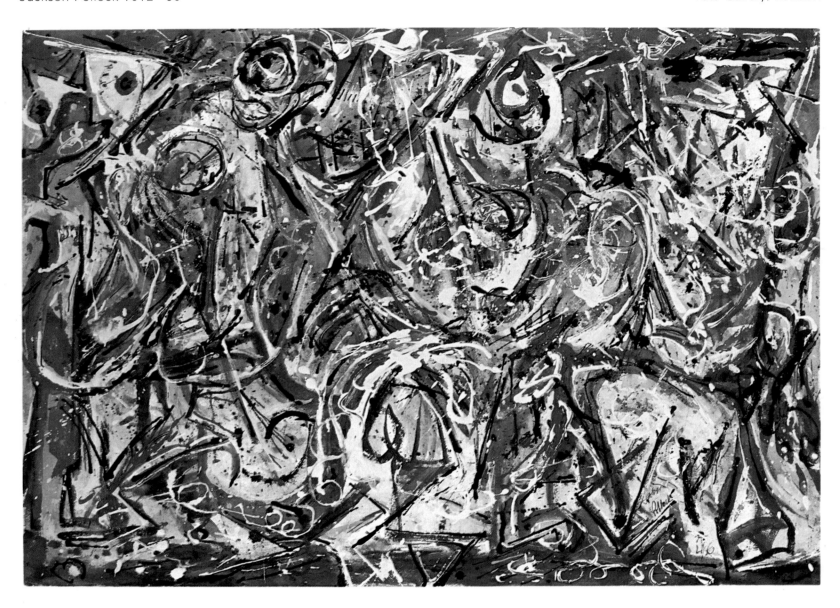

of detached calculation, an art in which sight and touch, imagination and instinct are brought together and resolved. However abstract the work, poetic breadth, richness and poise remain its keynotes.

One of the principal innovations of 20th-century artists has been the abolition of the old distinction between painting and sculpture. Ben Nicholson is notable for his studies in coloured relief. His reliefs are not simply carved and then painted. Colour is worked into the relief surface during the carving process and is subject to the same degree of precise adjustment, so that he may at times be carving into what already looks like a solid block or area of colour. Curved

edges appear for the first time in some of the 1967 reliefs, bringing to the relief a particular tension which had previously been confined to the use of line in his paintings and drawings. In *1967 (Tuscan Relief)* this tension helps to suspend the strong forms clustered around the transparent blue at the centre and so lightens what would otherwise be a slightly overpowering composition.

Tension is also vital to the paintings of Bridget Riley. She avoids all traces of personality (just as she rejects all subject-matter) because it would cloud her central issue which is to capture the tension created by certain intervals between colours, tones and lines. Her means may seem suspiciously

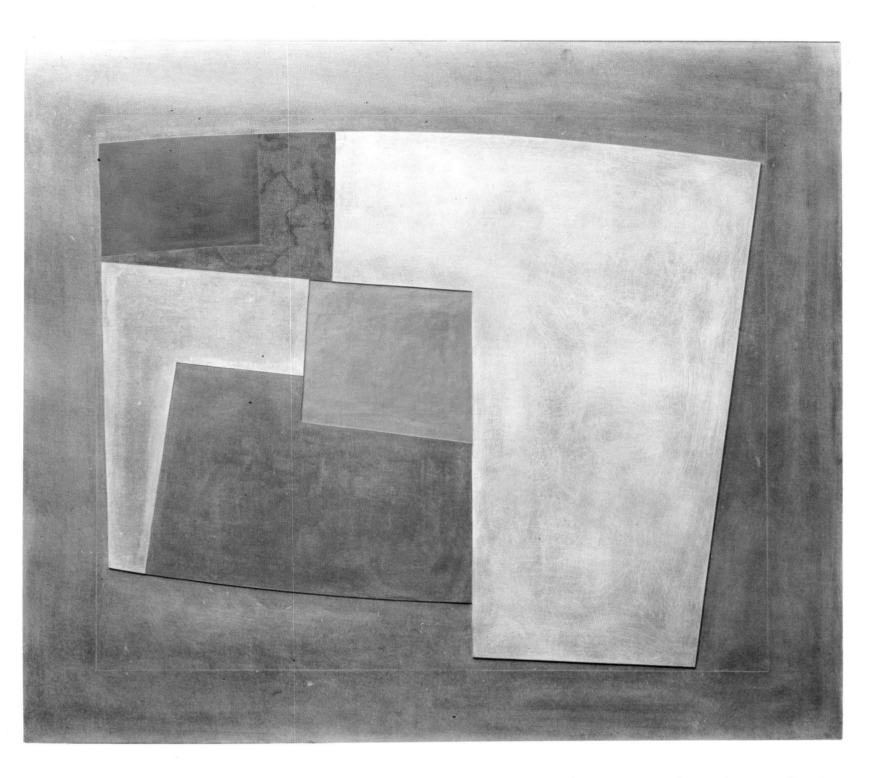

dry and formal. She lays bands of different hue, strength, tone and width in varying rhythms across the canvas, usually interspersed with bands of white. The result, although sounding monotonous, can produce a great variety of visual images, from elegant and delicate panels to muted meditations, or to vividly contrasted canvases which ring out like fanfares. Riley makes us feel with our eyes instead of merely perceiving, and the resulting sensations are new and strange and still not fully explored.

Throughout the history of art it is possible to see how sometimes the subject has been of particular significance because, perhaps, of its religious, moral or political message, and how sometimes the subject has been of secondary or of no importance to the artist's interpretation. In addition, artists tend to vary in their emphasis of one artistic element, which might be the linear pattern, the illusion of space, the capture of light, the effect of colour, or the texture of the paint itself. The balance between the content and the form of a painting changes from one artist to another and from one age to the next. Today pure abstract painters confront the Photorealists. Tomorrow will bring new ideas, new interpretations. It is this state of flux which makes the history of painting so interesting, and which continues to fascinate painters and art lovers alike.

100
Cataract III
1967
Bridget Riley 1931—
British Council Collection

Glossary

Aerial perspective: the technique by which an illusion of depth can be achieved on a flat surface by adjusting the tone and colour of objects represented according to imagined distances between them and the spectator.

Broken colour: a method of painting a layer of colour over another of a different shade or tone so that the one underneath is partly visible. This gives an uneven, broken effect.

Chiaroscuro: the balance of light and shadow in a picture.

Contrapposto: a pose in which one part of the body is twisted in the opposite direction from that of the other.

Foreshortening: the effect achieved when applying linear perspective to a single object.

Fresco: true fresco is a painting on a wall or ceiling in which the artist works with a water-soluble medium directly on to wet plaster, so that the finished work becomes part of the actual wall. The artist could only work on a small area at a time and had to finish before the plaster had dried. In order to paint in a more leisurely way, some artists have worked on dry plaster. This 'dry fresco' technique is unstable and the result is prey to variations in the weather, as the painters have found to their cost.

Impasto: the thickness of paint when applied to a canvas.

Linear perspective: the mathematical law by which an illusion of depth can be achieved on a flat surface by adjusting the size and shape of objects represented.

Mosaic: a form of floor and wall decoration where small squares of coloured stone, marble or glass are closely set into a cement ground.

Trompe l'oeil: use of pictorial techniques to deceive the eye into taking that which is painted for that which is real.

Vanishing point: in linear perspective, the point on the horizon where all parallel lines apparently meet.

Acknowledgements

The illustration on page 43 and the endpapers are reproduced by Gracious permission of Her Majesty the Queen.
The following illustrations have been reproduced by permission of:
The Greater London Council as Trustees of the Iveagh Bequest, Kenwood, 52–53; the National Gallery of Victoria, Melbourne, 70 bottom; the Warden and Fellows of Keble College, Oxford, 25.

Sources of photographs
A.C.L., Brussels, 20;
Allbright Knox Art Gallery, Buffalo, New York, 26, 27, 117 bottom;
Bayerische Staatsgemäldesammlungen, Munich, 34, 48;
R. Braunmuller, Munich, 56;
British Council, London, 124;
J. Allan Case, London, 88 top;
Walter Drayer, Zürich, 119;
R. Einzig, London, 120;
Fotochronika Tass, 101 bottom;
Frankfurter Goethe-Museum, 108;
Frans Halsmuseum, Haarlem, 36–37;
Fratelli Fabbri Editori, Milan, 103 top;
Gallery Ostergren, Sweden, 104–105;
Giraudon, Paris, 21, 30, 45, 64–65, 74 bottom, 85, 115;
Golden Press, New York, 29;
Leo Cundermann, Würzburg, 76–77, 94;
Hamlyn Group Picture Library, 39, 40, 60, 82 bottom, 83, 84, 95, 98–99, 102;
Hamlyn Group Picture Library–Hawkley Studio Associates, 41, 50; Hamlyn Group Picture Library – John Webb, 60–61, 62–63, 88 bottom, 96, 103 bottom, 109, 118, contents page;
Edward James Foundation, Sussex, 116;
Marlborough Fine Arts, London, 121, 123;
Mas, Barcelona, 23;
Metropolitan Museum of Art, New York, 68, 86, 117 top;
Erwyn Meyer, Vienna, 90;
Museum of Fine Arts, Boston, 58;
Museum of Fine Art, Montreal, 70 top;
Museum of Modern Art, New York, 86;
National Gallery, London, 13, 14, 15, 32, 33, 35, 38, 42, 54–55, 57, 59, 67, 72–73, 75, 78–79, 80–81, 112–113, jacket illustrations;
Philadelphia Museum of Art, Pennsylvania, 114, W. P. Wilstach Collection, 66;
Phillips Collection, Washington, 100;
Preiss and Company, Munich, 47;
Bruno del Priori, Rome, 16;
Ramos, Madrid, 111;
Rapho Agence Photographique, Paris, 82 top;
Réunion des Musées Nationaux, Paris, 22, 93, 101 top;
Rijksmuseum, Amsterdam, 92;
Scala, Milan, 9, 10, 11, 12, 18–19, 24, 31, 46, 74 top, 107;
Sotheby Parke-Bernet, New York, 69, 122;
Wallace Collection, London, 44, 91.

Index

Plate numbers are shown in italics

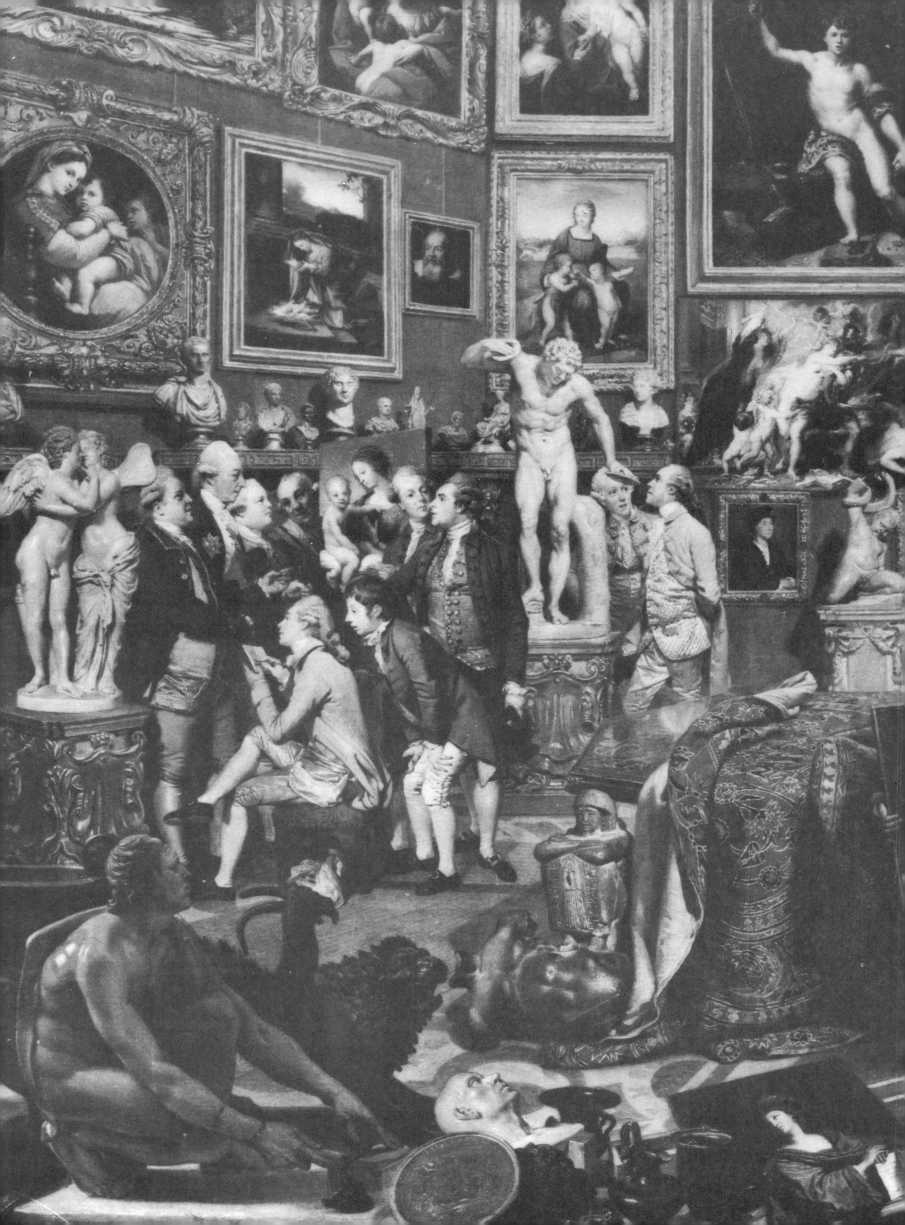